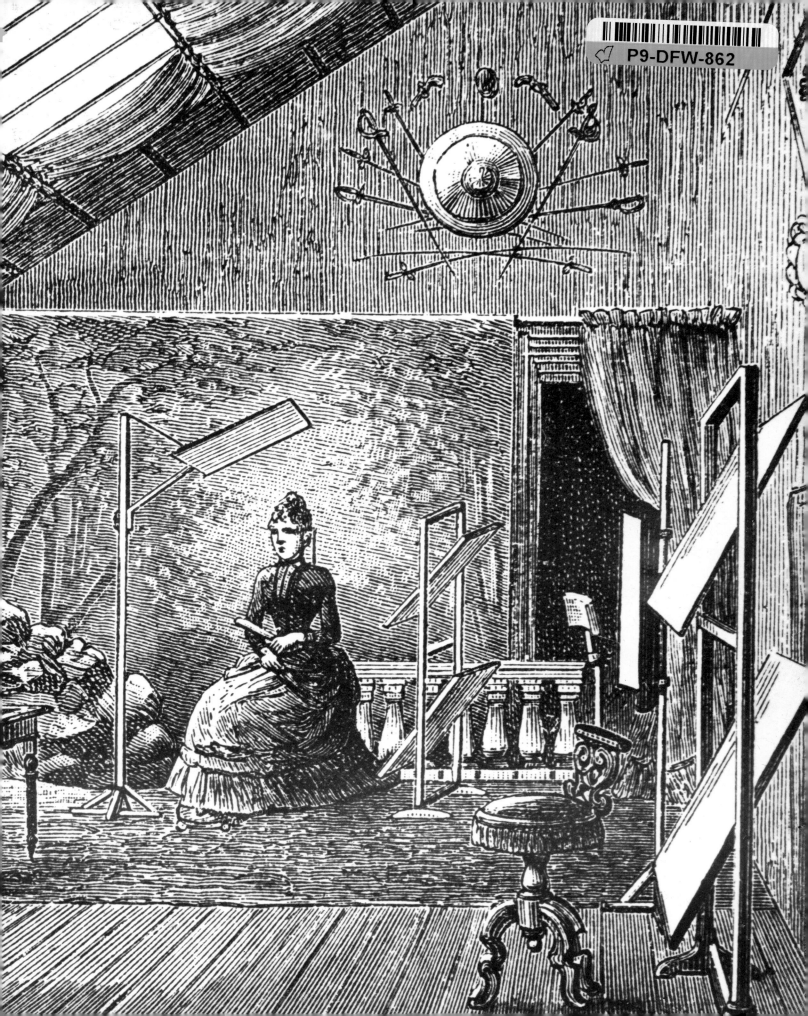

An Age
of
Cameras

Edward Holmes

Produced in Great Britain
Filmset by Keyspools, Golborne, Lancs.
Origination by Colour Craftsmen, Chelmsford, Essex
Printed by Tindal Press, Chelmsford, Essex
Bound by Hazell, Watson and Viney Ltd., Aylesbury, Bucks.

Fountain Press Argus Books Ltd.,
Station Road, Kings Langley
Hertfordshire, England.

Contents

Prelude to a Period

Cameras were once made for, and owned by, the few. In this historic period, more than a century ago, cameras were entirely unsophisticated, and to an equally unsophisticated public, photography was a form of magic.

In this period, there is much to be said—and it has already been set down by many excellent writers—about the emergence of the photographic process. There is little to be said technically, about the cameras, for they were little more than simple wooden boxes.

The age of cameras which concerns us here is that which began about 1879, and ended in 1939. It is the age in which cameras diffused into all sections of society, and became a part of everyman's life; it is the age during which cameras took many and varied forms, before settling down into the relatively small number of basic types which are popular today. It lasted about sixty years.

Photography had been a matter of strange alchemies, of glass plates and special papers, sensitized in guarded darkness with recondite emulsions and painstakingly exposed in cavernous cameras of panelled wood—a matter for the few and the expert. But from about 1879 when it became possible to buy 'gelatine dry plates', ready made, the art lost many of its most troublesome disciplines, and now cameras were for everybody.

Cameras existed long before photography. The invention of the camera obscura, in which hand sketching did the work of the sensitive plate, is usually attributed to Baptista Porta, a sixteenth century Neapolitan, although there is little doubt that this type of image projector was known to the wise men of the Arab world at least five centuries before this.

The camera did not progress beyond being an optical aid to draughtsmanship until the early nineteenth century, when Nicephore de Niepce, Daguerre, Fox-Talbot and other workers demonstrated that the optical image could be captured by the action of light on chemicals, instead of being laboriously drawn by hand, or painted, as men like Canaletto drew or painted such camera images.

From the time when it was first discovered that a photo-chemical image could be produced in a camera, there followed half a century of exploratory activity, during which photography was encysted within a number of messy and rather daunting chemical disciplines. To develop cameras for anything resembling a popular market at this time was pointless.

This was half a century during which expeditions with a camera involved the transportation of a mass of corrosive chemical luggage, and a portable dark room of some form as well, for in the wet-plate process, which emerged preeminent in this period, plates had to be sensitized as needed, for they remained sensitive only for as long as they were wet.

But when the dry plate arrived, all that was changed. Soon dry plates could be bought ready made, and after exposure, they could be developed, within reason, whenever it suited the photographer. Furthermore, there was no rea-

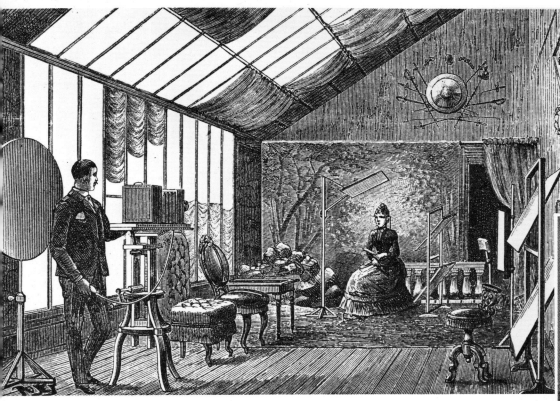

Photographers' studios, in the earlier years of the period which concerns this book, relied on daylight for most of their work. These two engravings from the Kodak archives, show typical studios of the period, and on the right is a carte de visite picture, probably the most representative end-product of the early professionals.

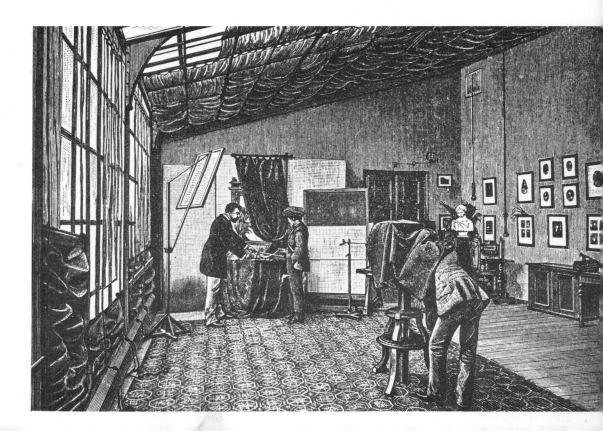

son why dry plates should not be used in existing wet-plate cameras. The manufacture of ready-to-use dry plates became a profitable activity, as was realised, for example, by George Eastman, when he designed and patented a machine for this purpose in 1879, and laid one of the foundation stones of what was later to become the Eastman Kodak Company.

Now photographs could be made without the absolute necessity of a light-proof chemical laboratory—portable or otherwise—within a few minutes access to the site of the intended picture.

This point marks the beginning of the age of cameras which concerns this book. It is the age in which cameras ceased to be mere light-tight boxes whose function was to keep the lens and the emulsion the right distance apart. It is the age when, because the demand for cameras was enormous, a considerable number of variations on the basic theme appeared. Mechanical inven-

tion marched forward alongside optical design to offer the would-be photographer a wide choice of what were, on the whole, very nicely made instruments of varying capabilities.

Because cameras existed, the visual facts of the arts and sciences, and of history itself, could be recorded with an ease and objectivity that had never previously been possible. The photograph became a universal language of information, and the moving picture and all that has grown from it, became a practical possibility.

The camera was to change the world—the dry emulsion camera. This book is concerned with the evolution—the childhood and adolescence —of that sort of camera. The time-span involved is from the advent of the dry plate, up until the start of the second world war.

It is the period which also includes the invention and development of the internal combustion engine, powered flight, and wireless telegraphy. It is the period which saw the birth and blossoming of mass communication. It is the period in which the world changed more rapidly than it had ever done before.

This book is concerned with looking at the kinds of cameras that played their parts in this changing world.

The advent of the dry plate changed the whole image of photography, as makers of dry plates were not slow to point out.

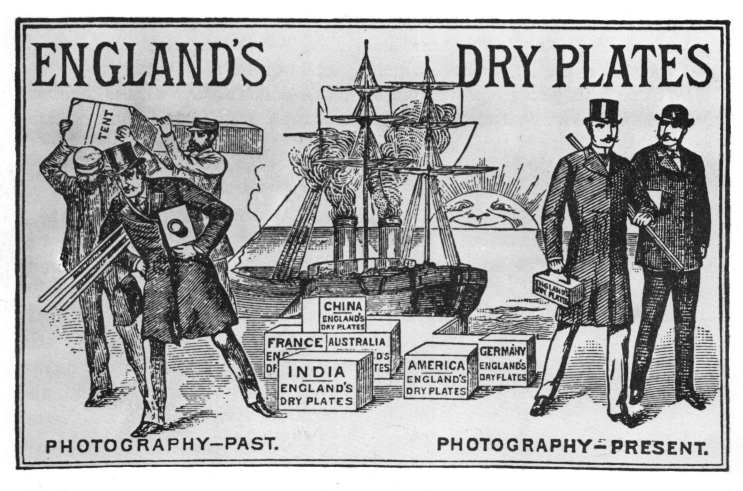

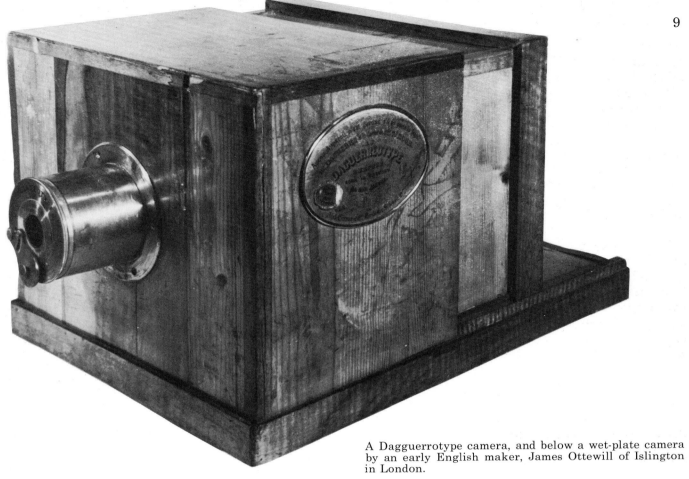

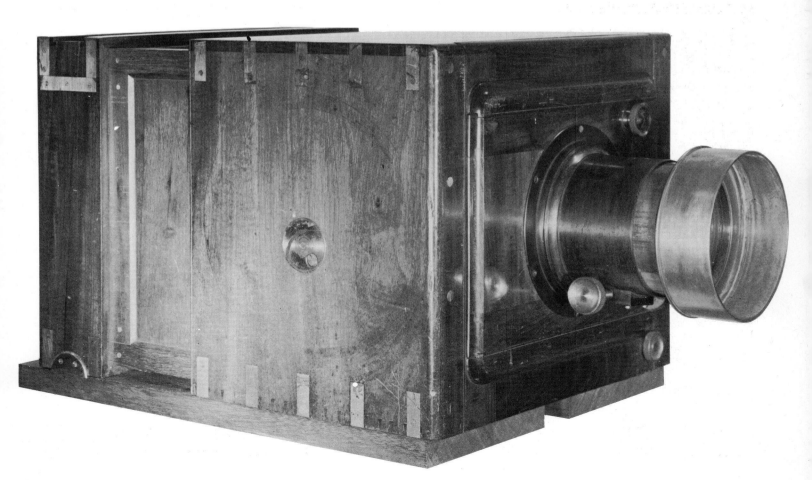

A Dagguerrotype camera, and below a wet-plate camera by an early English maker, James Ottewill of Islington in London.

Glass, Brass, and Polished Wood

A camera made of polished mahogany, with lacquered brass fittings, is an old camera to most people. Many dealers automatically describe such a camera as 'Victorian', which can be far from accurate.

Such cameras were, in fact, the main type made during Queen Victoria's reign, (there were other forms of construction) but they also went on being made and sold for long after her death in 1901, and bellows type cameras, stemming directly from this era are still being made at the present time by two companies, Gandolfi of London, and Deardoff of New York. These cameras are capable of work of the highest class, and are still the choice of many notable photographers. They possess an elegance which accords better with the concept of photography as an art than does the starkness of the modern studio camera.

No other basic camera type has endured anything like as long as this. Therefore I think it is fitting that we should start our consideration of our age of cameras with this type, which already existed when the age began, and still exists today as a valued photographic tool, and not just a collector's item.

At the beginning of the age of cameras which concerns this book, in 1879, the only cameras that existed were those which had been made with Daguerrotype, wet plate, or one of the other earlier processes in mind.

Dry plates, when they became commercially available in 1879, could be, and were used in these cameras. No modification to the camera was necessary. The dry plates could be carried in the original 'slides', or 'backs', which had been designed to carry wet plates.

The term 'slide' or 'back' used in connection with cameras refers to the lightproof container which carried the sensitive plate. They were made in the form of flat boxes. The wet plate form of these slides was fitted with a sliding shutter on one side, which could be opened when the slide was fitted to the back of the camera, in order to make the exposure. At the back of the slide was a door, which was only opened in the dark room to insert the wet, sensitized glass plate, or to remove it after exposure. In these slides, the wet plate rested on four small inserts of silver wire, set in the four corners of the slide, and there was no reason why a dry plate should not do the same.

But with the advent of dry plates it now became possible to make the slide double sided. Now the slide could be fitted with two shutters, one each side, and could carry two dry plates, back to back. This type of slide became known as the 'double dark slide', and is the type most often found with wooden dry plate cameras.

Thus, at the very beginning of our period, one finds cameras, originally made for wet plate photography, and originally fitted with one or more wet plate single slides, which have also been provided with double dark slides for dry plate photography. I think that it is convenient to call such cameras 'wet plate conversions'.

In the field of firearms, one finds 'flint lock conversions'—flint lock weapons which were

converted for percussion ignition. But whereas the original flint lock weapon ceased to exist as such when it was converted, wet plate cameras suffered no such regrettable ruination, and merely acquired a new set of 'backs'.

These wet plate conversions are the first cameras in the dry plate era. Broadly, they fall into two classes; box form cameras, and cameras with bellows.

The Early Forms

The box form camera was the earliest form to emerge. It took the form of a simple wooden box, on the front of which the lens was fitted in some form of focusing mount, or a double box, with one part sliding within the other for focusing. In this latter form, the lens was often in a focusing mount, but sometimes in a simple fixed mounting.

In these box form cameras, as in all early cameras, correct focusing was arrived at by inspection of the image formed on a ground glass screen, which was fitted into the back initially in place of the slide which carried the sensitive plate.

On these box form cameras, shutters as we know them are non-existent. They were made at a time when all sensitive material was very slow indeed, and some form of light-tight cover which fitted over the lens front was quite adequate for the exposures required, which were often measured in minutes.

This cover can be in the form of a hinged flap which folds down over the lens, or a flat disc which can be revolved about an eccentric pivot to begin and end the exposure. It can be a nicely made brass lid, which slides snugly over the lens front, or it can be a 'pill-box lid' made of thin card, covered with leather, and lined with dark velvet. This last form of lens cap is by far the most common.

The workmanship of these early box form cameras is very much that of the cabinet makers of the period, from whose ranks the early camera builders largely emerged.

Mahogany is the wood most often used for the construction of these cameras. This wood was not only readily available, but was one whose qualities were well known to the trade. Well seasoned stocks of mahogany were plentiful, and since a camera maker would need only small quantities, he could afford to be very choosey about his wood. This is one of the

A 5 × 4 camera by Thomas of Pall Mall, made originally for use with wet plates, and later converted for dry plates.

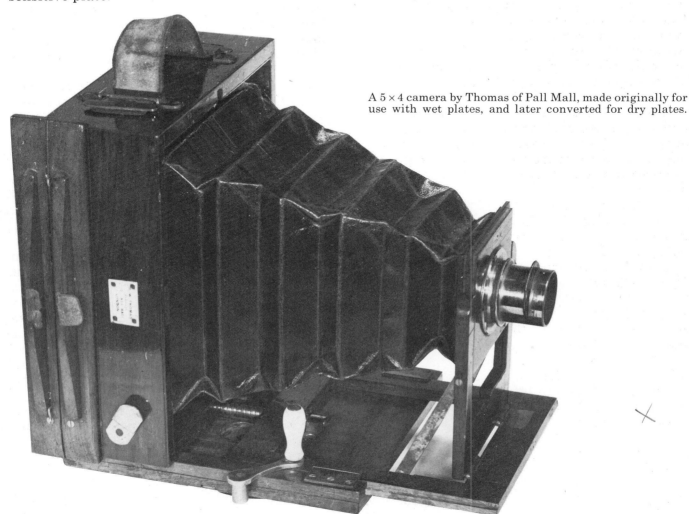

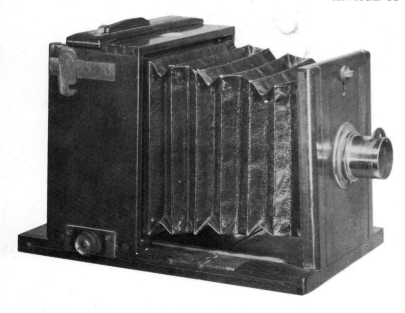

Another 'conversion', supplied by Murray and Heath of Jermyn street. It was probably made, as a wet plate camera, about 1860.

'Le Meritoire' by Lancaster, about 1887. This is a single extension half plate camera. It is fitted with a Lancaster landscape lens of later date.

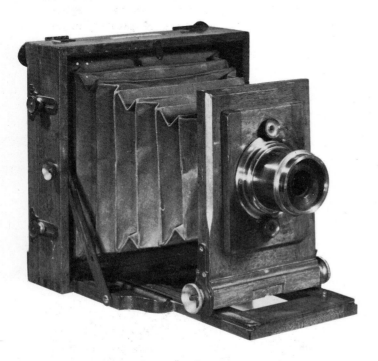

reasons for the durability of the best of these early cameras.

The other basic form of early camera—the bellows camera—was also well established by the time our period begins.

Bellows cameras vary considerably in the details of their construction, but there are some basic features which are common to all of them. They all have a baseboard, on which is mounted the rear frame, which carries the focusing screen. This screen is arranged in such a way that it can be removed, and the slide which carries the sensitive plate put in its place. Also mounted on the base is the front frame, which carries the lens panel. There is some arrangement for varying the distance between the front and rear frames for focusing purposes, and the front and rear frames are joined together by flexible, light-tight bellows.

Bellows are made of very thin leather, lined with black cloth. Between the leather and the lining are strips of paper, or thin card, and it is the narrow spaces between these strips that determine the lines at which the folds in the bellows occur.

There were two types of bellows current at the beginning of our period. They were 'square' bellows, and 'tapered'.

Bellows

The term 'square' is a little misleading. Square bellows are parallel sided, and rectangular in cross section. 'Square' in this connection means rectangular, and one can find many square bellows which are oblong in cross section.

Tapered bellows are bellows which again are rectangular in cross section, but smaller at the front than at the back. These tapered bellows were often referred to as 'Kinnear pattern' bellows, after one Captain Kinnear, who designed a camera using tapered bellows around 1865, in the wet plate era. Kinnear pattern cameras are among those that one may discover as wet plate conversions.

On the subject of bellows, it should be noted that all early camera bellows have square—ninety degree—corners. The later patterns of bellows have cut off corners; that is to say they are really eight sided, four of the sides being very short.

These early bellows, with their square corners are very vulnerable to wear. The leather

 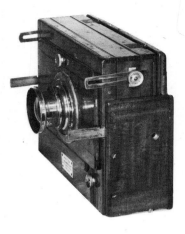

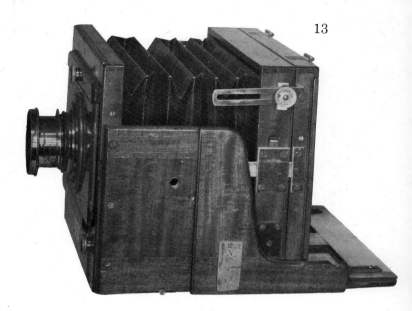

Left, the Murray and Heath camera, folded. Right, a tailboard camera by Wratten and Wainwright, folded and open. Circa 1890.

in the rectangular point of a corner is folded through 180 degrees in two planes, or, to put it another way, is the common point of two 180 degree folds. Clearly the tiny area of the corner itself is a point of very high strain because of this, as well as being the point most likely to suffer rubbing. In consequence, it is not unusual to find early cameras with pin holes at these corners—particularly the corners along the two top edges. The later pattern of folding, which came into use in the 1890s, puts far less strain on the leather, is much less vulnerable to rubbing, and is much more durable in consequence.

Bellows can be quite useful in dating a camera, but they can be misleading. For one thing, a few makers clung to the square corner pattern long after others had abandoned it. For another, one does come across good cameras of early date which were fitted with new bellows after many years of service. If the replacement was done about 1900, the chances are that the newer type of bellows would be specified by the owner. If he thought that his camera was worth the expense of refitting, he obviously hoped to go on using it for a long time. That this did happen is proved by the fact that I have come across nice early cameras, with later type bellows, that I was reliably informed were working for their living until just a few years ago.

The box form cameras of this period were cumbersome, heavy, and not easily portable. It must be admitted that some early bellows cameras were almost as massive, but the bellows construction did offer the possibility of a camera which could be folded up for carrying.

Probably for this reason, the term 'field camera' came into use to mean a wooden camera which could be folded up to be carried on outdoor photographic excursions. But the term was not universally used in the early days. Many folding wooden cameras that one would today call field cameras were, at the time of making, described by their makers simply as 'cameras'.

I think it is useful at this point to define just what was meant by the term 'camera' in these early days. The word, basically, is the same word as 'chamber' in the sense of a room. Originally it was 'camera obscura' and referred to the 'dark room' in which a sun image of something outside the room could be traced by an artist. In the early years of photography,

This half folded camera displays the new type of bellows, which became common about 1900, and which had 'cut off' corners, as distinct from the earlier squared corners.

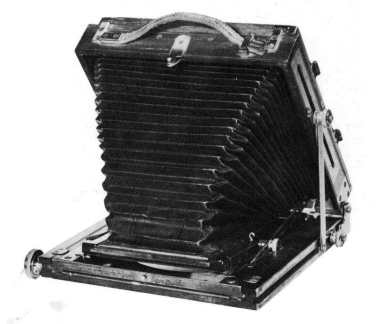

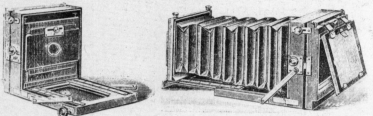

ROSS' IMPROVED DRY-PLATE CAMERAS

Extra Light and Portable Double Extension Cameras, constructed with a view to extreme lightness and portability, with every desirable swing motion, reversible holder, one double slide, and extra front.

Size.	Price.	Highest Finish.	Brass Binding.
5 × 4	£5 8 0	£6 0 0	£0 18 0 extra.
6½ × 4¾	6 8 6	7 2 6	1 0 0 ,,
7½ × 5	6 15 0	7 10 0	1 0 0 ,,
8½ × 6½	7 17 6	8 15 0	1 0 0 ,,
10 × 8	8 16 6	9 16 0	1 6 0 ,,
12 × 10	9 18 0	11 0 0	1 10 0 ,,

EXTRA DOUBLE SLIDES
For DRY-PLATE CAMERAS.

Size.	Price.	Highest Finish.	Brass Binding.
4¼ × 3¼	£0 13 6	£0 15 0	£0 4 0 extra.
5 × 4	0 16 6	0 18 0	0 4 0 ,,
6½ × 4¾	1 0 0	1 2 0	0 4 0 ,,
7½ × 5	1 0 0	1 2 0	0 4 0 ,,
8½ × 6½	1 2 6	1 5 0	0 4 6 ,,
10 × 8	1 9 0	1 12 0	0 5 0 ,,
12 × 10	1 16 0	2 0 0	0 5 6 ,,
15 × 12	2 9 6	2 15 0	0 6 0 ,,

DIVISION FOR STEREOSCOPIC VIEWS supplied with all 8½ × 6½ size and smaller Cameras, and with larger when desired.
RACK AND PINION ADJUSTMENT TO SWING BACK, 8½ × 6½ size and smaller, 5s. extra; larger, 10s. extra.

TEN PER CENT Discount when Remittance accompanies Order.

ROSS' IMPROVED DRY-PLATE CAMERAS

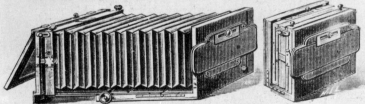

PORTABLE BELLOWS CAMERAS,

Expanding from 3½ to 10 inches and upwards, with Screw or Rack Adjustment, Folding Tail-board, one Double Slide and Extra Front.

Size.	Price.	Highest Finish.	Square, with Reversible Holder. Price.	Highest Finish.	Swing Back
4¼ × 3¼	£3 3 0	£3 10 0	£3 10 0	£3 17 0	15s. extra.
5 × 4	3 6 6	3 14 0	4 4 6	4 14 0	15s. ,,
6½ × 4¾	4 1 0	4 10 0	5 3 6	5 15 0	15s. ,,
7½ × 5	4 10 0	5 0 0	5 12 6	6 5 0	15s. ,,
8½ × 6½	5 8 0	6 0 0	6 6 0	7 0 0	15s. ,,
12 × 10	7 11 0	8 8 0	8 15 6	9 15 0	25s. ,,
15 × 12	9 9 0	10 10 0	11 0 0	12 3 0	30s. ,,

ROSS & CO., Opticians, 112 New Bond Street, LONDON, W.
MANUFACTORY—BROOK STREET.
[See *preceding and next pages.*]

the camera was just the light-tight chamber. The lens was a separate item. Today, the term 'camera' embraces the complete apparatus for making a photographic exposure. The term was taking on this meaning in general usage by the early 1890s.

To return to our folding bellows cameras: within the scope of the overall description set out above, there were three main sub-types.

The first of these is the pattern which derives from the George Hare design of 1882. George Hare, of Calthorp street in London, is an important early maker. Early in his career, he had worked with James Ottiwill of Islington, who is often referred to as 'the father of English camera design'. He set up a business to manufacture cameras before our era begins, and is among the most notable of the early pioneers.

His apprentice, George Hare, is hardly less notable.

George Hare's Classic Camera

His design of 1882, which was later widely copied by other makers, had baseboard and back hinged together, while the front standard could be set anywhere needed on a movable board within the baseboard. This movable board was fitted with rack and pinion for precise focusing, and the front standard was located on it by two long vertical tie-rods, with knurled brass nuts at the top. To fold the camera, the nuts were loosened, and the front standard slid right back into the back. Then the stays which kept the back at right angles to the base were loosened, and the base could then be folded up flat against the back.

This simple design, carried out in George Hare's superb workmanship, is one of the classics among early cameras. My own example, in the 8½ in × 6½ in size, is a pleasure to handle and use. It was recently borrowed by a photographer for a particular job which demanded this size, and, fitted with a Zeiss Protar lens, performed superbly. The facial expression of the photographer when he returned the camera to me can only be described as wistful.

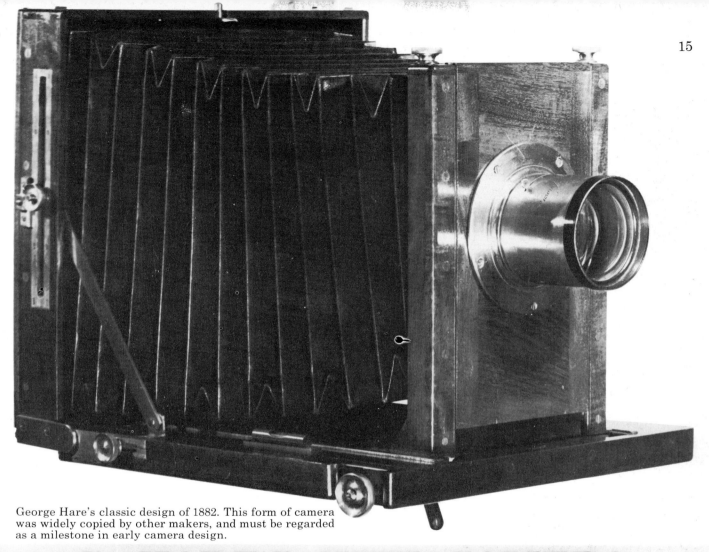

George Hare's classic design of 1882. This form of camera was widely copied by other makers, and must be regarded as a milestone in early camera design.

G. HARE'S NEW CAMERA,
Invented and Introduced, June 1882.
THE BEST AND MOST COMPACT CAMERA EVER INVENTED.

Since its introduction, this Camera has received several important modifications in construction. It stands unrivalled for elegance, lightness, and general utility. It is specially adapted for use with the Eastman - Walker Roll Holder. A 6½ × 4¾ Camera measures when closed 8 × 8¼ × 2½ ins., weighs only 3¾ lbs., and extends to 16½ ins. The steady and increasing demand for this Camera is the best proof of its popularity.

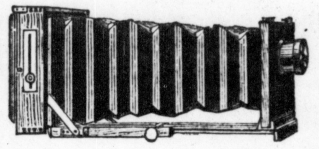

'Little need be said of Mr. George Hare's well-known Patent Camera, except that it forms the model upon which nearly all the others in the market are based.'—Vide *British Journal of Photography*, August 28, 1885.

Size of Plate.	Square, with Reversible Holder.	Brass Binding.	Size of Plate.	Square, with Reversible Holder.	Brass Binding.
5 × 4	£6 0 0	16/-	10 × 8	£9 16 0	£0 18 0
6½ × 4¾	7 2 6	16/-	12 × 10	11 0 0	1 0 0
7½ × 5	7 10 0	16/-	15 × 12	13 5 0	1 0 0
8½ × 6½	8 15 0	16/-	These prices include one Double Slide.		

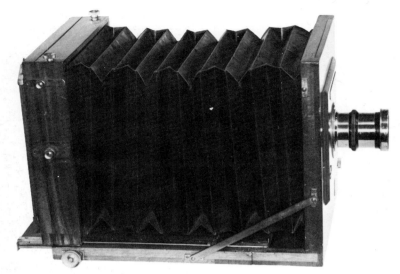

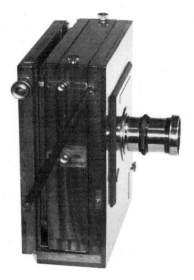

'Tailboard' Cameras

The second sub-type of folding camera can be designated as the tailboard type.

In this type the back, which can be locked in various ways to the baseboard, is slid right up behind the front standard for folding. The baseboard is hinged at a point about one fifth of the way along its length from the front. This hinged rear section then folds upwards, like the tailboard of a van, to cover the back of the camera. This arrangement has the great advantage of providing protection for the ground glass focusing screen.

Most tailboard cameras have a board within the baseboard which moves by rack and pinion for focusing the image, by adjusting the position of the back. This is a great advantage for copying and close-up work, since the lens can remain at a fixed, pre-determined distance from the object being photographed.

A typical square bellows tailboard camera, open and folded. The earlier pattern of bellows persisted longer on this design than on others. Circa 1925.

However, there are some tailboard cameras which focus from the front, and still others in which the user has the choice of either front or rear focusing.

The tailboard camera originated in wet plate days, before our period begins, and to this day you will find studios with fixed front tailboard cameras set up more or less permanently to cope with any copying work that may be required. It is interesting, too, that many photographers still prefer to dispense with a shutter, and to use a lens cap to control exposure on these cameras.

Most tailboard cameras have square bellows, but there are exceptions.

This fine Sands and Hunter 'Imperial' of 1888 is a tailboard camera with front focusing.

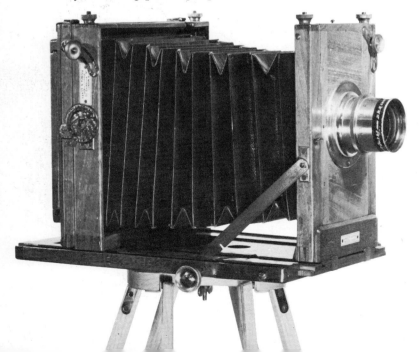

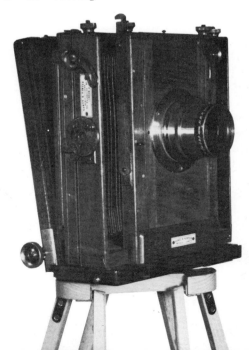

Field Cameras

The third sub-type of folding wooden camera is the type most often referred to now as a 'field camera'. It is also the most commonly found type, since in its most sophisticated forms, it is the most versatile of the three sub-types we are discussing here. It is also capable of accepting a great number of minor design variations.

It could, perhaps, have evolved from the first sub-type; it could have been the result of quite separate thinking. In that this third sub-type comprises many variations, it is virtually certain that it had multiple origins. But I think that it is easiest to describe it broadly in terms of the George Hare pattern, and how it differs from it.

Irrespective of any other differences within this third sub-type, the front is always arranged so that it folds, lens-front downwards, into the base. The base then folds against the back in the manner of a G.H.

This dropping of the front into the base is achieved in two ways; either the entire front standard, carrying the lens panel detaches completely from the base, and the front flops down on the flexible bellows, or the panel carrying the lens on one side, and bellows on the other, can be unlocked from the front standard, and revolved within it. The front standard then hinges back into the baseboard, and base and back fold together flat.

Another feature of this third variety is that the back can be set to any position required on the baseboard, though it must always be at the extreme rear for folding up.

As I have said, this third type of folding wooden camera is by far the most versatile in use. If it possesses a disadvantage compared to the other two, it is that in some forms it is very easily damaged by careless folding. With a tail-board, or a George Hare type, it would require sheer genius to collapse them so badly that they suffer damage. With the third type, particularly if the front standard is narrow, it is quite possible to drive the top ends of the front standard, or the brass stays which support it, into the bellows, and damage them severely.

I have come across cameras of this type which have been carelessly and forcibly folded up, and then left in this condition for years in storage. The state of what had been until then nicely made leather bellows has made me feel like weeping.

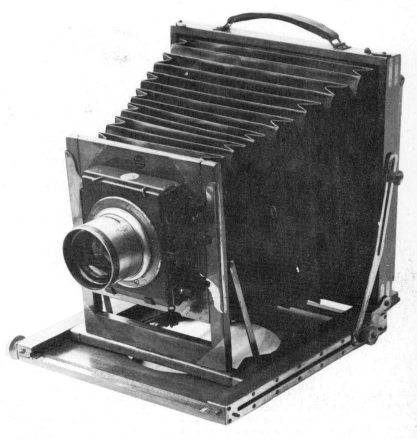

This Sharp and Hitchmough whole plate camera, circa 1900, is of the type in which the front standard lifts out of keyhole sockets to allow the camera to be folded.

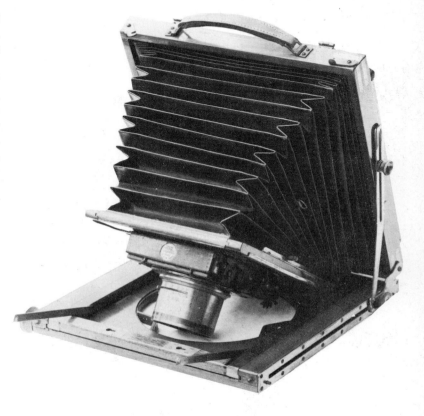

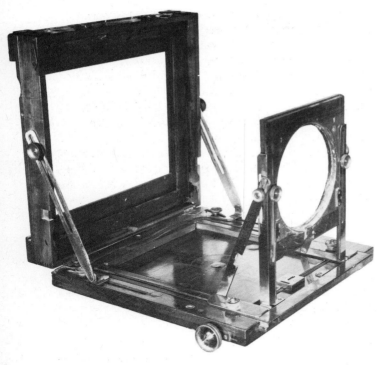

Without its bellows, the camera above by Underwood of Birmingham (circa 1885) shows clearly a typical double extension construction.

Below, a 'Royal Ruby', by Thornton Pickard, in which a very useful form of triple extension is seen. One extension worked from the front, and another from the rear of the base-board.

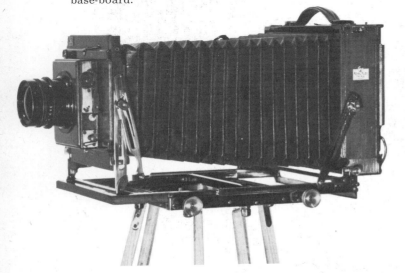

Take it gently, watch what is happening, and above all don't force the camera into its folded state. Those are the rules. The camera was made to fold without force, and if it doesn't want to do so, then you've got something wrong.

Many cameras of the third sub-type, and a few in the other two, are fitted with turntable bases. That is to say that a large circular hole is cut in the baseboard, on or in which is fitted a round brass turntable designed to accept the three legs of a tripod. This pierced base has an additional advantage in the case of the third sub-type, since it allows the camera to be folded up with the lens still in place. With all the other variations, the lens must be removed before the camera can be folded up.

Extensions

In connection with wooden cameras, the terms 'double extension' and 'triple extension' will often be met with, and very rarely 'single extension' as well. All three terms are also applicable to cameras other than those under consideration in this chapter, so it would be as well to define them at this early stage.

In a single extension camera, all focusing adjustment takes place within the length of the baseboard.

In a double extension camera (probably the most common form in early years), the baseboard contains a sliding panel, which allows for focusing extension up to something like a seventy-five percent addition to the length of the baseboard. This extension may occur in either a forward, or a backward direction.

In a triple extension camera, there are two sliding panels in the base. They may work one within the other, in 'series', in which case they both work in a forward direction, or they may be arranged so that one can be extended from the front, and one from the rear of the base. This latter type of triple extension camera is most useful, for it gives you the choice of either normal front focusing, or rear focusing for close-up work.

Many of these wooden cameras are equipped with 'movements'. This means that either the back or the front, and occasionally both, can be 'swung' and 'tilted'.

Most frequently, only the back is fitted with provision for 'swing' and 'tilt', and since the

effect is the same in principle where ever it is applied, let us consider a camera with back 'movements' only.

Movements

'Swing' is movement of the back about the vertical axis. 'Tilt' is movement about a horizontal axis. Both are generally limited to about ten degrees on either side of the rectangular position.

Movements are an aid to focusing. It can often happen that the subject to be photographed lies in a plane that is far from parallel to the plane of the lens. In such a case, the sharply focused image will also lie in a plane which is not parallel to the lens. By tilting or swinging the back, the focusing screen, and therefor the sensitive plate in its slide, can be brought into this plane.

One useful application of camera movements was in the job of photographing a large number of people seated at a banquet. The plane in which all the faces lay was horizontal, and the plane of the lens would probably be at about seventy-five degrees to this. The nearest faces might be six feet from the camera. The furthest, thirty feet. A minute aperture, and an unacceptably long exposure would be needed to get sharpness over the entire field of a subject like this, if you tried to get your depth of field by stopping down. By tilting the back of the camera, you could get all of those well fed faces into sharp focus, and still keep your lens well open, and your exposure short.

This type of job must have been a frequent chore for a photographer around seventy years ago, since one can come across references to cameras which were particularly recommended for this kind of photography, because they were 'fitted with banquetting tilt'!

Tilts, demonstrated with the help of a Thornton Pickard half plate 'Imperial' triple extension camera.

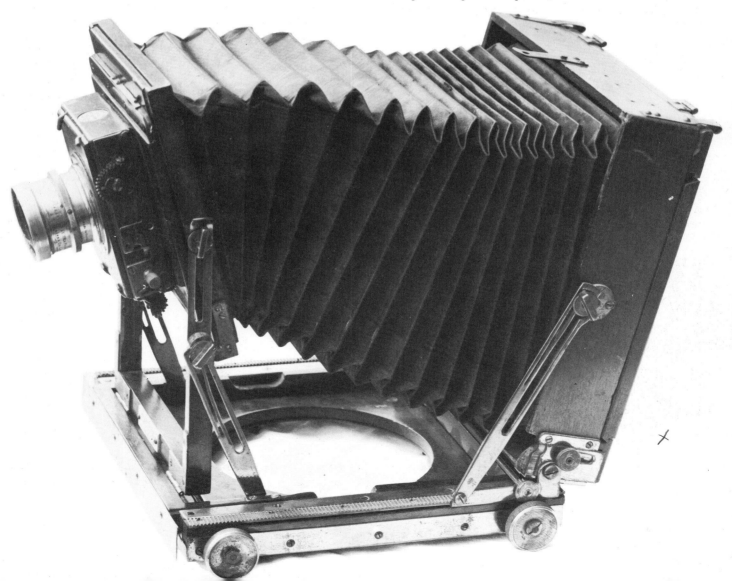

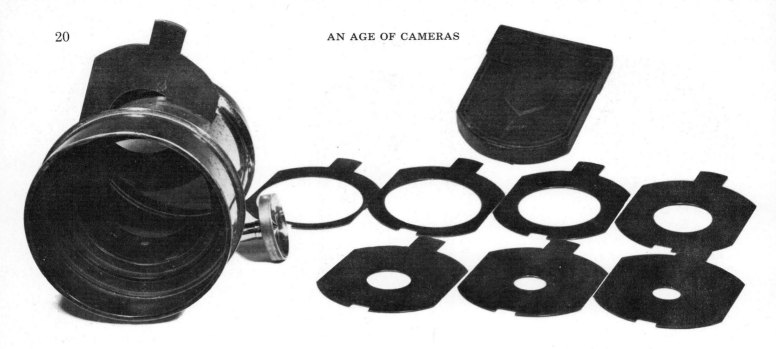

An early portrait lens, with Waterhouse stops.

The 'rising front' was another feature of these wooden cameras. Many of them also had provision for lateral movement. By this means the lens could be moved relative to the focusing screen, in a plane parallel to it. Since most lenses provided an image that included more than you normally saw on the focusing screen, moving the lens in this way allowed you to select the part of the image you needed. You could, for example, cut out excessive foreground, or take in the upper parts of a tall building.

Another simple provision on these wooden cameras was the reversing back. The back was square, and could be taken off, and replaced after turning it through a right angle. This meant that you could take your picture with the plate lying with its long axis either vertical, or horizontal. Your picture, in other words, could be either upright, or landscape. If your camera was sitting upon its tripod, clearly you could not turn it on its side, as you do with a modern 35mm camera.

As I have said, wooden cameras of the sort we are considering could be bought without lenses. In fact, in the earlier part of our period, this was the way they were offered by the makers. As time went on, many of them were listed, and a price quoted by the makers, including a lens. But these stand/studio/field/ cameras, probably because they were the original, all purpose, basic camera, continued to be available as simple cameras, without lenses, for longer than any other type.

Earlier lenses are all mounted in lacquered brass barrels. Some of the earliest are fitted

with rack and pinion focusing in the lens mount itself.

These adjustable lenses, when they really 'belong' with the camera—that is when they are contemporary fittings—are found on cameras of either sliding or fixed box type. Under these conditions, they may be taken as what the antiquarians call an 'early sign'. They are to be found on box-form cameras of the wet plate period, on wet plate conversions, and on dry plate cameras that were made in the box form.

It is not impossible to find a lens in an adjustable mount fitted on a bellows camera. It is unusual, because the bellows camera almost always has its own built in focusing adjustments, but it doesn't have to be an anachronism. However, it nearly always is.

Lenses in fixed mounts go with cameras which are provided with focusing adjustments, which as far as the types of cameras we are discussing in this chapter are concerned, means most cameras.

Stops

Most lens barrels are fitted with 'stops'. The ones which aren't are almost all of the adjustable type, and are early. Adjustable lenses mounts with stops, have Waterhouse stops.

So what is meant by stops?

Lenses with wheel stops. Many workers preferred this form of diaphragm long after the iris became commonplace, for it was absolute, and could not go wrong.

Used without stops, a lens passes the maximum quantity of light possible. If the photographer wished to reduce the amount of light, he would 'stop' some of it, by pushing a piece of metal with a hole in it into the path of the light passing through the lens. He would have a number of these pieces of metal, with holes of differing sizes in them, so that he could select the one which allowed just the right amount of light to pass.

These pieces of metal with holes in them were called stops—Waterhouse stops—and they came with the lens, usually in a neat flat leather case, and the lens barrel had a slot cut in it to receive them.

Sadly, most lenses which were meant to work with Waterhouse stops have the slit in the barrel, and that's all. In the course of time, lenses have got separated from their own stops, and in my collection I have just about as many lenses, with no stops to fit them, as I have sets of stops without lenses.

Some early lenses are simple singlets, mounted at the back of the lens barrel, and here the stops can take the form of 'washers' which drop into a small open ended 'pill-box' at the front of the lens barrel. These washer stops seem to have been even more losable than the Waterhouse variety.

The next form of stopping device which appears is the 'wheel stop'. Here you have a disc of metal slicing into the lens barrel, which has a series of holes in it. With this, you revolve the disc, until the right amount of light has been stopped.

This type of aperture control was simple, accurate, and impossible to mislay. So it is not surprising that it was greatly preferred to the earlier forms of stops, and, indeed, supplanted them. Wheel stops are still with us on many cheaper cameras, and are probably still in use on many older studio cameras.

The final form of stopping is, of course, the iris diaphragm, which has the great advantage

Below, brass mounted lenses with iris diaphragms.

of being continuously adjustable. Earlier iris diaphragms were adjustable by a lever projecting from the lens barrel through a small slot. In the later types, there was a knurled ring on the lens barrel which could be revolved to change the stopping.

Wooden cameras, in the early part of our period were made without any form of shutter, other than the simple lens cap.

Shutters

Shutters appeared, initially, as quite a separate item of equipment. At first, they were used on the front of the lens barrel. One simple form was a flat wooden box, containing a blind, which ran over a small roller. On each end of the blind was a string. Pull the shorter string, and that end of the blind moved towards and then across the lens opening—while at the same time the other end was doing the reverse. So that the lens was uncovered for a short period, dependent on how rapidly you pulled the string. In an era when exposures of one to five seconds were commonplace, such a shutter could work very well in experienced hands.

Of the same period were the simple flap, or door shutters, some opened and closed by a simple knurled knob on the hinge line, which was operated with the fingers. More sophisticated versions were fitted with a small pneumatic cylinder to open and close the flap. You squeezed a rubber bulb, which moved a piston in the cylinder by air pressure, and the piston rod moved the flap.

So the ubiquitous rubber bulb came onto the photographic scene. It is still represented by the 'B' setting on the most modern cameras, in which the shutter remains open as long as the button is pressed. In those days, the flap stayed up as long as you kept the bulb squeezed.

The bulb release was an important convenience to the photographer. By means of it, he could open and close his shutter without touching the camera. By means of it, he could avoid the risk of moving the camera, and spoiling the exposure. The bulb release was 'antinous'—non-touching—though that term later became reserved for the wire type of release.

Shutters were becoming more mechanical.

The see-saw was another type. Two circular lobes, joined together, and pivoted midway, could effect exposure, as they rocked across the lens front.

The rotating disc formed the basis of another type of shutter. This mechanism is still with us in many cheap box cameras, and can be quite effective. The early versions, in which the disc was spun in front of the lens, so that a round or specially shaped hole made the exposure, were powered by rubber bands.

The out and in shutter was briefly popular. The single blade of this type was operated by an eccentric. Most of these shutters, in which the blade literally moved 'out and in', were positioned in front of the lens. Newman's patent shutter, which was of this type, worked in the slot which was provided in the lens barrel for Waterhouse stops.

However, all of these out and in shutters had one serious defect; the blade reversed its movement at the precise point when the lens was fully opened, and this reversal caused a tiny jolt, which was enough to blur the picture on most cameras of this era.

Left, Place's shutter, circa 1886, and right an 'out and in' shutter, complete with velvet sleeve for fitting to the lens.

Sarjeant's patent shutter, which fitted rigidly on to the lens front.

But among these accessory shutters which appeared alongside the early wooden cameras of the dry plate era, and were used with them, one type is more frequently found than any other. This is the roller blind type, often referred to as the mouse trap shutter, which was mainly manufactured by the firm of Thornton Pickard of Altrincham. It was, and still is, a good reliable shutter, and I do not doubt that many are still in use.

The principle is simple. A small fabric blind with a hole in it runs from one roller to another, powered by a spring. This mechanism is housed in a small wooden box, which enables it to be fitted in front of, or behind the lens. To set the shutter, you pull a string, which tensions the spring. Generally, these shutters were released by a rubber bulb. Spring tension could be

altered, and the nominal range of shutter speeds claimed was 1/15–1/90 of a second.

Mouse trap shutters came in two basic types, apart from a variety of sizes. The first type fitted onto the front of the lens barrel, and there was a fat, coarse threaded screw, working in the thickness of the wood at one side, to lock the shutter in position.

To cope with the vast number of different sizes of lens barrels, the makers of these shutters also supplied specially designed 'packing' in various widths and thicknesses. This took the form of rubber strip, with one beaded edge, which could be wrapped around the lens barrel, to make it fit the next size up in shutters.

The second type of these shutters was made to have the lens mounted in front of it. These shutters were screwed onto the front panel of the camera, in place of the normal lens flange. The lens flange was then mounted on the front board of the shutter. This front board was detachable, and you could get spares. So with this arrangement, you were providing your camera with a more or less permanent shutter, on whose front boards a variety of lenses for different work could be mounted.

It was claimed for these mouse trap shutters that, since the hole in the blind moved from top to bottom, they would, if mounted on the front of the lens, expose the foreground of the picture more fully than the sky. I think that this does happen, but only under certain conditions. If the lens is wide open, so that slit width is only slightly greater than the effective diameter of the lens, the effect is diminished. As the lens is stopped down, it becomes more marked.

But that is only part of the story. The really critical factor is the behaviour of the shutter

Two Thornton Pickard Time and Instantaneous shutters. The one on the left carries the lens on its front panel, while the one on the right pushes on to the lens front.

Focal plane shutters for fitting to the rear frame of the camera body.

blind. When these shutters were in good working order, the spring tension on the blind was quite light. So the blind had a tendency to slow up as the hole came towards the bottom of the lens. . . .

Focal Plane Shutters

In the middle nineties, another form of shutter became available for these cameras. It was the focal plane shutter, and again it was supplied as a separate accessory. However, the nature of its fitting rendered it a rather more permanent part of the camera. The makers of these shutters asked that you should send the reversible back of your camera, together with the focusing screen and one slide to them when you ordered your shutter. It would then be returned to you, fitted up so that it would go onto your camera in the same manner as the original reversing back had done, and would accept your focusing screen or slides.

The price for all this doing and supplying, in 1896, for a quarter plate camera was thirty five shillings in the currency of the time. One pound seventy-five.

These shutters were simple roller-blind jobs, with two slits—a working slit, and a focusing slit. This latter was plate width, and you brought it into use by releasing a simple catch and winding beyond the normal set position, to

focus your image and compose your picture. Then you let it run back to use the normal slit for exposure.

This normal slit was adjustable for width, so that exposure could be regulated. But at this stage there were no setting knobs for the purpose. Working with the back of the camera open, you had to adjust the length of the links at each side of the slit.

Spring tension in the blind roller could be altered, but I fancy that in practice this was less of a calibration factor, than an adjustment for the convenience of the intelligent user. A tension could be arrived at which moved the blind uniformly and smoothly across the plate— then you could discover the widths of slit that suited your various needs. It was up to you.

I said earlier that the wood and brass cameras that are the subject of this chapter were made without any form of shutter, other than the simple lens cap—but there is an exception. As far as I know, it is the only one.

In 1907, Thornton Pickard brought out a camera in which the back was one of their focal plane shutters. Possibly other makers did the same. In either case, I think it is true to say that the focal plane shutter is the only type that was ever a true integral part of one of these classic, polished and lacquered wooden cameras.

They were with us before the dry plate era began. They are still with us today. If you find a nice one, and use it, you will understand why.

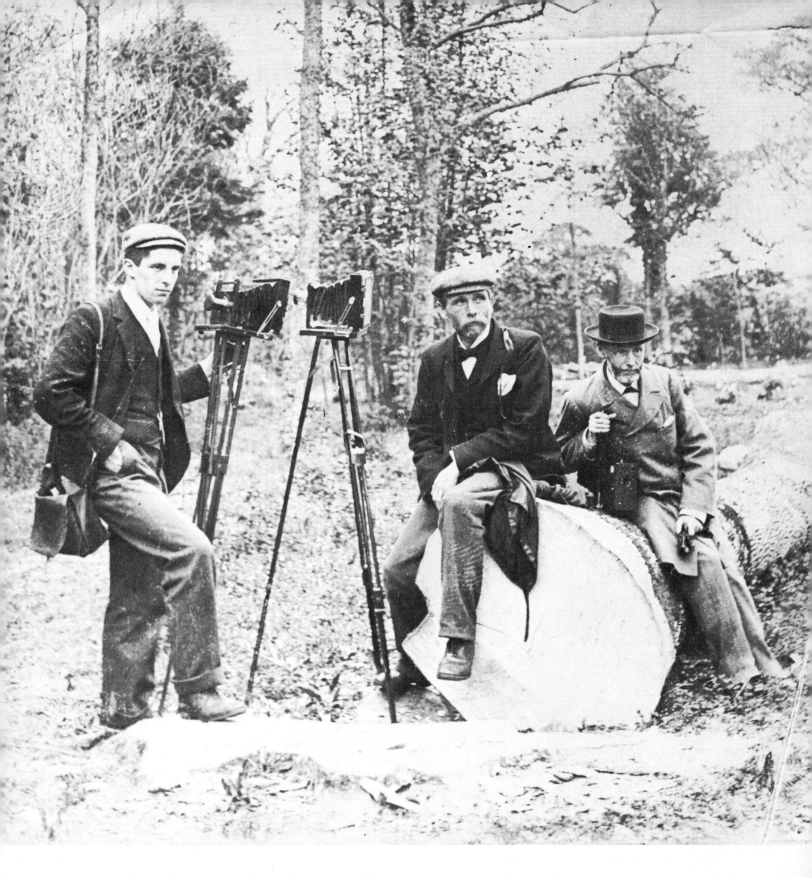

Pictures of early photographers are not at all common.
Photographers seem always to have been shy of others of
their own kind. This picture was taken near Eastbourne
in Sussex, around 1896.

Early and Portable

There is all the difference in the world between a camera which can be carried, and a camera which is designed to be used while it is being carried. It is in this latter sense that the term portable is used in this chapter.

The types of camera discussed in the last chapter are all essentially stand cameras. In these cameras, the picture was focused by the process of examining the actual image on a ground glass screen at the back of the camera, and making adjustments, until that image was sharp. To carry out this process of examining the image, the camera just had to be mounted on a stand.

If a camera was going to be used hand-held, then there had to be some means of focusing it reasonably accurately, without having to examine the image on a screen. So, the focusing scale came into being. This scale was arranged in some way, so that if you set the distance of your proposed photographic subject on it, then the distance between the lens and the sensitive plate was such that your subject was sharply focused.

But apart from being an aid to achieving image sharpness, the focusing screen had also shown the photographer what that image was. So, if that camera was to be hand-held, there would have to be some alternative means of displaying to the photographer just what would be in his finished picture.

So here are the two extra attributes that a camera must have if it is to be hand-held for picture taking. A focusing scale, and a view finder.

Most of the types of camera that are described in later chapters of this book meet these requirements, but they also have other features which make it desirable to consider them separately. The early, portable cameras that concern us here, are basically very simple cameras, to which a focusing scale and a view finder have been added.

The Hand and Stand Form

Many of these cameras were described at the time of their currency as 'hand and stand' cameras.

This term, or the variation of it—'hand or stand'—seems to have come into use in the eighteen-eighties. To begin with, it was a somewhat optimistic description of the capabilities of the cameras it was applied to.

Fitting a camera with a focusing scale and a view finder certainly did not solve all the problems of hand-held photography. It did not solve the problems arising out of the very slow emulsions of the time.

And the gelatine dry plates of the eighties had other shortcomings. . . .

The following words were written by one C. H. Bothamley in 1888; 'The rapidity of plates varies in different batches, nay, even in different plates in the same packet.'

Taking this difficulty as read, he then goes on to discuss other variables affecting exposure time, and concludes that the only reliable way to a good exposure is to examine 'the apparent

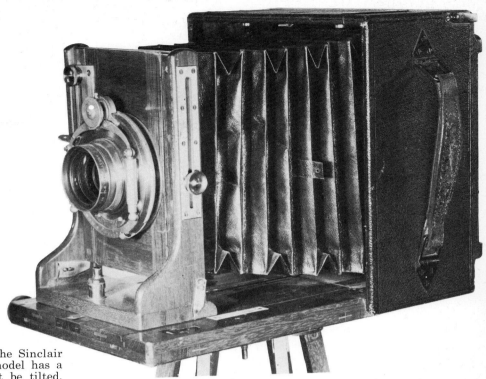

A typical hand and stand camera. This is the Sinclair 'Una', introduced in 1904. This half plate model has a reversing back, and the front panel cannot be tilted, although it rises in the front standard. These features date it somewhere before 1909.

brightness of the image on the focusing screen after the stop has been inserted.'

All this may be summed up by saying that, at the time the term 'hand and stand' camera first appears in maker's descriptions, the problems of any sort of photography—certainly of hand photography—were not to be solved by ingenious camera design alone.

And as far as Mr Bothamley was concerned, the focusing screen was not be set aside in the judgement of correct exposure. So, perhaps, in the first instance, makers who would have liked to have claimed that their cameras could produce fine results held by hand, and without the aid of tripod or focusing screen, thought it prudent to retain the latter, and to call their cameras 'hand and stand'.

One man was prepared to cut out the focusing screen, and go all the way towards a hand-held camera. He was George Eastman, for 1888 was the year in which he launched the 'Kodak', and provided a practical solution to the problems of hand-held photography for everybody.

But it must be remembered that what George Eastman launched so successfully was not just a camera, but a system of photography. This story is dealt with in the next chapter of this book, but at this point it is worth noting that the founder of Eastman Kodak had been making and selling photo-sensitive plates for nine years, before he offered a camera to the public.

Many other camera makers of the time were being optimistic, to say the least, in claiming hand-held capabilities for their cameras using the generally available plates of a host of manufacturers, over whose quality they had no control, and in many cases, I suspect, little knowledge. George Eastman, as we shall see, arranged matters so that his cameras were used with his own films.

So in the eighties, we find various cameras for 'hand and stand' work. And then, as time went on, what had been a mere hopeful description became a specification, limited to a particular form of construction.

The 'hand and stand' camera became a quite specific article, and the description excluded many cameras which could be used 'hand and stand'. Folding plate cameras, for example, could be, and were, used 'hand or stand'. But they were not described as 'hand and stand cameras'.

The design which emerged to make the tag 'hand and stand' its own was a simple one. In use it was versatile, and in the sophisticated form of such cameras as the Linhoff Technika series, it is with us today.

Basically it is a box, with the lid at the front, hinged along the bottom edge. This lid is arranged so that it can be let down to a position at right angles to the body of the box, and forms the baseboard on which the lens standard is moved forward, in single, double, or triple extension forms. Scales are provided on the

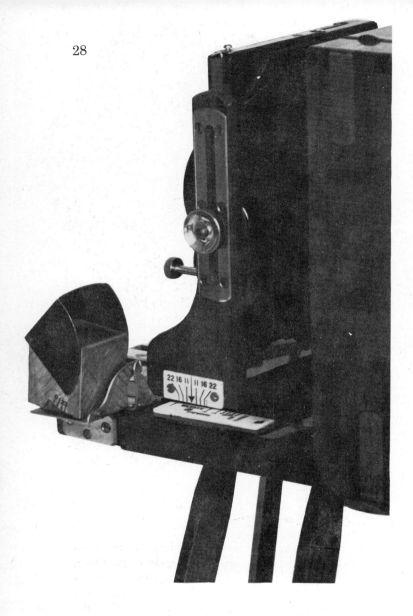

Focusing scale, and finder—both features essential to hand use of these cameras.

baseboard, so that focusing may be achieved without reference to the focusing screen. But the focusing screen is there if you should need it, for stand work.

The fact that there was a focusing scale meant that the camera was designed around a particular lens. Also, because the camera was to be used hand-held, there had to be some form of mechanical shutter to make the exposure.

There was, of course, a view finder, wherewith the camera could be aimed, and the picture composed. This was usually mounted on the baseboard, alongside a small spirit level, which was regarded as an essential aid to good work, either hand-held, or on a stand.

The back of a hand and stand camera was, almost without exception, arranged so that it could be turned so that the focusing screen, and therefore the plate in its slide, might be used either 'upright' or 'landscape'. In the earlier forms, the back was 'reversing'. That is to say, it could be taken off, and replaced in the alternative position. In later forms, it was 'revolving'. That is to say, it would not come off, but could be revolved in a circular seating for either 'upright' or 'landscape' use.

One further point in our definition of 'hand and stand' cameras. They are all bellows cameras.

As far as nearly all the English made 'hand and stand' cameras are concerned, the body of the box, and the lid, is made of wood, most often mahogany. The ordinary models had all the external surfaces of their woodwork covered with hard grain morocco leather, black or brownish black. This leather was glued on, and with the animal glues of the time, this gave rise

The 'Pony Premo No 5'. A half plate hand and stand camera from the Rochester optical company in America. Circa 1911.

A superb tropical 'Una', in Spanish Mahogany reinforced with brass. It was made by the Sinclair company while their shop was still in London's Haymarket. They moved from this address in 1925.

These 'Una' cameras were made right up to the 1930s, though the Haymarket address puts this example before 1925. It must, however have been made after 1910, since it has a revolving back.

to problems in damp and very warm—tropical—conditions.

So there were special 'tropical' models of these cameras, made without leather covering, and reinforced at the corners with flush insets of brass.

Tropical Construction

These are among the most handsome and appealing of all types of old cameras. In them the finest work of the old cabinet maker camera builders is to be seen displayed to its best advantage. Brass and wood is finished off flush, and polished over all to a surface that commands that you handle it with a care and respect commensurate with the craftsmanship that has been lavished on it.

In many tropical models, teak is the wood used instead of mahogany, and the makers, in their advertisements were all very positive that the wood of their choice was preferable to the alternative. I do not believe that there was anything to choose between the merits of teak or mahogany construction. With the quality of workmanship one finds in these cameras, either was superb.

There is one form of finish which is vary rare. This is the stitched hide covering. Some makers, Sinclair for example, offered cameras in which the woodwork was covered with top quality bark-tanned calf, beautifully hand stitched at the corners. I have seen a few of these in good condition, and they are very fine, but as far as

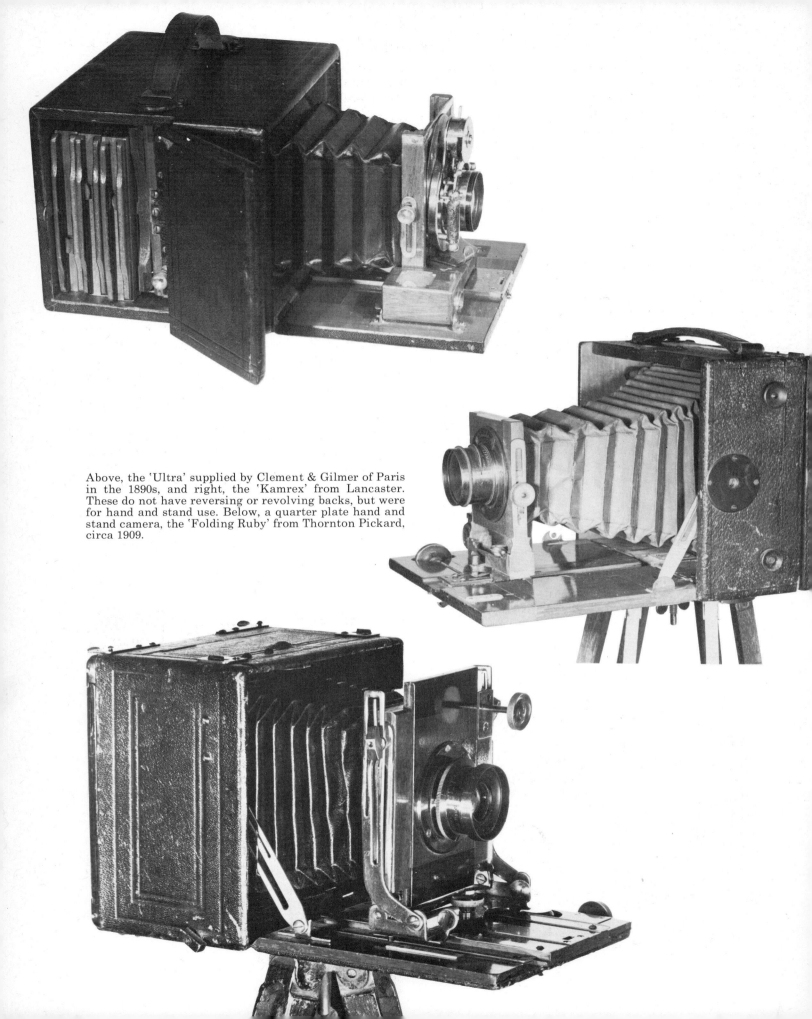

Above, the 'Ultra' supplied by Clement & Gilmer of Paris in the 1890s, and right, the 'Kamrex' from Lancaster. These do not have reversing or revolving backs, but were for hand and stand use. Below, a quarter plate hand and stand camera, the 'Folding Ruby' from Thornton Pickard, circa 1909.

hide-covered cameras which have come into my collection are concerned, they have all been well and truly scuffed, I regret to say.

Used in the hand, 'hand and stand' cameras had of necessity to be used with their own lenses, or the focusing scales would be invalidated. However, most makers offered their instruments with a variety of different lenses, from stock, with scales to suit. Or, they made the offer, 'customer's own lenses fitted to order', and delivered your camera with its own individual focusing calibration.

However, if you were using the camera for stand work, and assessing your focusing on ground glass, there was no reason why you should not use any lens that the camera would carry. With this in view, the lens panel was detachable. It is not unusual to come across these cameras with three or four lenses, mostly in shutters, fitted on lens panels, and carried in the camera case. But, as a rule, the camera will carry a focusing scale for only one of them.

When a camera does have more than one focusing scale, it is usually because the lens fitted is a 'divider', or to use the more conventional term, a 'convertible' lens. That is to

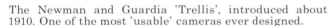

say, one half of the lens can be removed, and the remaining half works on its own, at an increased focal length. So that with a lens such as a Goerz Dagor, in which the two halves are identical, you have the choice of either using it with its two halves in combination, or either half on its own, giving you approximately doubled focal length.

Dividing Lenses

Other lenses, such as the series VII Zeiss Protars, or the much rarer Goerz Pantars, may give you three focal lengths, because the two halves of these lenses can be of different values, and you can use either on its own.

So where you find a camera with two or three focusing scales—and two or three aperture scales as well—it means that the camera was originally supplied, fitted with a convertible lens, and it is to be hoped it is still in situ.

It is sad, how many lovely old cameras show up, minus their lenses . . .

Most 'hand and stand' cameras are fitted with one or other of the many types of 'between the lens' shutters, though on the earlier models you may find one of Thornton Pickard's ubiquitous roller blind jobs perched on the front of the lens.

In the case of the 'between lens' shutters, these were, for the most part, the product of

The Newman and Guardia 'Trellis', introduced about 1910. One of the most 'usable' cameras ever designed.

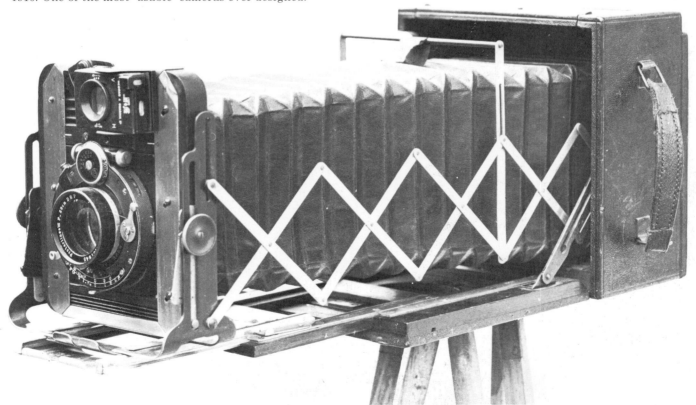

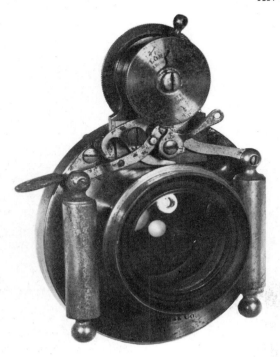

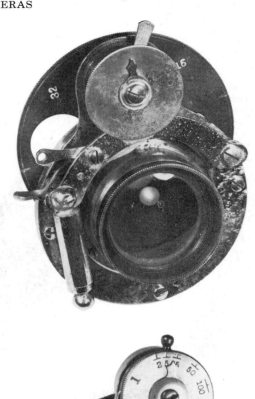

Above the Bausch and Lomb pneumatic diaphragm shutter of 1891. One set of blades controls both exposure and aperture. On the right is a simple spring action shutter by the same company, which incorporates a wheel stop. Lower right, the best known of the Bausch and Lomb pneumatic shutters, the 'Unicum'. All of these three B & L shutters were patented in 1891.

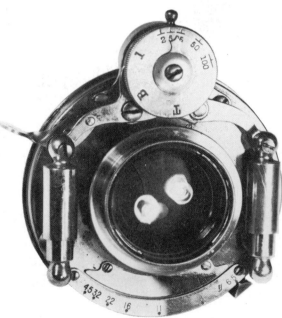

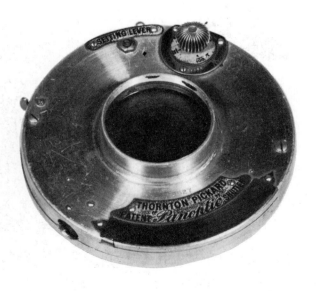

Left, the Thornton Pickard 'Panoptic', circa 1904, a spring action shutter using vulcanite blades.

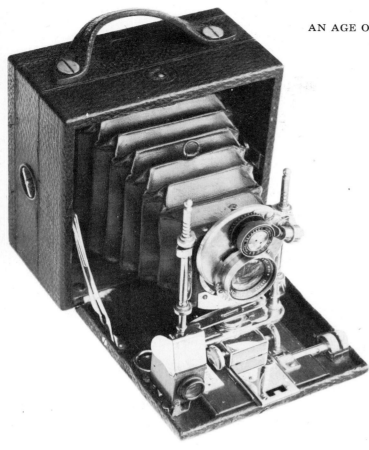

Kodak body—Beck shutter. A 'plate' Kodak, marketed in London.

quite well may be—then they are not listed items, and were made to order.

The metal-bodied 'hand and stand' cameras, with the exception of Sinclair's 'Traveller Una', were all of Continental European origin, and follow the same general designs as their wooden counterparts.

Some features of certain 'hand and stand' cameras remove them somewhat from the general run, because they are features which were the patents of particular makers, and gave those cameras additional possibilities. For that reason, I have made no mention in this chapter of the special features to be found in the Sanderson 'hand and stand' cameras, or of the Eastman Kodak models, which can be properly put in this class.

'Hand and stand' cameras had established themselves as a recognized class by the beginning of this century, and they continued in wide general use up to the second world war. They persist to the present time as the general purpose, large format camera for professional use.

specialist firms, and were not made by the firm who built the camera. In consequence it was customary for makers to list their cameras with alternative shutters, as well as alternative lenses. Even in cases where firms made their own shutters, it was still possible to have another shutter of your own choice fitted when buying a new camera.

The one instance where, as far as I know, 'hand and stand' cameras always had their maker's own shutter occurs when the shutter is of the focal plane type. Here the shutter is truly integral, and built permanently into the back of the camera body.

The smallest 'hand and stand' cameras I have come across are for the $2\frac{1}{4}$ in \times $3\frac{1}{4}$ in negative size. Above that, they were available in quarter plate, 5 in \times 4 in, postcard, and half plate. If there are any larger ones around—and there

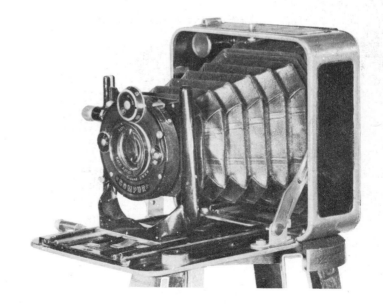

Right, the Kern 'Bijou', a neat and very workmanlike miniature hand and stand camera that appeared about 1925.

The Coming of Kodak

In 1879 George Eastman, then twenty-four years old, constructed a machine for coating gelatine dry plates, and laid the foundation stone of what later became the Kodak company.

At that time the word 'Kodak' did not even exist, for the very good reason that George Eastman had not yet created it.

As a manufacturer of dry plates, and as the patentee of a machine that would turn them out more reliably than they could be made by hand, he had taken an important step in making the possibilities of the photographic camera available to a much wider public than it had possessed before.

His next contribution to photography was to perfect a paper roll film, a length of which could take the place of several heavy glass plates, and in 1885 he introduced his 'roller slide'—the Eastman-Walker roll-holder.

This took the place of the ordinary slide or back, and provided the photographer with the means of making a large number of exposures with greater convenience than with glass plates.

Eastman roller slides could be fitted to any existing camera.

In 1888, George Eastman marketed his first camera, and invented the word 'Kodak' as its name and trade mark. Simple, short, incapable of being mispronounced, the word was his invention. It did not have its roots in any existing word in any language; it was his word entirely.

To look at, the first Kodak was a small box camera. But it was a lot more than just that.

It was the system of photography that, finally and uniquely popularized the art.

For twenty-five dollars, you could buy a Kodak. It was a little black box, about $6\frac{3}{4}$ in long by $3\frac{1}{2}$ in wide and high. It came in a leather carrying case, with a shoulder strap. It came fully loaded with Eastman paper roll film—enough to take one hundred small circular pictures, $2\frac{1}{2}$ in in diameter. The whole apparatus weighed just under a pound and a half.

To take a picture, you pulled a string. That cocked the shutter. Then you pointed the camera at your subject, and pressed the button. That released the shutter, and made the exposure. Finally you wound the key, which moved the paper film on its way, and readied the camera for your next picture.

When you had used up all the film in the camera, and taken one hundred pictures, you returned the camera to the Kodak factory, and for the sum of ten dollars your pictures were processed, and returned to you with your camera reloaded ready for a further hundred pictures.

It was simplicity itself.

What the Kodak did was to reduce the actual taking of a picture to its simplest terms, and to separate this simple mechanical process from the chemistry of photography.

The result, in practice, was that ordinary people who neither understood the photographic process, nor wanted to, could take pleasing pictures. The average success rate was around eighty per cent.

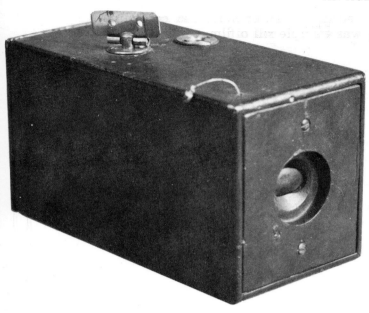

The 'Kodak'. When this famous camera first appeared, it was the first of its line, and was not designated by any number.

George Eastman and his Kodak sold photography to Everyman.

After the number one Kodak, came the number two. Similar, but larger, it took eighty pictures $3\frac{1}{2}$ in in diameter at one loading.

Eastman's next step was to produce celluloid roll film, in place of the original paper version ... Kodak was on its way.

This first generation of Kodak cameras, which may be defined as the cameras which were marketed along with a factory loading and processing service, came in six versions. The smaller, first model had a shutter which consisted of a small vertical cylinder, which revolved on its axis to bring a transverse hole into the path of the light, so making the exposure. The larger model, and the later small ones had a sector shutter, that is to say the shutter consisted of a disc, with a sector cut out, which made the exposure as the disc revolved. The other factory loaded models, the No 3, the 3 junior, the No 4 and the 4 junior, followed in 1890.

The second generation of Kodaks came in December 1891. The reputation of Kodak had been established by a camera in which the company kept processing in its own hands. In the second generation of cameras, loading with film—Kodak film—and processing, was placed in the hands of the customer.

The cameras also were bigger, and because of the longer lenses, a focusing adjustment was added. You had to set the distance of your subject on a small scale.

Customer Loaded

The photographic public had been taught to walk with the first generation of cameras. Now George Eastman was allowing them to break into a gentle trot. The 'ordinary' Kodak, as the first three models of this second generation were called, continued the story of Kodak success. They were dark room loaded, but were followed by corresponding daylight loading versions.

During the eight years that followed the launch of Kodak, the company produced a number of variations on the box camera theme. 1895 saw the introduction of the Pocket Kodak, the first cartridge loading Kodak camera. By 1896, the company had sold 100,000 cameras.

1897 was the year of another Kodak masterstroke. It was the folding pocket Kodak, the camera that was to establish the second 'standard format' for cameras for years to come.

The first of these standard popular formats was obviously the small box camera. The second was the folding pocket instrument—a flat, pocketable box, which opened into a small bellows camera, using what we now call roll film, but which at this time was called cartridge film.

The second model 'Kodak' took a larger picture, and had a different type of shutter from the original model.

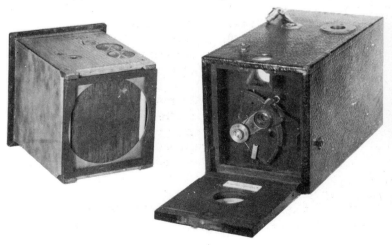

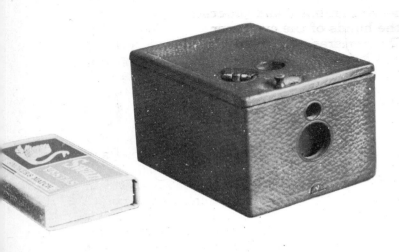

Above, the 'Pocket Kodak', important in camera history since it was the first camera made to take cartridge—roll—film.

Kodaks of the second generation (below) were customer loaded with rolled flexible film, the fore-runner of the paper-backed cartridge, or roll films.

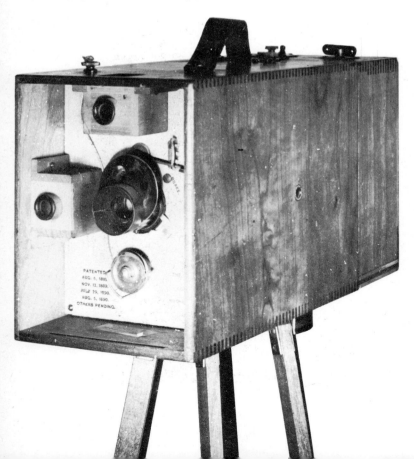

Rolled film in roller slides had come first. This was a simple roll of film, which had to be loaded into the roller slide in the dark room. This film was unbacked, and when you wound it on, the amount that was transported was controlled by a measuring device inside the roller slide. The new cartridge film was backed with paper, had a long paper 'leader', and could be loaded into the camera in daylight. The winding on of the correct amount of film between exposures was controlled by observing numbers printed on the film backing through a small red window.

Cartridge film, and the consequent possibility of cameras which could be loaded in daylight, and, thanks to the neat design of the F.P.K., carried in the pocket, was another step that made photography more popular than ever.

Cartridge film was also, as George Eastman well realised, the form in which photo-sensitive material could be sold to the public in ever increasing quantities. The continuing revenues of his company would depend in large part on sales of film.

That this should come about, cameras should be owned by as many people as possible. It didn't really matter whether the cameras were Kodak cameras, provided they used Eastman cartridge film. George Eastman knew that the time must come when many other companies would offer cameras using cartridge film. But for now, while he practically speaking had the market to himself, he intended that the maximum possible number of people should own his cameras.

In 1900, the 'Brownie' series of Kodak cameras was launched. The number 1 Brownie was a small box camera, which took pictures $2\frac{1}{4}$ in square on cartridge film. The price was five shillings—twenty-five pence. There followed a number 2 model, in 1901, which took pictures $3\frac{1}{4}$ in \times $2\frac{1}{4}$ in which cost ten shillings—fifty pence.

The box Brownies took over gradually from the older box-form cameras, which had grown out of the original Kodak, and the customer loaded 'ordinary' Kodaks that followed it.

In fact, at this point Eastman had established the two main lines of his cameras for the general 'snapshotting' public.

One, the folding pocket Kodaks.

Two, the cheaper 'Brownie' Kodaks, first in box form, and later in folding form as well.

All of these cameras used cartridge film in various sizes, and in George Eastman's estimation, every camera his company sold was good

for a consumption of at least twenty cartridges.

These, then, were the two lines of camera development that Kodak was to pursue for many years to come.

In addition to this, the company was to produce other cameras, of a more specialized, or more professional nature, and these cameras we may regard as separate lines of camera development.

So, in reviewing the early cameras of the Kodak company, I am going to group them as follows.

First, the cameras which belong in the 'pioneer' period, from 1888 to roughly 1896.

Second, the folding pocket Kodaks.

Third, the Brownies.

Fourth, specialized and professional cameras.

To reiterate, the first group of cameras began with the number one Kodak, with cylindrical shutter, which was followed by the number two Kodak, larger, and with a sector shutter. Then came second models of number one with a sector shutter.

The three models of the 'Ordinary' Kodak— for $2\frac{1}{4}$ in $\times 3\frac{1}{4}$ in, $3\frac{1}{4} \times 4\frac{1}{4}$ in and 4 in \times 5 in negative sizes followed, and the three 'daylight' models. These used Eastman's celluloid film in rolls, and had to be loaded in darkness by the customer. These incorporated a focusing adjustment. Like the first two Kodaks, they took the form of an oblong box with the axis of the lens

along the greatest length.

Other cameras in this first nine years were the first 'folding' Kodaks, not to be confused with the 'folding pocket' Kodaks, which came later. The folding Kodaks took a rather bulky box form, and the front side dropped forward to form the baseboard on which you could pull forward the front standard and the bellows. They incorporated the E.W. roll-holder. They were hand and stand cameras, and were available in a number of sizes up to $8\frac{1}{2}$ in $\times 6\frac{1}{2}$ in (whole plate) negative size. A number of versions were produced, incorporating different shutters.

In this period also came the 'pocket' Kodak, again not to be confused with the later 'folding pocket' cameras. This one looked rather like a miniature version of the number one. It measured $2\frac{1}{4}$ in $\times 2\frac{7}{8}$ in $\times 3\frac{7}{8}$ in, used a cartridge of film which gave 12 exposures measuring $1\frac{1}{2}$ in $\times 2$ in, and weighed only five ounces. It could be fitted with a holder for plates if you wished.

Other cameras of the early period were the 'Flat folding Kodak', which provided 48 negatives 4 in \times 5 in, and may be considered as the fore-runner of the 'Cartridge Kodaks', which we shall consider later, and the 'Kodet', which was a plate version of the 'Ordinary', and came in three sizes.

Towards the end of our first nine year period came two box cameras, the 'Bull's Eye' and the 'Bullet'. They were very similar. Bull's Eyes

Two models of the 'Folding Kodak'.

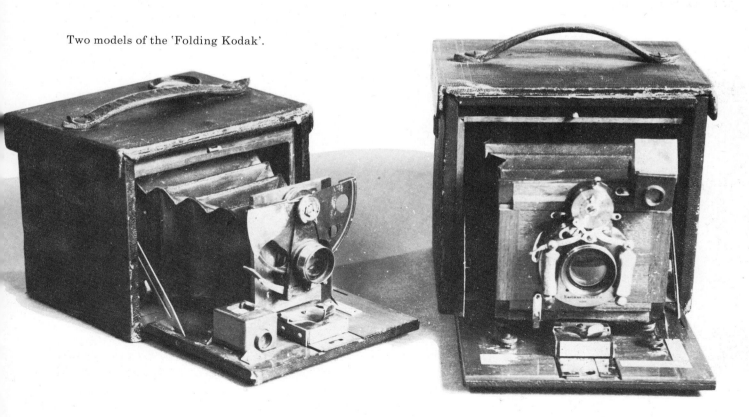

used Cartridge film only—Bullets had provision for using plates as an alternative.

Both these box cameras came in two sizes—$3\frac{1}{2}$ in \times $3\frac{1}{2}$ in, and 4 in \times 5 in negative size. In either size, two models were available, ordinary and special. The ordinary had a revolving disc shutter, and a simple meniscus lens. The special had a more sophisticated shutter, with a choice of speeds, and a rapid rectilinear lens.

These cameras are opened for loading by sliding out a catch at the bottom of one side, when you will find that the bottom and four sides of the outer case drops off, leaving you with the works depending from the lid.

A thing that must strike you at this point, if the camera you are looking at is in reasonable shape, is the excellence of the workmanship. These cameras are neatly constructed in American whitewood (which is rather yellowish), and varnished over. Inside the bottom of the casing, you will find a deal of printed data concerning the Kodak company, and the patents connected with the camera.

On the Bullet cameras, you will see the small lid of the compartment which accepts the plate holders at the back of the camera. Don't try to force this. It will not come out until you open the camera case for loading, when you will see the small catch that releases it.

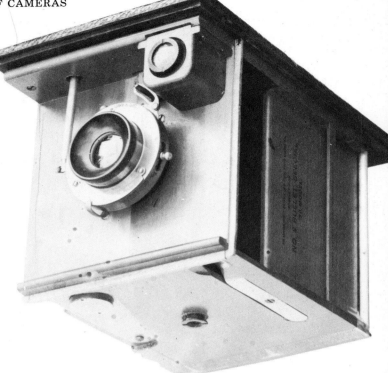

'Bullet' (above), and 'Bullseye' (below) were both available with the 'special' lens and shutter (above), or the 'ordinary' (below).

The Kodak Sizes

Coming to the second group of Kodaks, which begins in 1897, we are considering the Folding Pocket Kodaks, which continue right on until the end of the period which concerns this book.

First, some general data which concerns all, or most of these cameras.

Kodaks gave these cameras numbers, which denoted sizes of negatives. These numbers also apply to later cameras in the 'Brownie' series, and the Cartridge Kodaks.

They are as follows:

No 0, $2\frac{1}{2}$ in \times $1\frac{5}{8}$ in. No 1, $2\frac{1}{4}$ in \times $3\frac{1}{4}$ in. No 1A, $2\frac{1}{2}$ in \times $4\frac{1}{4}$ in. No 2, $3\frac{1}{2}$ in \times $3\frac{1}{2}$ in. No 3, $4\frac{1}{4}$ in \times $3\frac{1}{4}$ in. No 3A, $3\frac{1}{4}$ in \times $5\frac{1}{2}$ in. No 4, 5 in \times 4 in. No 5, 7 in \times 5 in, or $6\frac{1}{2}$ in \times $4\frac{3}{4}$ in. No 6, $8\frac{1}{2}$ in \times $6\frac{1}{2}$ in.

To this must be added, No 1 Brownie $2\frac{1}{4}$ in \times $2\frac{1}{4}$ in, and No 2 Brownie $2\frac{1}{4}$ in \times $3\frac{1}{4}$ in.

These numbers also apply to some of the cameras in the later part of our first period. As far as I have been able to discover, no camera was ever made by Kodak which comprised all the sizes designated above, but the Folding Pocket cameras came nearest in the early days.

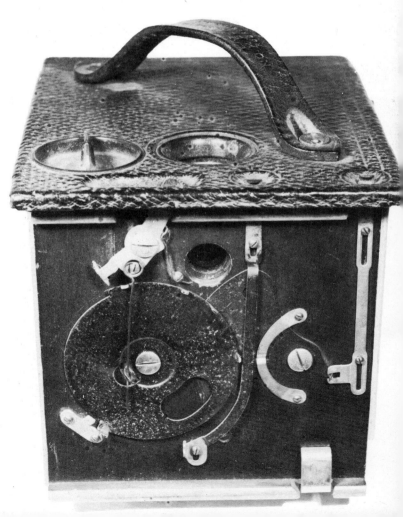

They ranged from No 0 up to No 5. This, however, was only true at about the turn of the century, or just after.

The other points about the F.P.K. cameras which is of general application, certainly up until 1930, is the use of the term 'Special'. It may be taken to mean that the camera is fitted with a better than ordinary lens and shutter, and towards the end of the use of the term, that the camera was better—or more expensively—finished, and might also have other special features, not to be found on the standard cameras with the same numerical designation.

The Folding Pocket Kodak

Now let's start at the beginning of the F.P.K. era. The first model was a No 1. It used a cartridge which gave twelve exposures.

Strangely, although it was of the same folded shape that later became the standard format for

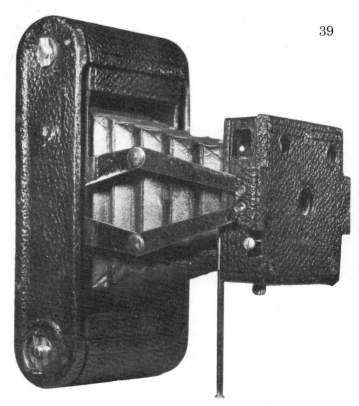

A Folding Pocket Kodak of 1897. It is important to distinguish between the 'Pocket' Kodak, the 'Folding' Kodak, and the 'Folding Pocket' Kodak.

One of the earliest pictures taken with a Folding Pocket Kodak. Taken by George Eastman himself in 1897, shortly before the camera came on the market.

all folding pocket cameras—flat, rectangular, and with rounded ends—it was different in one important particular, and in my view, better than its successors in this respect.

It had no lid, or door, in the front which opened out to form a baseboard for the lens panel. The lens panel simply snapped out on four jointed, spring-loaded struts. It opened 'at a touch', and came exactly to working position, whereas on the later models, the lens

panel had to be pulled to working position by the user, with the consequent possibility of error, or for that matter, distortion by bad handling.

This first model F.P.K. anticipated the self-erecting cameras of the thirties. However, with no cover on the front, the lens was rather unprotected, and a later model did combine both the spring-out feature, and a cover.

By 1900, the spring-out feature was being abandoned in favour of the front lid, with slide-out lens board design.

As far as I can discover, the spring-out F.P.K. cameras, with or without a front lid, were only made in the No 0, 1 and 1A sizes.

Another unusual feature about the spring-out F.P.K. cameras was the way they opened for loading with film. The whole back, with rounded ends and one flat side pulled off the camera sideways, being released by a sliding catch, roughly in the middle of the remaining flat side. This method of opening is not immediately obvious, as was the simpler detachable back, which came later, and because of this was liable to distortion through forcing, which is possibly why this design was dropped.

The earliest of these cameras—the model 'A', No 1,—have shutters which are built into a

rectangular wooden box, covered, like the rest of the camera, with black morocco leather. Later ones have a circular metal shutter, attached to a rectangular front-board. Oddly, these shutters are detachable, complete with lens, by moving a small rotary catch, and I am told that this was probably a matter of production expediency.

By 1903, the Folding Pocket range of Kodaks was settling down into a format which comprised certain standard features which were to persist in cameras of this type—made by a host of other makers, as well as Kodak —for many years to come.

Standard Features

These features were: a front lid that hinged down to form a baseboard for the extension of the lens, and a back which was removable for loading. Among Kodak cameras in the class we are considering there is only one exception to this construction, the V.P.K., which we shall consider later.

Among the various sizes of early F.P.K. cameras there is one that you will probably come across more frequently than any other. This is the No 3, negative size, $3\frac{1}{4}$ in × $4\frac{1}{4}$ in. 96,000 of these were sold in the U.K. alone. Over the years some forty-odd variations on the No 3 F.P.K. theme were produced by Kodak, not including all the 'specials'. These No 3 cameras really are the ones you are most likely to come across in seeking early Kodaks.

However, no collection of cameras is complete without a representative selection of the different models of this very important and popular camera. Even the curator of Kodak's own museum at the Harrow factory discovers, from time to time, variations on the No 3 which are not already represented in their collection.

You will find 3- and 3A-Kodaks with a dual focusing scale. The second scale is for use with a plate back and focusing screen, which was supplied with suitable double dark slides, as a separate accessory. This fitted onto the camera in place of the ordinary back, and since the focal plane of the plates was slightly outside

Left, an FPK no 3, model AB of 1899, and right an FPK no 1, model D of 1909.

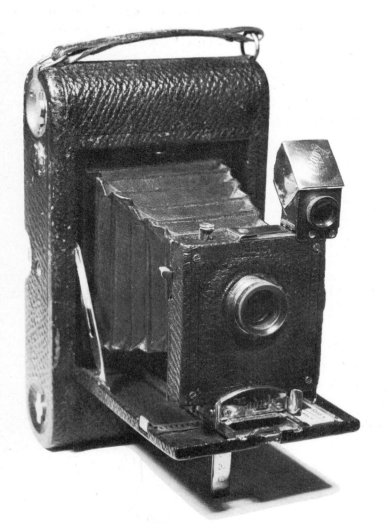

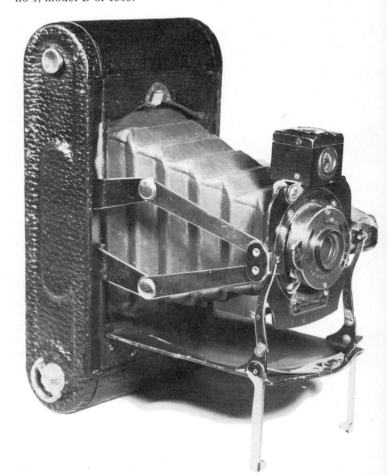

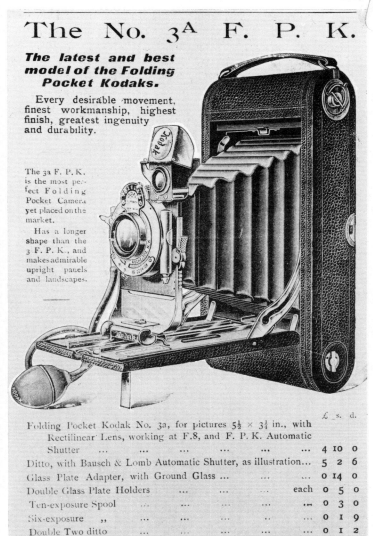

The No. 3ᴬ F. P. K.

The latest and best model of the Folding Pocket Kodaks.

Every desirable movement, finest workmanship, highest finish, greatest ingenuity and durability.

The 3a F. P. K. is the most perfect Folding Pocket Camera yet placed on the market.

Has a longer shape than the 3 F. P. K., and makes admirable upright panels and landscapes.

	£	s.	d.
Folding Pocket Kodak No. 3a, for pictures 5½ × 3¼ in., with Rectilinear Lens, working at F.8, and F. P. K. Automatic Shutter	4	10	0
Ditto, with Bausch & Lomb Automatic Shutter, as illustration...	5	2	6
Glass Plate Adapter, with Ground Glass	0	14	0
Double Glass Plate Holders each	0	5	0
Ten-exposure Spool	0	3	0
Six-exposure „	0	1	9
Double Two ditto	0	1	2

the body of the camera, it necessitated a second focusing scale, set back from the ordinary one by a distance equal to that between the ordinary film plane, inside the camera, and the plane of the plates, just outside it.

Autographic

At about the outbreak of the first World War, a new general feature was added to the F.P.K. cameras. It was introduced with a complete new range of Kodak and Brownie cameras. This was the autographic feature. Cameras fitted with this have a small door in the back of the camera, and a stylus, either fitted alongside the edge of this door, or in rings on the lens panel of the camera. By means of it, you can write on the backing of a special film, and the pressure of your writing produces an image of

your words on the negative, so that you have a record of who, where, and when on your actual picture. This was regarded as a major step forward in popular snapshotting by Kodaks, and they even made autographic backs available for their older cameras. But it is doubtful whether, in fact, it ever contributed very much to photography. Certainly, had full use been made of this device, our records of people and places in the twenties, when the autographic feature was a major item in all Kodak advertising, would be far more complete. In practice, it is clear that D & P companies did not always bother to include it on the prints they supplied. Looking through old photo albums it is not often that one comes across prints captioned, as they might have been, in this way.

In 1912 the V.P.K. appeared. The initials stand for 'Vest Pocket Kodak', the word 'vest' signifying what is usually called a waistcoat on this side of the Atlantic. It was a dainty little camera, and was produced in the one size only, using 127 film.

In a way it was a return to the thinking of the first F.P.K. There was no hinged front lid; the lens panel was supported on struts—not spring loaded in this case, and loading was from the side, not the back.

Most of the V.P.K. cameras you will come across will have the autographic attachment. The absence of this feature denotes an early model.

There were several variations on the V.P.K. The basic design of the camera bellows, with the front panel on latticed struts did not change. The variations were in the lenses, and the shutter.

Above left, the classic 'Kodak' look of the 3A, and below, the neat little VPK.

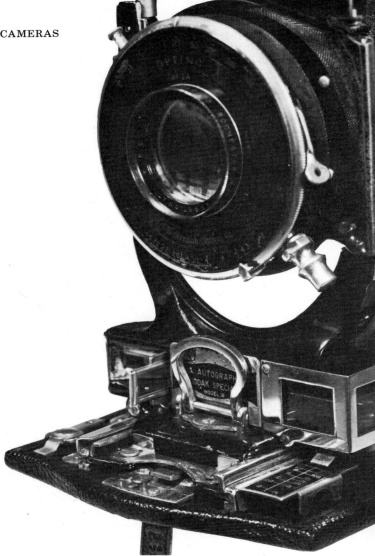

The front of the rangefinder Kodak. The two rangefinder windows can be seen facing forward at the base of the front standard. The 'look in' point faces outwards at the right.

The ordinary V.P.K. cameras had a simple meniscus lens, behind the shutter. Then there are many examples using a Bausch and Lomb Rapid Rectilinear lens, which has symmetrical glasses in front of and behind the shutter. These lenses are named on the rim of the front lens cell.

Other models—'Specials'—were mostly fitted with Kodak anastigmats, but could have a Cooke lens, or a Zeiss Tessar. These cost more than three times as much as the ordinary model.

The ultimate de luxe version of the V.P.K. was one using a Tessar lens in a Compur shutter, and this really was a most admirable little camera. It was made in 1926, and is very rare.

Before leaving the V.P.K. cameras, it should be noted that there are other folding Kodak cameras in the vest pocket size. However, the term V.P.K. is usually taken as referring to the original 1912 design.

To describe all the folding pocket cameras that Kodak has produced through the years would just about take the rest of this book, and this chapter is really concerned with tracing the Kodak contribution to the cameras of popular photography. However, we cannot leave the Autographic Kodak special cameras without mention of one particular 'Special'.

It appeared at about the end of the first World War. It was made in 1A, and 3A sizes, and it was the first camera to be placed on the market which had a built in coupled range finder. It used the split image principle, and to use it you had to take sight into the base of the front standard, at right angles to the direction of your picture. When you had adjusted the focusing until the split image became one, your camera was sharply focused.

As a range-finder, it was not hard to use, and it was accurate, but the arrangement was such that it got in the way of actual picture taking. It would give you beautifully focused tripod shots, but it removed the camera from the snap-shotting class. It was a notable first for Kodak, and it pointed the way to the possibilities of the coupled range-finder.

Our third class of Kodak cameras are the Brownies, said to have been named for F. A. Brownell, an early Kodak stalwart who had first come into George Eastman's orbit back in the days of the roller slide.

The Brownies

As we have said, the first Brownie box cameras appeared in 1900. They were cheap, simple, and they set a style that many other manufacturers would later follow. Over the years that followed, the earlier more expensive box cameras, the Bullet and Bulls-Eye etc, were phased out, and Brownie reigned supreme in the box camera field.

In 1904 came the folding Brownie in the No 2 size, $2\frac{1}{4}$ in × $3\frac{1}{4}$ in followed by No 3, $3\frac{1}{4}$ in × $4\frac{1}{4}$ in, in 1905 which sold at £1.05 and £1.87$\frac{1}{2}$ respectively. These were adjustable for focus, and had a simple time and instantaneous shutter.

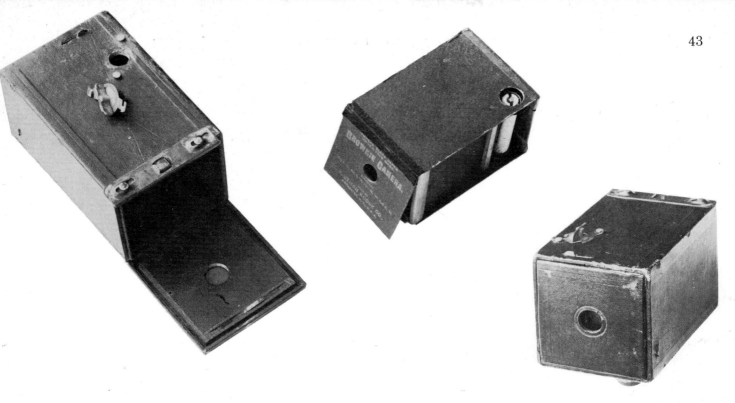

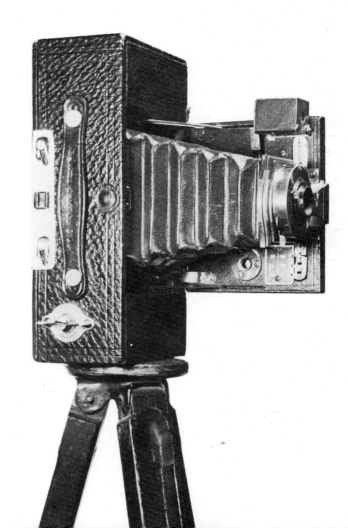

The two parts of the box Brownie are seen left and centre, with the complete camera on the right.

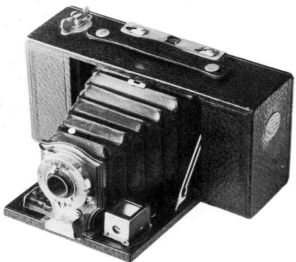

The early models of the folding Brownie have two easily distinguishable features. One is the red leather of the bellows, the other is the front standard, which is of polished wood with a moulded edge.

As a small boy in the 1920s, I had one of the smaller ones. It was my first camera, handed on to me by my father, and older by about ten years than I was. It says a lot for the simplicity and effectiveness of this little camera that the first picture I ever took was successful.

The fourth class of Kodak cameras to be considered are the more specialized or professional ones. Some of these—the reflexes and other press cameras, the stereoscopics, panoramics and miniatures—are best considered in the chapters which concern the particular formats.

One type, however, is best considered here, although it might well have been included in the last chapter, along with the hand and stand cameras. It is the Cartridge series of Kodak Cameras. These came in sizes 3, 4, and 5. Effectively, they were double extension hand and stand cameras, built to use cartridge film, and with provision for using plates as an alternative.

The No 4 first appeared in 1897, using Rapid Rectilinear lenses and simple time and instantaneous shutters, and were later offered with better lenses, and more advanced shutters. There was a No 5 in 1898, and a No 3 in 1900. One comes across these cameras quite often, particularly in the two larger sizes. They are handsome, competent looking instruments, and worth having in any collection.

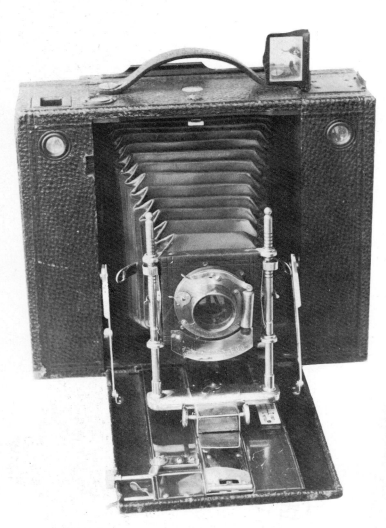

This number five cartridge Kodak has been fitted with an extra finder, of the sort that was called an 'optical' finder at the time.

This 'Plate' Kodak, (see also page 33) is fitted with a Beck 'Celverex' shutter. A few English companies imported Kodak bodies, and fitted lenses and shutters of their own choosing. This applied to several of the more expensive Kodak models.

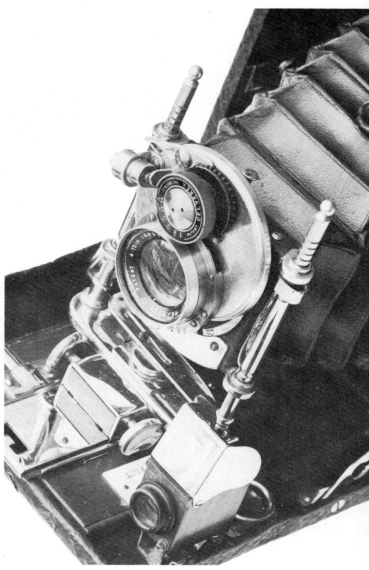

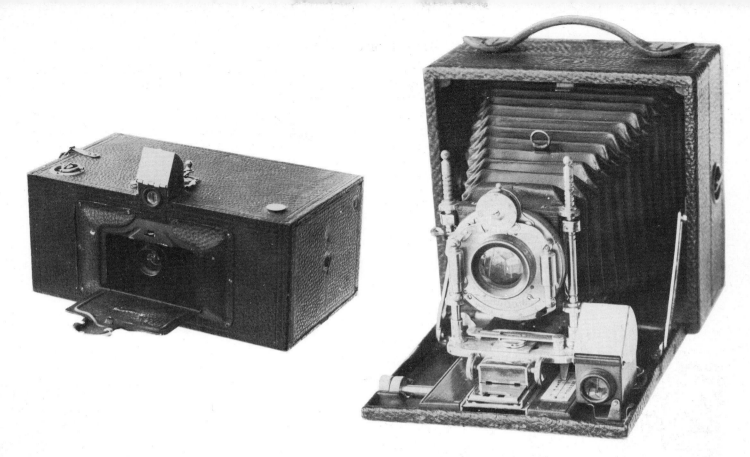

Above left, a Kodak panoramic camera, and right, the normal form of 'Plate' Kodak, fitted with a Bausch and Lomb 'Unicum' shutter. Below are three Kodaks from the end of our period, just before Hitler's war; the Bantam special, the inexpensive 'Jiffy' Kodak, and the handsome 'Regent'.

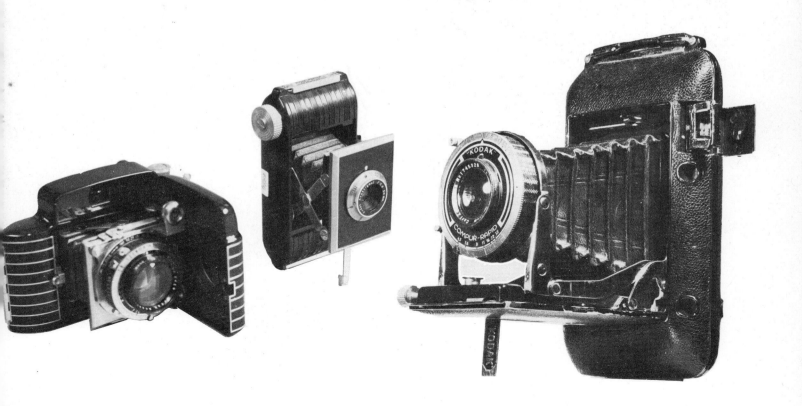

Mr Sanderson's Movable Front

If I get up from my typewriter, and walk across this room, I can find on my shelves eleven different types of Sanderson Camera. There are around fifty more, that are not represented in my collection.

Down the years, from 1895 to 1939, some sixty-odd different models of 'The Sanderson' were marketed. In appearance and capabilities, they varied widely, but they all had one feature in common, the Sanderson patent front, which Frederick H. Sanderson patented in January of 1895, and which was modified, improved, re-designed in special ways for special purposes, and added to, in the years which followed.

Yet this basic idea—the thing which makes a Sanderson a Sanderson—remained unchanged in essence throughout.

Frederick H. Sanderson was born in Cambridge in 1856. When he grew up, he worked as a cabinet maker, and as a stone mason, apparently specializing in carving in both wood and stone. So perhaps it is not surprising that when, as a young man in the 1880s, he took up photography, it was architecture that interested him. It would seem, from the early advertisements of his cameras in the Houghton catalogues, that church architecture was of special interest to him.

And he must have run into the problems which beset everyone who tackles this field.

You set up your camera on a tripod, and examine the contents of your image. The church, or the cathedral, is usually surrounded by other buildings, and it is not possible to get very far back. So you have chosen a wide-angle lens.

The chances are, that with your camera levelled on its tripod, what you will see in your finder, or on the focusing screen, is a lot of foreground that you don't want, and a total absence of the upper parts of the building, which you do want.

Tilting the camera upwards will bring in the upper parts, and lose the foreground, but it will also give you converging verticals, and a distorted view of your cathedral.

The classic answer to this problem is to keep your camera level, and use the rising front, so that you take in more top, and lose that useless expanse of foreground.

The rising front existed in Mr Sanderson's early days, but it was very limited. And there are problems in this type of photography which the rising front alone will not solve. What is needed is considerable and very flexible perspective control.

Frederick Sanderson set about designing and building a camera which would provide solutions to all the problems he had already encountered—a camera which would afford a greater degree of perspective control than any other camera which then existed, and which could be used with relative ease.

In his original construction, the design is surprisingly simple.

The lens panel is supported in four slotted arms, two on each side, which are pivoted at the front of the camera, or the extension slide.

On each side of the lens panel is a threaded stud, which passes through the slots in the arms. Finally, on each side, a knurled finger nut threads onto the studs.

So the front panel can slide up and down between the arms, and be locked by the nuts in any position. It can be locked out of square, if you so wish, for all four of the slotted arms are hinged independently.

The Sanderson front provided rise and fall, swing and tilt, all controlled and locked by one pair of finger nuts, which you could operate from the back of the camera, as you viewed the image on the ground glass focusing screen.

The actual rise provided was such that the lens axis could be raised level with the top edge of the focusing screen when the focusing screen was in the vertical position for upright pictures.

Altogether the Sanderson patent front gave a control of composition and perspective which left nothing to be desired by the architectural photographer.

This arrangement of the front panel within four slotted arms was the subject of the first Sanderson patent. All the subsequent patents concerned with the Sanderson series of cameras merely enhanced the usability of the original feature. Some of the later patents were taken out to extend the sixteen year life of the original patent, which, when it lapsed was copied by other firms than Houghtons, who from the beginning were the makers of the Sanderson.

The second Sanderson patent is an interesting one, and very simple.

The ordinary camera reversing back was square, so that it would fit into the rear frame with the focusing screen either horizontal or vertical. The back end of the camera bellows was glued to the inside of this square rear frame.

With the very great rise that is possible with a Sanderson camera, there was a tendency for

The classic Sanderson front construction. This example is circa 1898.

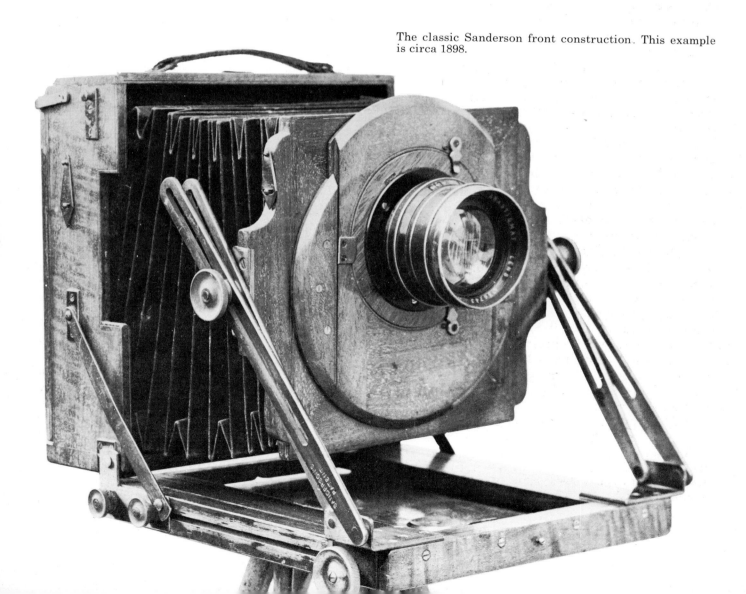

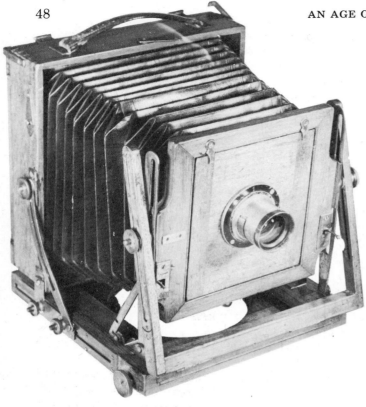

A Junior Sanderson, with the front in two positions. Note the struts which hold one pair of slotted arms at right angles to the base, and the latches which maintain the alignment of the front panel.

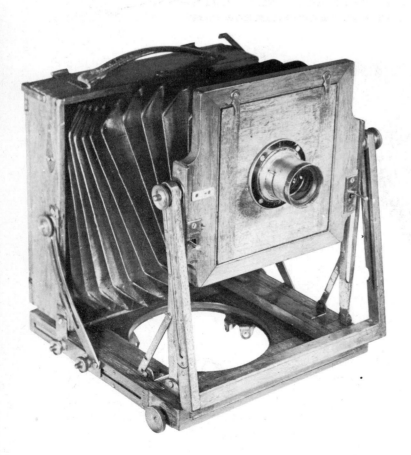

the bellows to bunch up at the top near the rear frame, cutting down the illumination to this part of the picture. So Sanderson merely extended the rear frame, and the bellows, for a small amount above the square area which accepted the reversing back. This meant that there was a small amount of dead space up top where the bellows could bunch if they wanted to, without interfering with the picture. Very simple, but it is a practical and useful feature which was included subsequently in all appropriate versions of the Sanderson camera.

This feature gave rise to an item of camera terminology which, as far as I can discover, was used more in the camera-making trade, than among photographers, and I am indebted to Mr Frank Gandolfi, who kindly explained it to me.

The 'Tallbody' Feature

These cameras with an upward extension of the rear frame to keep the bellows clear of the image when extreme rise is in use were called 'tallbody' cameras.

It was this simple 'tallbody' feature that was the subject of Sanderson's second patent.

Sanderson's first cameras, made and marketed by Houghtons were not of the tallbody type. What I believe to be the first advertisement for them appeared in the Almanac of the British Journal of Photography for 1896, which would have gone to press late in 1895.

A Sanderson feature which appears in the second year of this camera's history is the curious revolving panel on the camera front. Within this circular panel is a sliding panel, controlled by a rack and pinion, which carries the lens.

This means that the lens could be shifted in any direction from the centre of the front panel, in addition to any ordinary shift achieved by the use of the rising front. Therefore, without moving your camera on its tripod, you can control precisely the exact composition of your picture.

In these days of picture cropping in the enlarger, we are apt to forget that the best of our Victorian forbears really did compose their pictures in the camera, and used the whole negative in making their prints.

However, this revolving front really was a somewhat misleading refinement. True, it worked, but you could get precisely the same final result by the combined use of the ordinary

rising front, and a simple lateral shift, without the added complication of a turntable. This feature disappeared from the Sanderson field cameras in the course of time.

In 1899 the first of the Sanderson hand and stand cameras appeared—described at the time as a 'Hand Camera'. These first model H & S Sandersons are quite rare, and they have one feature that makes them easy to recognize. Sanderson must have felt that to leave the front panel held only by the two finger nuts—'floating', to some extent, between the four slotted arms—was not good enough for a camera which would be used away from the solid support of a tripod. Furthermore, it would be used in conjunction with a focusing scale on the baseboard, and if that scale was going to have any meaning, there had to be a means of determining the exact datum position of the

front panel when it was at right angles to the base.

If you were going to tilt the front out of the rectangular position, then you would have to use the focusing screen anyway (as you do in any camera with provision for tilt and swing, to this day) and the focusing scale would not be used.

So, to fix the rectangular datum position of the front, there were two small hinges, between the slotted arms, whose lower halves were fixed to the base-plate on which the four arms were mounted. The upper halves of these hinges slid in sockets at the base of the front panel.

With this arrangement, the front panel could only be vertical in one fore and aft position in relation to the base-plate, and this was the datum position required by the calibration of the scale.

These hinges, as I have said, are only found on the early Sanderson H & S cameras.

In January of 1902, the new model hand and stand camera was ready. In so far as the design of the front standard was concerned, it took

Below, the first of many Sanderson advertisements in the British Journal Photographic Almanac.

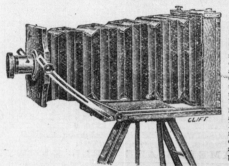
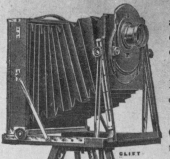

The advertisement above shows the earliest hand and stand form of the Sanderson.

what to all intents and purposes was its final form in this model. First, the slotted arms were redesigned. Each pair consisted of one straight arm, and one with a bend in it. The slots in both were quite straight, and when they coincided, they were at right angles to the base. Furthermore, there was a spring catch which engaged when they were in this position, and gave you what was in effect a fixed, rectangular front standard, within which the front panel was pivoted. However, this front standard could be tilted as desired, merely by releasing the catch.

There was also an addition to the front panel —or rather a pair of additions. At each side of the bottom of the front panel, a small latch was added, the bolt of which engaged in the paired slots of the two slotted arms. With these two bolts engaged, and the spring catches 'in', your Sanderson became a normal fixed front camera with provision for rise, which could be focused simply by use of the scale, and used in the hand.

The Classic Sanderson

With the bolts and catches disengaged, you had all the flexibility and perspective control you could wish, focusing your camera with the aid of the focusing screen.

About this time also, this system of catches and bolts, in a somewhat different form, became a feature of the Sanderson field cameras.

Returning to the H & S models, 1902 also saw the introduction of the De Luxe model, which was much as the regular model, described above, plus the addition of the 'tallbody' feature, and rack and pinion rise to the lens panel.

Pause for sizes. The Regular and De Luxe H & S cameras were available in quarter plate, 5 in × 4 in, and half plate.

In the field cameras, the old Model A, with its revolving panel on the front, came in half plate, whole plate, 10 in × 8 in, 12 in × 10 in, and 15 in × 12 in. The other models, called the 'Popular' and the 'Royal', came in quarter plate, half plate, and whole plate.

Seventeen models in all.

In the following year, the H & S 'Tourist' model in the same three sizes as the Regular made its appearance, and the roll-film model, again in three sizes, appeared. To say nothing of the 'Compact Popular' in the field cameras.

Twenty-six models now. Add to this all the variations of the early types, and there are about thirty-five from the inception in 1895.

1904 saw the introduction of the 'junior', in quarter plate size only.

1905—a new model De Luxe, with the addition of a short focus rack, which moved the front standard within the body for very short lenses. 1905, the new Postcard Sanderson. And if you think that accounts for six new H & S models in 1905, you can double it, because both of these were also available as tropical models in teak, in all three sizes. Plus teak variants of some of the field cameras.

That's around fifty models in ten years.

In 1910, the short focusing feature was added to the regular and postcard models. That's another six.

Subsequently the clamping arrangement that held the front standard to the extension slide

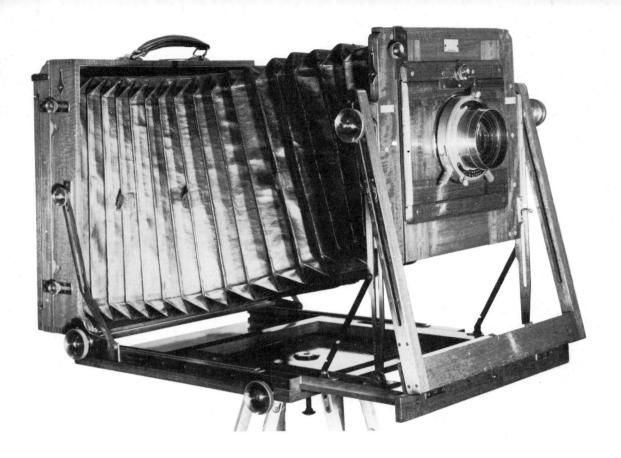

Above, a fine 12 × 10 Sanderson, made about 1910, and below a 5 × 4 tropical model Sanderson in polished teak.

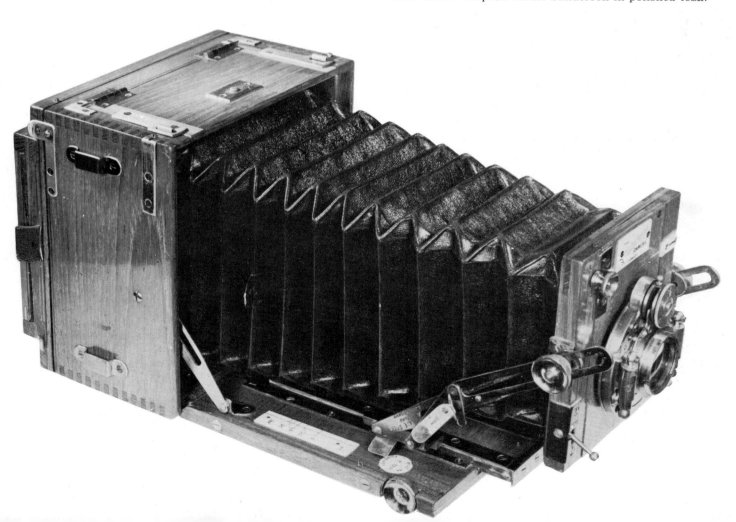

was redesigned, and there were minor changes to the front panel.

After the first world war, the number of models offered began to dwindle. It never again reached the peak of 1905, when some thirty models were currently available out of the total of about fifty sizes and types that had seen the light of day in the first ten years.

Eventually, in the years just before Hitler's war broke out, the number of types on sale came down to two. They were the last model H & S, with nickel fittings in place of the traditional lacquered brass, in quarter plate only, and one model field camera, a ten by twelve in teak.

My original estimate of sixty-odd types is, perhaps a little conservative, and, I should point out, takes no account of all the various alternative lens and shutter combinations that were offered by the makers. I do not think that these variations should be considered, since all that the Sanderson was ever supposed to be was a first class camera, which would get the best out of any lens and shutter you cared to fit to it.

The Sanderson was, and is, a very good camera indeed, whether you consider the H & S versions, or the field cameras. I say is, because I know that some are still being used, and turning out exemplary work.

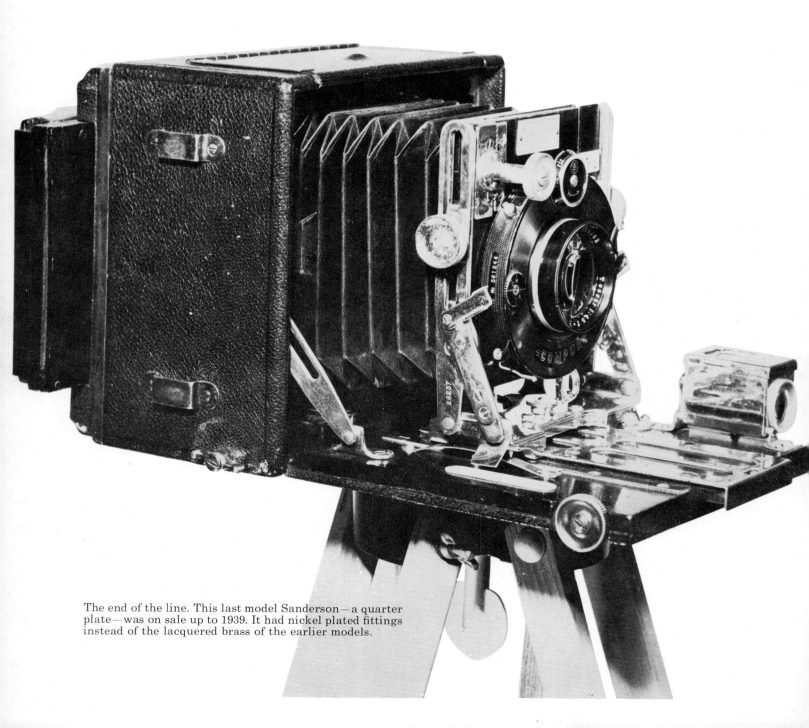

The end of the line. This last model Sanderson—a quarter plate—was on sale up to 1939. It had nickel plated fittings instead of the lacquered brass of the earlier models.

The Reflex Principle

This chapter is concerned with the class of cameras that fathered what is now the most popular camera format extant—the small single-lens reflex.

There seem to have been single-lens reflexes in existence, if not in production, at the very beginning of the dry plate period, although the idea did not begin to blossom into an important possibility in camera design until the 1890s. It was not until the very end of the period which concerns this book—in the late 1930s—that single-lens reflexes began to assume their final, miniature, form.

In the early days of photography, as we have seen, focusing was achieved in one of two ways.

First, by the visual inspection of the image on a ground glass screen at the back of the camera.

Second, by setting the estimated distance of the subject on a scale.

The first method, although it could, and still can, give the most precise results of all, had one great disadvantage. When you had adjusted the camera so that the image on the ground glass was sharply focused, you had then to remove the ground glass focusing screen, and replace it with a dark slide containing your sensitive plate. Then you had to set your shutter, open the dark slide, and make your exposure.

If your subject was what the French call an 'actuality'—a fleeting moment of interest which you wished to capture—the chances were that your moment would have passed by the time you were ready to expose.

The hand camera, with preset focusing on a scale could overcome this difficulty, but it could only do so if the construction of the camera was such that the validity of the scale could be relied on at all times. Unfortunately this was seldom the case. And over and above the question of reliability was the very simple fact that many people were not good at guessing distances.

In any case, reading back over things that were written about photography nearly ninety years ago, one gets the strong feeling that professional photographers tended to regard scale focusing as an expedient for amateur use only. They regarded the inspection of the image as the only satisfactory way of focusing a camera, but what was needed was some way of eliminating the interval between the observation of the desired picture, and the moment when it became possible to record it by making the exposure.

This meant that the sensitive plate, and the focusing screen had both to be in the camera, in working position, at one and the same time. There could be no taking one out, and putting the other in.

What many people regard as the best solution to this problem is, to this day, the single-lens reflex design.

The great virtue of this design is that the observed picture can be focused and recorded with almost total immediacy.

It is not surprising therefore that this type of camera, quite early in its history, became adopted for press work. Indeed, the big SLRs of earlier days are often referred to as press re-

flexes, and they dominated this area of photography for many years.

The principle involved in the SLR design is simple enough. A mirror, placed most usually at 45 degrees to the lens axis, reflects the light passing through the lens onto a focusing screen at the top, or sometimes the side, of the camera. When this mirror is moved out of the light path, the light can then travel straight to the sensitive plate. Matters are so arranged that the distance between the lens and the plate is exactly equal to the distance from the lens to the focusing screen, via the reflecting surface of the mirror. So that if you can see a nicely focused image on the screen, it will be focused with equal nicety on your sensitive plate.

Obviously, a shutter capable of timing your exposure must be introduced into the light path at some point, and since you do not wish to eclipse your image by covering the lens, it would seem that your shutter must work behind the mirror, in the area of the sensitive plate. And indeed, to this day, the focal plane shutter is the most usual type to find on a single-lens reflex.

However, as we shall see, there have been most ingenious designs, using shutters at the front of the camera, from almost the earliest days of these cameras.

The Action of the SLR

First, let us consider the ordinary SLR with a focal plane shutter. The condition of readiness is as follows:

1. The mirror is in the light path, so that the image formed by the lens can be observed and focused on the screen.

2. The sensitive plate is in place at the back of the camera, in its slide, which has been opened.

3. The shutter blind has been wound, so that it is in tension, and completely covers the plate, so that no light can reach it.

At the moment of taking the picture, the following things happen (or should happen):

1. The mirror moves out of the light path, impelled by some mechanism, which may be your own thumb, but which most often is a spring.

2. The mirror, or some other connected screen or curtain, must blank off the focusing screen so that no light enters the camera at this point to fog the plate.

3. When condition two is satisfied, the shutter is released, and the slit in the blind travels rapidly across the plate, so making the exposure.

In even the most unsophisticated SLR designs, the interval between the moment of decision—the observation of the desired picture—and the actual exposure, is very short. In the better designs, it is entirely negligible.

The earliest SLR design of which I have found any mention is Sutton's patent of 1861, which seems to have been a reflex studio camera, and had a mirror which was removed from the light path merely by turning a knob. However, this camera does not seem ever to have been manufactured. The same is true of McKellens patent of 1888, which comes within our period. McKellen at the time was marketing a 'Double-pinion Treble Patent Camera', which he had first produced in 1884, so presumably he had manufacturing facilities, but I cannot discover that he ever put his patent reflex design into production.

E. W. Smith & Co of New York did put a half plate reflex on the market in 1884, and this must, I think be the first SLR offered to the public.

The SLR and Telephotography

The earliest reflex I have in my own collection is by Dallmeyer, and is his 'Naturalist' of 1894. As the name implies, it was intended for wildlife photography, and the reflex device only allowed you to examine the centre of the image for sharpness. This would probably have been better done from a purely optical standpoint on a back focusing screen, but presumably Dallmeyer thought that, with wildlife as the subject matter of this design, the reflex arrangement gave the possibility of greater immediacy. However, he did not seem very confident of the light-tightness of his focusing screen with the mirror in the 'up' position, since he provided a sliding shutter to blank it off, which tended to inhibit the immediate taking of a picture, even though the sensitive plate was all ready for use in the back of the camera. I must confess, that after trying a few shots with the camera (in the first one I left the focusing screen unshuttered, and fogged my plate) I adopted the simple expedient of covering the eyepiece of the screen with my hand.

The real importance of the Dallmeyer 'Naturalist' lies in the fact that the design arises out of T. R. Dallmeyer's telephoto patens of 1892, and was the first camera designed specially to use a true telephoto lens.

The tiny round screen of the Dallmeyer 'Naturalist' was intended principally for focusing the image and 'aiming' the camera, rather than for composing the picture.

DALLMEYER'S NEW 'NATURALISTS' HAND CAMERA.

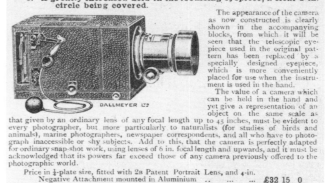

THIS instrument, which is a modification of the original 'Naturalists' Camera,' for which the Medal of the Photographic Society of Great Britain was awarded in 1894, is superior to its prototype in many details, the more important of which are—

1. **Great accuracy in focussing.**
2. **Adaptability for use with ordinary as well as Tele-photo lenses.**
3. **The power to use the Tele-photo lens at varying magnifications.**
4. **Portability.**
5. **Increased facilities for manipulating the shutter, which is now** of the well-known Anschutz pattern.
6. **A greatly increased field in the focussing eyepiece, a clear 2-in.** circle being covered.

The appearance of the camera as now constructed is clearly shown in the accompanying blocks, from which it will be seen that the telescopic eyepiece used in the original pattern has been replaced by a specially designed eyepiece, which is more conveniently placed for use when the instrument is used in the hand.

The value of a camera which can be held in the hand and yet give a representation of an object on the same scale as that given by an ordinary lens of any focal length up to 45 inches, must be evident to every photographer, but more particularly to naturalists (for studies of birds and animals), marine photographers, newspaper correspondents, and all who have to photograph inaccessible or shy subjects. Add to this, that the camera is perfectly adapted for ordinary snap-shot work, using lenses of 6 in. focal length and upwards, and it must be acknowledged that its powers far exceed those of any camera previously offered to the photographic world.

Price in ¼-plate size, fitted with 2B Patent Portrait Lens, and 4-in. Negative Attachment mounted in Aluminium £32 15 0
Or with 1B Lens and 3 in. Negative Attachment £25 10 0
The above prices include 6 solid double Slides, or Changing-box for 12 plates.

J. H. DALLMEYER, LTD. 25 NEWMAN STREET, Oxford Street, LONDON, W.

Dallmeyer was one of the inventors of the telephoto lens, and before we go further, it would be as well to set out what is meant by this term.

Obviously, in order to produce a large image of a distant object, a lens of long focal length is needed, and if it is an ordinary lens, you have two sources of considerable difficulty. First, your camera becomes long and unwieldy, and suffers considerable loss of rigidity. Second, unless your plate size is in proportion to your focal length, you have a lot of surplus light bouncing around inside your camera, since you are only using the middle of the large image produced by your very long lens. This surplus light degrades the quality of your picture.

To cure these troubles, you need a telephoto lens, which, although it has a long effective focal length, and produces the enlarged image

you require, does not require an inordinately long camera to bring it into focus. What is called its 'back focus' is considerably shorter than its effective focus, and may, in fact, require the telephoto lens to be no further away from the plane of the focusing screen than your normal lens. Also, your telephoto lens does not cover as large an area as a 'long lens' of the same focal length. It is designed so that it covers your normal plate size, and so eliminates the presence of unwanted light inside your camera.

In a telephoto lens, there is always a negative component at the back of the lens tube, and a positive element in the front. Dallmeyer's patent concerned itself with the design of the negative component, which was intended to be used in conjunction with a normal, complete lens of the day as the positive element. What you can see on the front of the 'Naturalist' is a normal brass mounted portrait lens. The negative lens combination, which converts this portrait lens into a telephoto lens, is back inside the camera.

Used with care, this camera will produce a very creditable picture with its pioneer telephoto combination. If I seem to have digressed

There were a number of simple, bulky SLR cameras available in the nineties. These two are typical.

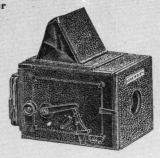

from the subject matter of this chapter, which is the SLR, to talk about telephoto lenses, it is because the only really effective way to use a telephoto lens has always been in a reflex camera. There have been, as we shall see, applications of the telephoto lens to other types of camera with scale and rangefinder focusing, and obviously, one can use telephoto lenses in simple cameras with focusing screens at the back, but really the telephoto lens belongs with the reflex camera.

T. R. Dallmeyer, in producing the very simple 'Naturalist' single lens reflex camera to make use of his telephoto lens invention, was seeing very clearly the way in which his lens could best be used, and a few years later he produced a second, greatly improved version of the camera, which used the same type of telephoto combination with a normal portrait lens up front, but had a reflex focusing screen of full picture size, and anticipated the cameras which press photographers, thirty years later used for close-ups of sports action taken from such distant vantage points as the roofs of grandstands, or tall neighbouring buildings. Needless to say, these later cameras were all reflexes.

There were several other reflex cameras of rather boxy construction, using normal lenses, produced in the nineties. One of the most notable was the 'Gambier Bolton', from Watson and Sons of High Holborn. This was named for a Zoologist of the day, who employed it in animal photography. With its Watson 'Holostigmat' lens, it was capable of excellent work, and could be used in conjunction with one of Dallmeyer's telenegative combinations.

The Press Reflexes

Early in the twentieth century, the single-lens reflex took what was to become its general configuration for about forty years—the general shape of the 'press reflex'.

This configuration was that of an approximately cubical box, the front of which extended on bellows to focus the lens it carried, and the top of which opened into a tall hood to assist in the examination of the focused image.

Shutters, as we have said, were focal plane shutters, and on the earliest types they were the same very simple blind shutters that could be bought as a separate item to be fitted onto ordinary wooden bellows cameras. The Gambier Bolton, for example, made use of a Thornton Pickard focal plane shutter unit, and the Dallmeyer 'Naturalist' was supplied fitted with a

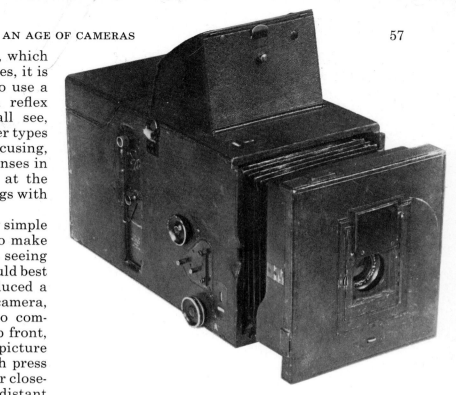

In the N & G SLR, the addition of the separate focusing hood shows the shape of things to come—the typical 'Press' reflex that emerged in the early years of this century, and persisted to the end of our period.

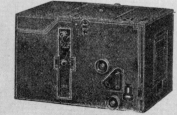

shutter from the continental firm of Goerz, the 'Anschutz' shutter.

These were very simple shutters. The width of the slit in the blind could be altered, but only by opening the back of the camera, and fiddling with the cords that bridged the ends of the shutter slit. The tension in the spring loaded roller, which towed the blind across to make the exposure, could also be changed. Greater tension moved the blind faster, and gave you shorter exposures for the same width of slit. In practice, photographers tended to keep the tension as low as possible, for with high tensions in the spring roller, the blind would accelerate during the travel of the slit across the plate, and give a varying exposure. This phenomenon was known as 'wedging'.

Wedging, or exposure variation across the width of the plate was sometimes extolled as a virtue, but only in cameras where the slit moved from the top of the plate to the bottom during exposure. This meant that the slit was moving most rapidly at the bottom of the plate, and if your subject was a landscape, this was where, in the inverted photographic image, the sky was to be found. Effectively, the sky got rather less exposure than the foreground, which could be very desirable. Indeed, graduated filters which are said to achieve this same result are still in use today. Skies in most pictures are over-exposed, compared to the foreground, and details of clouds are therefore lost.

However, in making these claims for some of the earlier focal plane shutters, the makers were making a virtue of necessity.

Shutter Adjustments

Obviously, a tension for the roller could be arrived at which moved the slit across the plate at a uniform speed. If the tension was limited, it would be considerably less at the end of the blind's travel, than it was at the beginning, and would therefore counterbalance the tendency of the blind to accelerate as it moved across. Having arrived at this condition, different exposures could be achieved by altering the width of the slit in the blind. But in the early shutters, the process of altering this width was lengthy, and fiddling.

By 1900, makers of SLR cameras were turning their attention to designing cameras in which the shutter was an integral part, and in which slit widths could be changed conveniently by setting a knob on the outside of the camera. Among the earliest of these makers was the

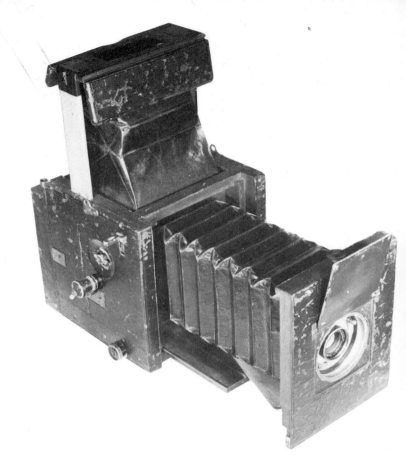

Above, the second form of N & G SLR, which appeared in 1904, and below, the Adams 'Vidiex'.

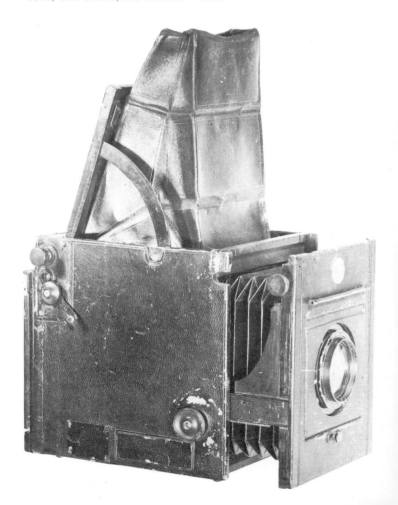

firm of Adams, of Charing Cross road in London, who produced such a camera late in 1901. The means of adjusting slit width was simple enough. The lower half of the shutter blind, below the slit, was not connected directly to the upper half, but by means of two narrow tapes, one at each extreme edge. These tapes were fixed to the edge of the upper blind, and ran down through narrow slits in the edge of the lower blind, after which they turned upwards, and were fixed to the upper blind roller, alongside the outer edges of the upper blind. The two short sections of the upper roller, which carried the tapes, could be turned in relation to the rest of the roller, and by this means the width of the slit could be altered.

The shutter was set by winding the blind onto the upper roller against a ratchet. Since there was a spring inside the lower roller, this was then tensioned. The ratchet was released by the upward movement of the reflex mirror, so that the blind did not start to move across the plate until the mirror was in the 'up' position, and therefore stopping off the entry of light through the viewing screen.

The first Adams reflexes, which were given no name by the company, and the 'Videx' series, which came out two years later, suffered one rather irritating drawback, which was a characteristic of the shutter, rather than the camera.

The winding knob, for setting the shutter, was attached directly to the top roller, and took a number of turns to wind. It was rather like winding a run-down watch, and if you were in a hurry to take a picture, the process seemed interminable.

But soon after Adams produced their 'Videx', which was capable of excellent work, the Kershaw company, of Leeds in Yorkshire, made a very notable and durable contribution to SLR design.

Soho Cameras

They had patented a very sophisticated and reliable shutter and mirror mechanism which was incorporated in cameras which were marketed by Marions of Soho, Ross of Clapham common, Dallmeyers of Newman street, the London Stereoscopic Company of Regent street, and by Watsons of Holborn. The models marketed by the various companies varied in minor details, and were fitted with various lenses, but they were all essentially the same. The ones marketed by Marions were called the 'Soho'

reflexes, and they went on selling them right up to the thirties. I would think that there were more of the Marion models produced and sold than all the others put together, and I think that this justifies what has long been the practice in the camera trade, to refer to them all as 'Sohos'.

Kershaws made the shutters and mirror assemblies for all of these cameras in the early days, but later, I think they were made under licence outside Kershaws. It was these mechanisms that made the 'Soho' cameras what they were.

First, the mirror. This was arranged so that the hinge on which it pivoted moved backwards as the mirror moved upwards. This meant that a lens of shorter focal length could be used than would otherwise be possible.

Up till this point in time, one criticism of the SLR design had been that it required a lens of longer focal length than was considered normal for the plate size involved.

The typical 'Soho' side plates show up well on this 1911 tropical model.

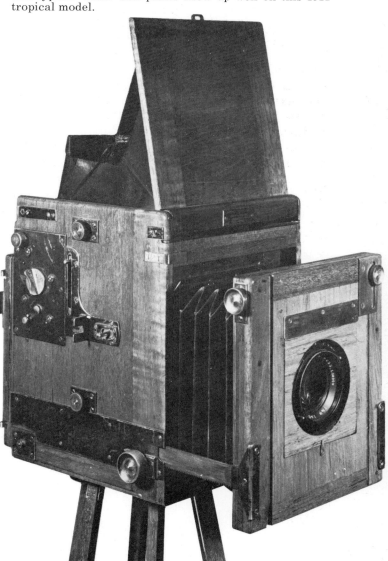

The 'Soho' inner frame, mirror down, (top), and part way up, (below). Note the damping cylinder.

There had to be enough clearance behind the lens for the mirror to swing upwards without hitting the lens.

With Kershaw's neat idea of having a hinge line that retracted as the mirror came up, lenses of normal focal length—that is, equal to the diagonal of the plate—were possible.

Another part of the mirror patent took the jolt out of the mirror. On earlier reflexes, the mirrors, impelled upwards by a spring an instant before exposure, tended to cause a jolt as they thumped home against the underside of the focusing screen. This could cause a slight vibration of the camera, especially if it was hand held, just as the exposure was commencing. This could ruin picture quality.

The 'Soho' mirrors were connected to a piston, which moved in a cylinder of air, which effectively cushioned its movement against jolt.

The cushioning could be adjusted by a simple variable leak in the cylinder, and the spring itself could also be adjusted to suit the user.

When the two adjustments were properly made in relation to each other, the mirror would come up smartly without a trace of jolt.

There was a simple test which could be applied, and it still works on my oldest 'Soho', which is about sixty-four years old.

You stand the camera on a level surface, with the focusing hood off. Having set the mirror and shutter, stand an ordinary pencil on end on the focusing screen, and operate the release. The pencil will not even quiver, much less fall over.

On many other SLRs of this date, and later, a pencil will positively jump, if you apply this test.

As far as the Kershaw shutter is concerned, its slit width is adjustable in much the same manner as the Adams cameras employed, but winding was vastly improved. One turn of the knob winds the shutter completely.

One further point must be noted, concerning the inter-action of mirror and shutter. While it was impossible to release the shutter without the mirror having first risen to blank off the focusing screen, it was your pressure on the release that triggered the shutter. As you pressed, the mirror went up, and then as you continued to press, the shutter flew across the plate. So, you could make one pressure which caused an uninterrupted sequence of mirror-shutter action, or you could be ultra careful. You could release the mirror by pressing carefully, and then, with a slight additional pressure, let the shutter go quite separately.

These old 'Sohos' are not only very fine cameras, capable of excellent work, but they are a very important part of camera history. At one time they were almost 'standard equipment' for a press photographer. As a young journalist before Hitler's war, I remember them well at newsworthy events. Often they outnumbered all the other types of camera put together.

Mirror jolt was eliminated very simply in another way in other SLRs. Those made by Goltz and Breutman—the 'Mentor' cameras—those by Thornton Pickard, and those by ICA or Butchers (these cameras were the same) all had a very simple mirror linkage which left the matter of mirror jolt entirely in your hands. It was simply your thumb pressure that moved the

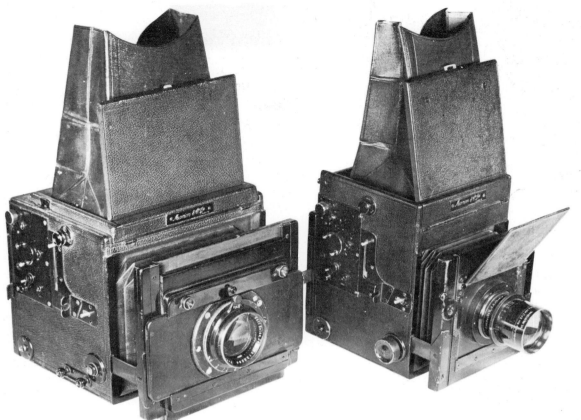

Two more 'Sohos', the postcard model, and the rather uncommon $2\frac{1}{4} \times 3\frac{1}{4}$ version with revolving back.

Below, a 'Special Ruby' from Thornton Pickard, and one of the many versions of the Mentor folding SLR.

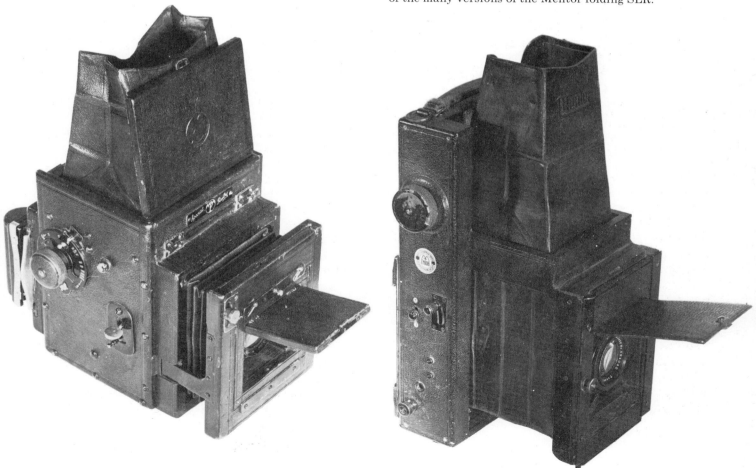

mirror, and the mirror then released the shutter. In practice, this worked very well, but it had one drawback. Often, taking press pictures, you find yourself in the middle of a crowd. Then, you can only get your picture by holding the camera above your head. With a Soho, or other type of reflex with a spring actuated mirror, you could peer upwards into your focusing hood, and see your picture, and therefore be able to focus it. If your mirror happened to be of the thumb-operated type, it just fell down and covered the screen when you inverted the camera, and you couldn't see a thing.

Another anti-jolt device is probably the simplest of all. As the mirror reaches the top of its swing, it enters what is in effect a shallow box. The air trapped in this box by the mirror itself then quite effectively cushions out the final jolt.

Focal plane shutters in SLRs varied considerably. Many—the Thornton Pickards, for example—were self capping. That is to say that the slit was closed during winding, and only opened during exposure. But since most photographers did not remove the sliding shutter from the plate carrier until after they had wound the shutter, this could be regarded as superfluous.

Some shutters had two blinds, each with ribbons, and the gap between them determined the slit width. Others had very long blinds, with a series of fixed slits of varying widths, positioned along the length, so that you selected which slit you needed for a particular exposure. The ICA and Butcher cameras used this, but the best known cameras of this type are the Graflex series, made for many years by Folmer Graflex as part of Kodak, and latterly by the independent Graflex company. I think that the Graflex Super D, made after the end of Hitler's war, must be the last of the big SLR designs.

Multi-slit Blinds

These multi-slit focal plane shutters were non-capping, but the Graflex cameras cannot be wound unless the mirror is down. However, I have got one curious exception in my collection. It is a Graflex which has a separate short blind added, which comes across when the mirror is brought down to the viewing position. It flies out of the way when the mirror moves up, and allows the exposing blind to work normally. This is needed because the mirror does not block off all the light from the lens when it is down. Some could pass underneath it.

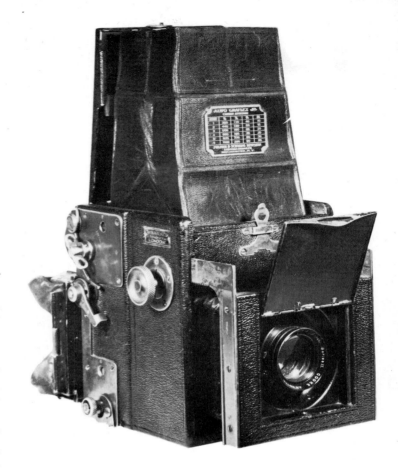

Two Graflex SLRs for landscape use only. The neat little $2\frac{1}{4} \times 3\frac{1}{4}$ 'Junior', and below, the bulky roll film postcard model.

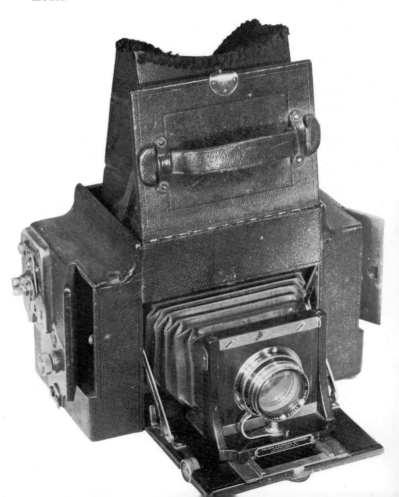

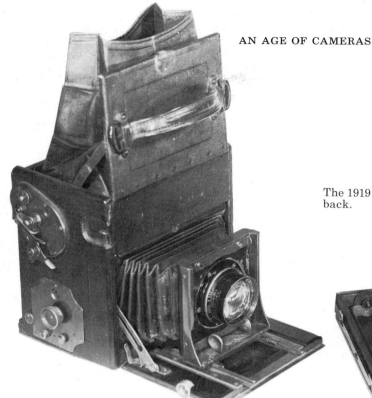

The 1919 postcard Graflex, for use with plates or cartridge back.

In earlier, similar models, this is not so. The bottom edge of the mirror homes against a light trap. However, when the front of the camera is pushed in to close it up, mirror and light trap are forced backwards past the viewing position, and I have found that they can jam, so I can only assume that this is the reason for the later arrangement. This particular camera dates from about 1919, and is the youngest of the three Graflexes I have with the folding front feature, and I think that it is possible that all the later 'folding front' Graflexes may have this separate capping blind. The more usual box-form, 'press' models, of course, do not need this feature, since the mirror in these is never pushed back beyond the ordinary 'down' working position.

The folding front Graflexes were an obvious attempt to reduce the bulkiness of the basic SLR design in the larger sizes. However, other camera designs in this field went a lot further in the direction of folding up. These folding SLRs appeared in the 1920s, and they form a most interesting group of cameras, especially if you appreciate ingenious mechanical design.

As long as an SLR has a viewing screen at the top, which is near enough the same size as the plate, and accommodation for the plate itself at the back of the camera body, then the basic shape of that body will remain a cube.

If the front is going to be collapsed into the back, then it must be possible to fold the viewing screen, and the reflex mirror, out of the way.

So, in all of these designs, both screen and mirror are arranged so that they can fold back flat against the inner face of the camera back. Once this is done, the front can be collapsed onto them by means of bellows, or some kind of folding body, and the focusing hood, too, can be made to fold.

Another horizontal roll film Graflex TLR, on the $2\frac{1}{2} \times 4\frac{1}{4}$ size that was often called 'poor man's postcard'.

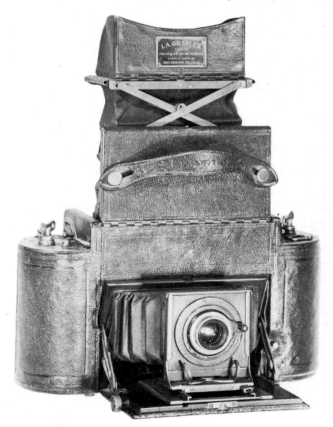

The design problems posed by these requirements were solved in various ways by different makers, but as far as I know, they all agreed on one thing. They all seem to have regarded a self capping shutter as a necessity, and as far as I know, all folding SLRs have such shutters.

The Folding SLR

In excellent reflexes like the Soho, or the Graflex where the shutter slit remains open during winding, it can be argued that no light can reach the film because the mirror is light-tight in its down position. In the one type of Graflex where light can get under the mirror, a capping blind is added.

Presumably the makers did not trust photographers to leave their dark slides closed during winding, though they almost always did.

In folding SLRs the reflex mirror has got to operate inside what must be a foldable box, generally of bellows form. So it cannot easily be made to achieve a light tight fit in the down position. If the body is a solid box, this condition is easily attained.

If you take the front panel off a folding SLR, and peer inside, you will find that there is clear space to each side, and at the bottom of the reflex mirror. There is plenty of room for stray light to get through, and if the shutter were of the non-capping type, plates could be fogged if the dark slide was open during winding.

So they fitted capping shutters.

These were not like the Graflex arrangement, where the slits in the blind were fixed, and the capper was a separate blind or curtain. In these, the actual slit closed during winding. There was no extra blind for capping.

The arrangement was simple enough. When the blind had travelled across the plate to make an exposure, the leading edge of the slit stopped, just past the bottom of the plate, and the trailing edge simply caught up with it, and closed the gap. When you wound, the two edges remained together, until the lower part of the blind covered the plate area, at which point this part of the blind was stopped, while the upper part of the blind carried on briefly, and opened the slit by the correct amount.

My own favourite among the folding SLRs is the Newman and Guardia. It was made in one size only, $2\frac{1}{4}$ in $\times 3\frac{1}{4}$ in, and could be used with plates, cut films, film packs, or roll films. There were two versions, the original, with an $f/4.5$ Ross Xpress, or similar lens, and the special, with an $f/2.9$ Pentac. The special was bigger when folded, and because of the bulk of the big fast lens, lacked one rather nice feature of the ordinary model.

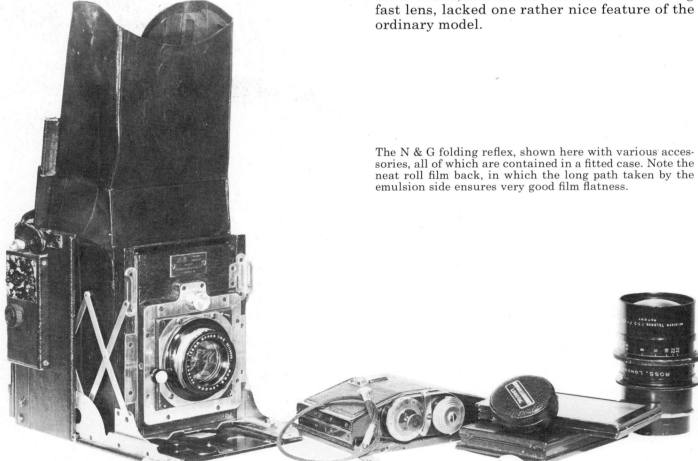

The N & G folding reflex, shown here with various accessories, all of which are contained in a fitted case. Note the neat roll film back, in which the long path taken by the emulsion side ensures very good film flatness.

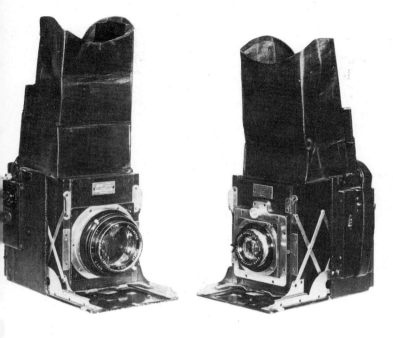

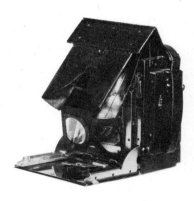

Left, the 'special' and 'ordinary' forms of the N & G, and above, closed and partly open.

The lens panel of the ordinary is equipped with a tilting arrangement, which is really quite practical, since you can observe the effect of its use in your viewing screen.

When you open these cameras for use, you bring the focusing screen from the folded to the working position by turning a small wing nut on the right of the camera. When you come to fold the camera again, you will find that this nut is quite immovable, and that the focusing screen appears to be in the working position for keeps. This is a slightly dangerous point in the design, and I have seen these cameras forced by people trying to fold them by the obvious method of reversing what they did to unfold them.

But that's not the way it works.

There is a flat tongue at the base of the front panel, in the middle of the baseboard. Just press it. You will hear the focusing screen, and the reflex mirror, snap smartly into the folded condition with what I can only describe as a competent clunk.

This is a delightful and interesting camera. It first appeared in 1921, and my own example is in first class working order still. However, I think that this is partly luck, because although this is undoubtedly a camera which could go on working perfectly for a lifetime, given proper handling, it is also a camera which is more than usually vulnerable to bad handling. There is the matter of correct collapsing, for one thing, and there is the gearing in the shutter mechanism for another. The wheels are of brass, rather light, and small toothed. They are completely adequate to do the job they were designed for, but there is no margin for ham-fistedness.

A folding reflex of which the complete opposite is true is the Adams folding Minex. I have the tropical version, in the same size as the Newman and Guardia folding reflex. It weighs six and a half pounds, against three and a half for the comparable N & G model. It is built in teak, and it is splendidly reinforced with brass.

It is one of the most handsome cameras I have ever seen, and had there been cameras in Nelson's day, I think they would have looked like this. It has the same feeling to it as have those splendid pieces of cabin furniture of the days of sailing ships—built in teak, and reinforced with brass.

This is one of the few reflex cameras I have come across in which the mirror, in the up position, does not blank off the focusing screen. It comes to rest a little below the level of the screen, and if it were not prevented by other means, light could get in via the focusing hood during the exposure, and fog the plate.

The device used to prevent this happening is a curious one. Inside the focusing hood there is a sleeve of black fabric, and the mouth of this is closed by a cord, connected to the reflex mirror itself. When the mirror is lowered to the viewing position, the cord slacks off, and a small spring opens the sleeve, so that you can see the image on the screen.

All this sounds a little involved, but in practice it works very reliably, and appears to me (I cannot find any reference to this point in any of the contemporary literature on this camera) to cushion out mirror shock. It is the cord, attached to the cloth sleeve with its spring loading, which brings the mirror to rest.

As a result, this very rugged and heavily built camera has one of the gentlest mirror actions you are ever likely to come across. If the mirror does clout in one of these cameras, it means that the cord is slack, and isn't doing its job of closing off that light trap in the focusing hood. Tighten it a shade, and both faults will be cured.

Arthur Adams, who designed the camera, seems to have liked cords at this period of the company's history, because there is another one.

Inside the mouth of the focusing hood is what might be described as a 'spectacle plate'. Lenses to correct for the photographer's sight faults can be fitted here. This plate is spring loaded, and also serves to hold the mouth of the focusing hood firmly open. When you fold up the camera,

the focusing screen and mirror are brought down against the camera back by a lever on the left of the camera body, and this same action folds the spectacle plate flat against the inside of the hood, so that it now becomes collapsible.

The N & G folding reflex was also fitted with a spectacle plate, but this was very simply put in place by hand. No springs or cords.

All the SLRs we have considered so far in this chapter have been focal plane jobs, and if I have said quite a bit about focal plane shutters, it is because they are inseparable from this class of camera. However, there is a bit more that I want to say about them.

Focal Plane Shutter Snags

These big old FP shutters were not like those in modern SLRs. The modern ones control exposure by the duration of the period during which the shutter is open. True, they may use narrower slits for the higher speeds, but they are tending towards the ideal, in which they would open fully in a negligible time, remain fully open for the period of the exposure, and close in a negligible time.

The older shutters controlled exposure by width of slit, irrespective of whether the speed of movement of the blind was variable. For an exposure of, say 1/500, the slit width might well be $\frac{1}{8}$ in. So that with the shutter travelling vertically, for an upright picture on a 5 in × 4 in plate, the top of the inverted image (the bottom of the plate) would be exposed 40/500, or roughly 1/12 of a second after the bottom of the inverted image (the top of the plate). Which means that

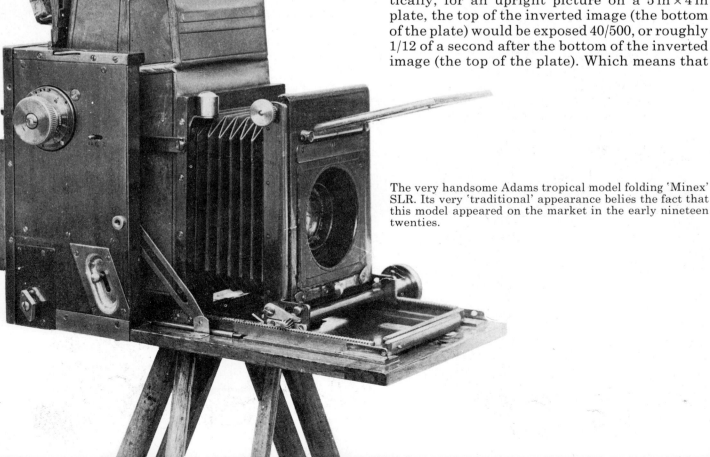

The very handsome Adams tropical model folding 'Minex' SLR. Its very 'traditional' appearance belies the fact that this model appeared on the market in the early nineteen twenties.

if you were photographing an object moving across your picture—say a racing car—the top of it would always be further forward than the bottom in your picture. Personally, where racing cars are concerned, I like the effect these old SLRs give you. The forward lean of the car enhances the effect of speed.

But whether I like it or not, the fact remains that these big old focal plane shutters, however good they were otherwise, gave you a distorted picture of a moving object.

Another drawback with these shutters is one that is not often mentioned. The blind was of fabric, rubberized on one side, and it was quite big. It could hold tiny particles of fibre, or dust, gathered from the air, and it could generate its own lint. It could, and did, give you a scatter of fine dust particles across the surface of your plate during exposure, unless you were con-

stantly meticulous about the cleanliness of your camera.

There was a lot to be gained if anyone could design an effective front shutter reflex.

The Front Shutter Reflexes

The first camera of this type that I can trace came from the firm of Newman and Guardia in 1902, and only a few were ever made. The company regarded the design as a failure, on account of its complexity, and all but one of their subsequent SLR cameras, which are illustrated in this chapter, were focal plane jobs, culminating in the folding reflex.

The exception was a focal plane camera, and a front shutter reflex as well, and it appeared in 1912. It is a rarity, and I have never seen one.

But before I say more about it, I'd like to describe a front shutter reflex which appeared in 1911, and was a very successful camera.

It was the Newman and Sinclair front shutter reflex, and the Newman involved was the identical Arthur Newman of Newman and Guardia.

Guardia, who seems to have been the business man of N & G, had died in 1907, and while the company carried on with the types of camera it was already well known for, Newman entered into an association with Sinclair of Haymarket, whose best known camera at that time was the very straightforward and beautifully made 'Una' hand and stand camera. Sinclair, incidentally,

The Newman and Sinclair front shutter SLR of 1910, shown below with its lens hood in position. Note the upright nickel strips which are a feature of this fascinating SLR.

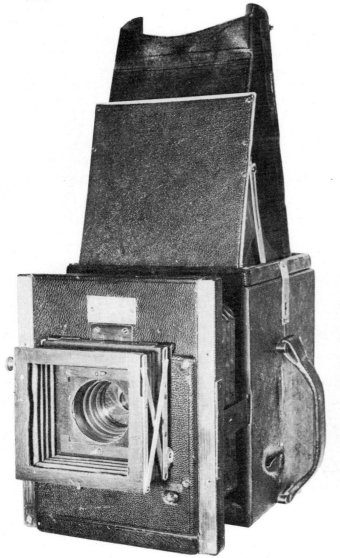

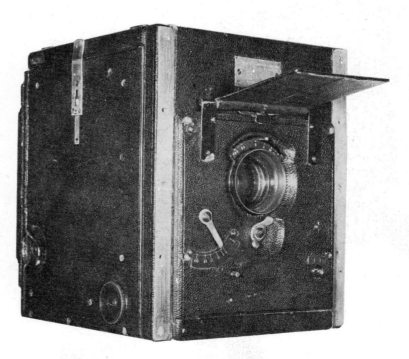

The same camera closed, and with its lens cover fitted in place of the lens hood.

moved from Haymarket to Whitehall in London, just after the first world war, and they are still there at the time of writing.

The front shutter reflex was the first camera to appear from the N & S partnership. It is quite complex, but it works beautifully. My own specimen, which I found in a junk shop, had obviously suffered from years of dirt and neglect when I found it, and nothing would move. However, when I had dismantled it, cleaned it, and reassembled it, it worked perfectly, which I think is a wonderful testimony to Arthur Newman's design.

The shutter is pneumatically controlled, and gives speeds from 1/2 sec to 1/100, and has provision for time exposures.

The sequence of events in this camera is interesting. Starting with the mirror in the up position, after an exposure, the shutter, which is between the elements of the lens, is closed. There is a butterfly nut on the front of the camera to open it, but with the mirror up, it cannot be moved. So there is a linkage, effected by universally jointed rods, between mirror and shutter, which works at all extensions of the camera, and allows for the movement of the

rising front as well. When the mirror is lowered to viewing position, by a knob on the side of the camera, this linkage releases the pawl which holds the shutter closed. Now you can open the shutter with the knob on the front, and view your image as in any other SLR. Your plate or film is safe from light behind the mirror.

When you opened the shutter with the butterfly knob, you also tensioned it, ready for exposure.

Now assume you have composed and focused your picture. You press the release . . .

A small lobe, pivoted to one side of the lens, flips across clockwise, and covers it.

Now the mirror moves up. But since, with no focal plane blind to protect the plate, it could be fogged by light through the focusing screen, there is behind the mirror a very light flap of aluminium, which remains down until the mirror is right up, and then follows it.

The pleasantly 'hand made' mechanism of the Newman and Sinclair front shutter SLR. The front element of the lens is removed to show the three cutaways in the thread which allow of quick changing of the lens elements.

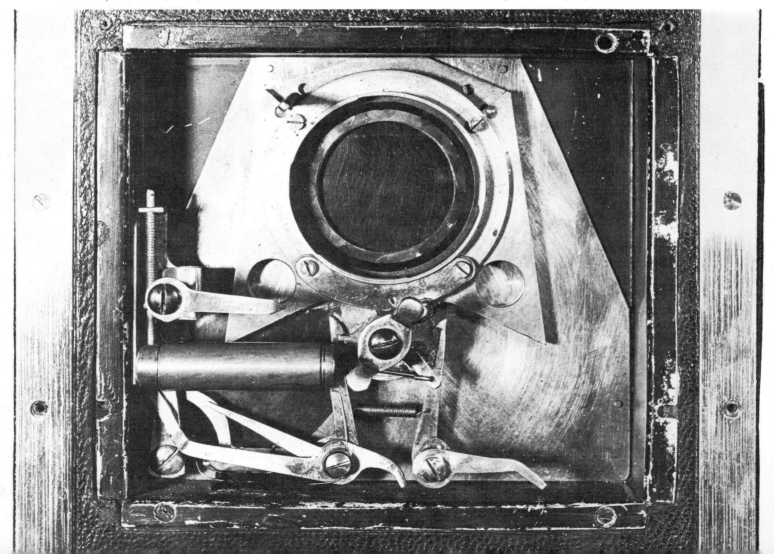

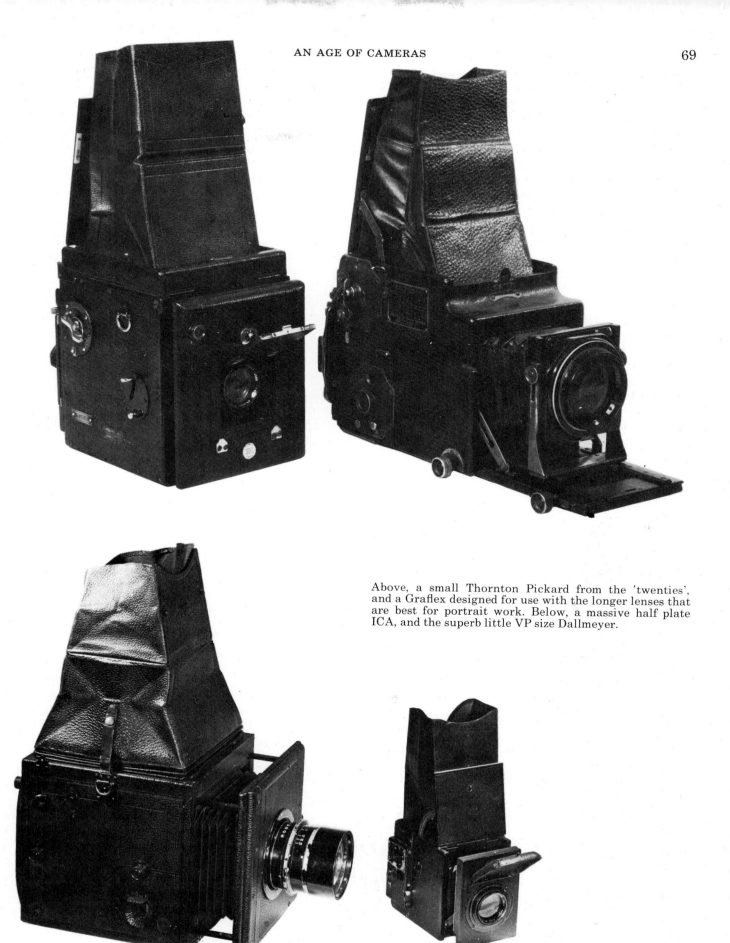

Above, a small Thornton Pickard from the 'twenties', and a Graflex designed for use with the longer lenses that are best for portrait work. Below, a massive half plate ICA, and the superb little VP size Dallmeyer.

Now the exposure can take place. The lobe which has already moved clockwise to close the lens, now moves back the other way, anti-clockwise, to open it again, followed at a short interval by a second lobe, which closes it off. The time taken by the gap between the two lobes to pass the lens centre is, of course the exposure you have chosen. As with Arthur Newman's earlier shutters, the actual speed of movement of the blades determines the exposure. They snap across swiftly for the shortest exposures, and drift gently across for the longest. This is achieved by linking the blades to a piston moving in an air cylinder. When you set the exposure, you simply alter a variable leak—the smaller the leak, the slower the movement of the shutter blades.

In the year following the introduction of this camera, in 1912, Arthur Newman brought out the N & G twin shutter reflex, which I mentioned earlier. Curiously, in advertising it, he did not make any great mention of the fact that the front shutter was linked to the mirror, as in fact it was. The impression one gains from his ads is that here is a focal plane reflex, with a front shutter added for use with the mirror up. In fact this camera operates as a front shutter reflex fully, and a focal plane reflex as well. One wonders why he chose to be so modest about its qualities.

Not so modest was the 'other Arthur' . . .

I am reliably informed that in the early years of this century a great rivalry existed between those two notable camera innovators and inventors, Arthur Newman of Newman and Guardia, and Arthur Adams of Adams & Co. In 1911, when the N & S camera had emerged from his rival's workshop, Arthur Adams was prompted to make the following statement in the Almanac of the British Journal.

'Reflex Cameras without Focal Plane Shutter, but with front lens Diaphragmatic Shutter. Whilst such a type cannot be such an all-round useful Instrument as our Minex and Radex, we shall shortly have a pattern *much* simpler and more *complete* than others now advertised, and which have to be held in quite impossible positions.'

I cannot discover that he ever produced such a camera, but then a great many plans for a great many things were lost forever when the Great War broke out just a few years later . . .

In 1931, the firm of Deckel had not long introduced their newest model of the Compur shutter, basically the same model they make today, with all settings for speeds made by turning the rim. One variation of it was made, mainly for studio use, with a 'focusing control'. This is a slightly misleading term, and refers to the fact that cocked or uncocked, the blades of the shutter could be opened in order to examine the image on the focusing screen. The firm of Goltz and Breutman realised that this shutter could be linked to the mirror in a front shutter reflex to provide a very effective and compact instrument, and the result was the Compur Mentor reflex, in the $2\frac{1}{4}$ in × $3\frac{1}{4}$ in size. When you pressed the release you returned the 'focusing control' to the closed position, and the mirror flew up after which it triggered the shutter in the normal way to take the picture.

Gradually the SLR was marching on, becoming more compact, more handy. In 1933 the Ihagee camera works of Dresden produced the Exacta, a small focal plane reflex, using V.P. roll film, and giving negatives measuring $2\frac{1}{4}$ in × $1\frac{5}{8}$ in. The second version using 35 mm cine film followed a year later.

The miniature SLR had arrived . . .

Left, the very solid little 'Baby Soho' shown beside the first of the new generation of SLRs, the Exacta. Both took a VP sized negative.

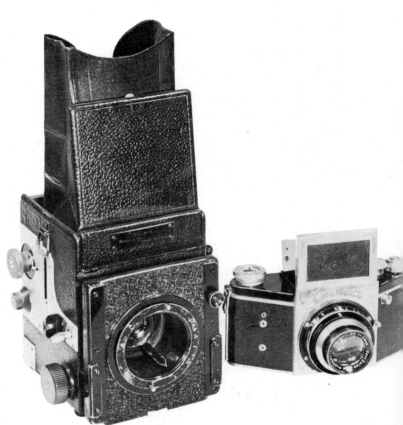

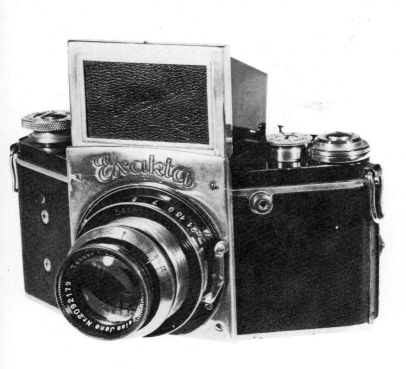

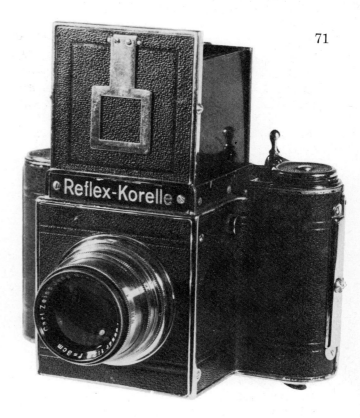

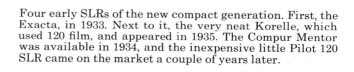

Four early SLRs of the new compact generation. First, the Exacta, in 1933. Next to it, the very neat Korelle, which used 120 film, and appeared in 1935. The Compur Mentor was available in 1934, and the inexpensive little Pilot 120 SLR came on the market a couple of years later.

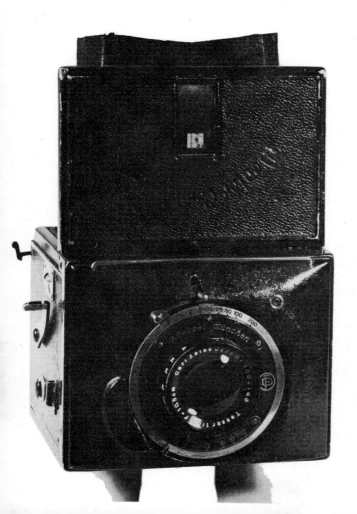

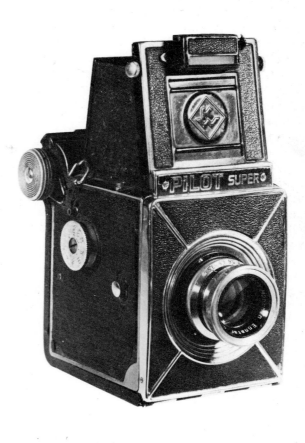

The Double Cameras

In the preceding chapter, 'The Reflex Principle', I made no reference at all to twin-lens reflex cameras. This was very deliberately done, because although I know that other writers have chosen to class them together with SLRs under the heading of 'Reflex Cameras', I think that to do so is to ignore the very basic difference between the SLR and the TLR.

To reiterate, in the SLR, we are using a reflex mirror to enable us to view and focus the image of our subject, and to take it without delay when the moment of truth arrives, *using a single lens*.

Another way to achieve the same object is to use *two lenses*, in two cameras which are coupled together. We use one camera to focus and view, and the other to take our picture. This is the important fact. The fact that most such double cameras also use a reflex mirror to enhance the convenience of viewing and focusing is also important, but it is entirely secondary to the over-riding principle, which is that we are using two cameras to view, focus, and take our picture, instead of one.

So I take the view that the most important fact about the TLR is that it is a double camera, not that it is a reflex camera, and I choose to class the TLR along with other double cameras which do not use a reflex mirror, because here, I feel sure, lie the origins of the TLR design.

There were designs of double camera which were not reflex cameras. They were put on the market soon after ready-made photographic plates became generally available, in other words very near the beginning of the Age of Cameras which concerns this book.

They were, very simply, two cameras coupled together, either side by side, or one above the other. They were fitted with a pair of matched lenses, and one camera carried a focusing screen at the back, the other a sensitive plate ready for use. What you saw, inverted, on the screen, was, nearly enough, what you would get in your picture when you exposed. To use these cameras, you had to hold them up in front of your eyes. Versions of this design were on the market right up to the 1930s.

Many of the early side-by-side designs were very much like the twin-lens stereoscopic cameras which are considered in the later chapter, 'Cameras with two eyes', and such cameras as this existed before the beginning of our period. Now I have no evidence which proves that owners of twin lens stereo cameras ever used them for single shots, using the second lens for viewing and focusing, but it is hard to believe that the idea did not occur to somebody. So I think that it is quite possible that the double camera may have its earliest form in an extension of the use of twin lens stereo cameras, back in the days of wet-plate photography.

One of the earliest double cameras which was made for sale to the public was the 'Academy', in 1882, made and marketed by Marion & Co of 22 & 23 Soho Square, the same company which later produced the famous 'Soho' Press reflex. The 'Academy' was produced in four sizes, from

a tiny model using plates just over an inch square, up to a quarter-plate model. These cameras consisted of two very simple wooden box cameras, mounted one above the other. The lenses of both were mounted on a single front board, which was adjusted for focusing by a single rack and pinion. The upper camera had a focusing screen at the back, on which the image could be viewed and focused. The lower camera accommodated the sensitive plate in a position corresponding exactly to the screen in the upper camera. The image you saw in the top camera was, nearly enough, the image you took in the bottom camera. Of course, if you were working at a very short distance from your subject, there would be an error due to the distance between the two lenses. The most complex part of the 'Academy' was the magazine for the plates, of which it contained twelve. It took the form of a box, which slid onto the bottom of the taking camera. It could be loaded on in daylight, and the procedure was that you started by placing the number one, on the side of the magazine, against a pointer on the camera body. Now you inverted the camera, and pulled a knob at the back. This opened a slot in the bottom of the camera body, and allowed the first plate to drop from the magazine into the camera body. Now you closed the slot by pushing the knob, and took your picture. When you had done, you pulled the knob again, with the camera right way up, and the exposed plate now dropped back into the magazine, which you now moved forward on the camera body to position two . . . and so-on.

To view the image, which was inverted, you had to hold the camera at eye-level. However, you could fit the viewing half of the camera with a reflex mirror, which enabled you to hold the camera at waist level, and look down at the image, which was now, of course right way up.

So that the Academy series of cameras, which were put on the market in 1882, and remained in Marion's range until about 1890, must be regarded as early precursors of the modern TLR.

The Photo-Jumelle

In 1892, Jules Carpentier in Paris produced a double camera, with direct viewing, which he called the Photo-Jumelle. The two cameras were side by side, and the taking camera was fed with plates by a magazine in the camera back. When you had made an exposure, you turned the camera so that the lenses were pointing upwards. Then you pulled a knob on

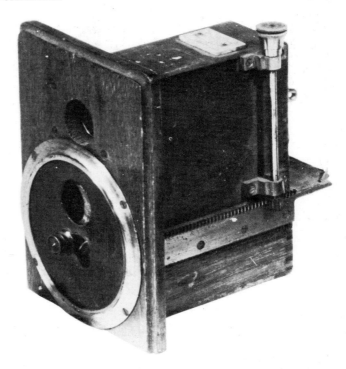

One of the earliest double cameras, the 'Academy' from Marions of Soho square in London.

the side of the camera which moved the plates into the viewing half of the apparatus, and allowed the plate you had exposed to drop down to the inside of the back. Now you pushed the knob, and the pile of plates slid back over the top of the exposed plate, and left you with an unexposed plate on the top of the pile, ready for use. Since the plates moved into the viewing camera during changing, there was a sliding shutter which came across to stop light through the viewing lens fogging the plate, and the viewing eyepiece in the back of the camera took the form of a small round red window, as there was some risk of light getting in to fog the film at this point. Carpentier made this camera in at least two sizes that I know of—$2\frac{1}{4}$ in \times $3\frac{1}{4}$ in and $1\frac{1}{2}$ in \times $2\frac{1}{4}$ in plate sizes. There was also a very similar camera, with reflex viewing, via an eyepiece at the top of the camera—a side-by-side TLR.

The Jumelle was in the form of a box, tapering towards the front, which contained the two cameras, one for viewing, and the other for taking, and it seems to have given its name to a whole series of French cameras produced about this time which were of the same tapered box construction. Most of these cameras were

THE STEREOSCOPIC COMPANY'S
'BINOCULAR' HAND CAMERA

Weighs, when loaded with 12 Plates or 30 Films, 19 ozs. only, but gives a picture measuring 7 × 5 inches.

THE 'BINOCULAR' CAMERA, No. 1.

IS a complete photographic apparatus, containing, within the space occupied by a small field glass, a rapid rectilinear lens of the highest quality, an instantaneous shutter, and one dozen prepared dry plates or thirty films. There is also a finder or sighting glass, which permits of the exact size and appearance of the proposed picture being seen at the time of pressing the button. The plates are automatically and instantaneously changed.

The shutter is also arranged to give time exposures, so that, besides taking pictures of moving objects in a good light, the Camera can be used for home portraits in ordinary rooms, interiors, and out-door work in dull weather.

One very important advantage possessed by this instrument over all other hand Cameras is found in the fact that in consequence of the 'Binocular' being held up to the eyes whilst the picture is being taken, the resulting photograph exactly represents the view as seen by a person of ordinary stature, and not as it would be seen by a child three feet high.

Although the negatives are necessarily of small dimensions, they are of such exquisite sharpness that they will bear enlarging to a considerable extent without loss of definition. This is most conveniently done by means of the special enlarging apparatus. The focus of the lens in this is permanently adjusted, and it is only necessary to place the negative in the frame at the one end and the bromide paper or film in the other, and give a brief exposure to daylight. Thus it is actually as easy to make a print upon paper 7 × 5 inches as it would be to make one by contact in an ordinary printing frame. Nor is the enlarging apparatus itself a heavy or bulky instrument, measuring as it does only 8¼ × 8¼ × 6¼ inches, and weighing less than 3¾ lbs. It is, of course, understood that the enlarging apparatus is kept in the laboratory, the Camera only (weighing 19 ozs.) being required in the field.

The small negatives answer admirably for printing lantern slides by contact, or prints from the same may be used for illustrating a diary or letter.

The 'BINOCULAR' CAMERA, No. 2,

is constructed upon the same principles, but takes 18 plates 3½ × 2¼. It is a perfect instrument for producing negatives for printing lantern slides by contact.

PRICE OF 'BINOCULAR' CAMERAS.

For plates	£5 5 0	
films	5 5 0	
*With ZEISS lens of *extreme rapidity*(f/6·3), enabling instantaneous pictures to be taken *without sunlight*	12 12 0	
* No. 2 'Binocular' Camera, taking pictures 3½ × 2½	10 10 0	
* With ZEISS lens	17 17 0	

* These Cameras are fitted with the improved shutter, with pneumatic time exposure attachment.

THE STEREOSCOPIC COMPANY'S
'BINOCULAR' ENLARGING APPARATUS.

Making the Enlarged Print.

By means of this instrument it is possible to produce ENLARGEMENTS from 'Binocular' Negatives with no more trouble than is involved in making ordinary contact prints. The *modus operandi* being to place the small negative in the holder shown at the top of the sketch, and a sheet of Bromide Paper in the holder at the bottom. The apparatus is then pointed to a clear sky for from fifteen to sixty seconds. The print is then developed and fixed in the usual way. The

ENLARGING APPARATUS FOR THE No. 2 'BINOCULAR' CAMERA.

is constructed upon similar lines, but is made to fold up for convenience of storage and transit.

PRICES.

No. I.—To enlarge from 2½ × 1½ to 7 × 5 ins.	£5 5s.		
No. 2. ,, ,, 3½ × 2½ to 8½ × 6½ ins.	£5 5s.		

A contemporary advertisement for a Jumelle camera, and for the daylight enlarger which was offered with it.

ordinary single cameras, and were presumably labelled 'Jumelles' because of their shape, which was like that of the original Carpentier double camera. Since 'Jumelle' is the feminine form of the French word meaning 'twin', one can understand why Jules Carpentier chose it for his double camera. However, I find it rather odd that the name was subsequently applied to single cameras of similar shape. Carpentier would not have been able to claim any exclusive use for the name, since it is a proper word in the French language, and such a word cannot be copyrighted. If you were to produce a highly successful camera called, say, the 'Camel', you would not be able to claim exclusive use of this name, since it is a proper word, in general use. You could, however, design a picture of a camel, and register this specific picture as your trade mark.

So M. Carpentier, with his little double cameras, gave the name to a whole range of cameras of similar shape, some of which the stereo Jumelles I shall describe in the appropriate chapters.

One point about these early double, direct viewing cameras which will have struck you is that they were generally small, compared to other cameras of the time.

This, however, was not true of the early TLRs when they appeared. In fact it is true to say that the sheer bulk of the first generation of TLRs was the major point of criticism levelled against them. For a given plate size, they were almost twice as bulky as an SLR.

So perhaps it is not surprising that they lost the battle to the SLR. These bulky, first generation TLRs fade out of the picture in the years just before the first world war, and the new generation, led by the first Rolleiflex does not appear until the late nineteen-twenties.

But they are most important cameras, and I believe that the American photographer, Peter

Gowland, marketed a large TLR, in quarter plate size, until quite recently.

In all essentials the big early TLRs were just like the modern ones. They consisted of two cameras, placed one above the other, with a reflex mirror in the upper camera so that the image could be viewed in a screen at the top of the camera. The two lenses were focused simultaneously, and thanks to the reflex mirror, the image was seen right way up, and not inverted as in a 'straight' camera. However, the image was still reversed left to right, as it is in a modern TLR.

Early TLR Cameras

The earliest TLR of which I have found any mention is one produced by the firm of R & J Beck of Cornhill in London in 1880. It was apparently made to order for a Mr Whipple of Kew observatory, and may have been unique. However, I think it is likely that having evolved the design, Beck's may have made a small number of them for interested customers.

In 1885 the London Stereoscopic Company of Regent Street offered the 'Carlton' twin lens reflex to the public. This was made in three sizes for use with quarter plate, 5 in × 4 in, and half plate, and was a magazine camera. Twelve plates were held in readiness at the back of the camera, and after each exposure a control on the front of the instrument caused the used plate to fall down flat into the bottom of the camera, while the next plate behind it was pushed forward to taking position by a spring at the back of the stack of unused plates. Each plate was held in a metal sheath which covered the back, and embraced two opposite edges, so that the emulsion did not get rubbed, and the backs of the exposed plates were protected from light as they lay in the camera bottom.

This form of magazine became very popular, and is usually to be found in the cheap box-form magazine cameras, which are considered in the next chapter.

I have always suspected that this form of magazine laid the user open to the risk of broken plates. Certainly in the larger sizes, the plates can fall to the bottom with quite an alarming crash, especially if the leaf springs, which are supposed to slow the plate's fall as the top edge brushes past them, are distorted. Perhaps this is why the London Stereoscopic Company, in their 'Artist's' camera, which appeared in 1890, decided to dispense with the

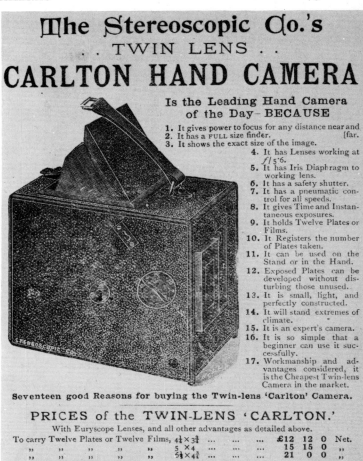

Note the range of claims that were made for the Twin lens Carlton.

magazine, and designed the camera to be used with ordinary double dark slides.

The earliest versions of this camera are not true TLRs, since there is no coupled focusing, and the upper camera is merely a large viewfinder. However, the cameras produced under this same name later in the decade were true TLRs, with viewing and taking lenses identical, and carried on a single front board.

These cameras were produced in four sizes— the three as for the 'Carlton', and whole-plate as well. That's 8½ in × 6½ in. I have never seen one of these monsters, but estimating from the dimensions of the smaller ones, they must have been about 10 in wide, by 16 in high, and 11 in from front to back, with the viewing hood closed.

Before passing on to the work of other makers of the time in this field, the London Stereoscopic Co also, at this time, marketed a camera which they called the 'Binocular', which was a

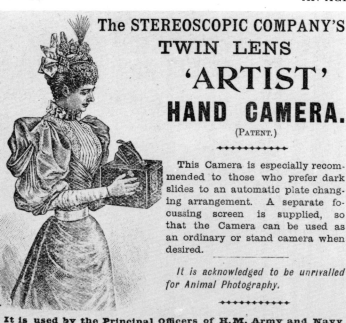

The STEREOSCOPIC COMPANY'S
TWIN LENS
'ARTIST'
HAND CAMERA.
(PATENT.)

✦✦✦✦✦✦✦✦

This Camera is especially recommended to those who prefer dark slides to an automatic plate changing arrangement. A separate focussing screen is supplied, so that the Camera can be used as an ordinary or stand camera when desired.

It is acknowledged to be unrivalled for Animal Photography.

✦✦✦✦✦✦✦✦

It is used by the Principal Officers of H.M. Army and Navy because it

☞ Has a Finder the exact size of the plate you are using.
Has Dark Slides of a novel description suitable for Plates or Films.
☞ Can be focussed even during the transition of the object to be photographed.
☞ Has an Instantaneous Shutter capable of various speeds, also time exposures.
☞ Can be used as a Hand Camera as well as on a stand for ordinary photography.
☞ It is fitted with exceptionally rapid lenses working at *f*/6.

Prices, complete with two Lenses and three Slides.

To take pictures 5 × 4	...	£15 15 0	To take pictures 7½ × 5	...	£26 12 0	
,, ,, 6½ × 4¾	...	25 0 0	,, ,, 8½ × 6½	...	35 0 0	

EXTRA DARK SLIDES CAN BE HAD.

Price for Three 5×4	£1 17 6	Price for Three 7½×5	£2 12 6
,, ,, ½-plates	...	2 5 0	,, ,, ¼-plates	...	3 3 0		

Send 9 Stamps for the Company's 200 page Catalogue.

The earliest so-called TLRs did not have coupled focusing between the viewing and taking lenses. The two models displayed in these advertisements were among the earliest which offered this feature.

direct viewing double camera almost identical with Carpentier's Jumelle. Indeed, it may have been the same camera, since the L.S.C. did import many continental models for the English trade.

Ross of Clapham common were another company in the early TLR field. In 1891 they advertised their 'Divided' camera. This was a true TLR, with a door at the front to protect the lenses. This folded back against the side of the camera in use, and the panel carrying both lenses could then be racked forward to working position. You will find these cameras fitted with either Thornton Pickard roller blind shutters, in front of the taking lens, or, later in their history, with Bausch and Lomb 'Unicum' pneumatic shutters.

These cameras, with various minor modifications, and different lenses and shutters, were

current right through the nineties, and were made in six sizes: 3¼ in × 3¼ in (lantern slide), 3¼ in × 4¼ in, 5 in × 4 in, 6½ in × 4¾ in, 7½ in × 5 in, and 8½ in × 6½ in.

In 1895 Ross produced a new model TLR. This had a body which was roughly two thirds the depth from front to back of the old model. This was achieved by having two doors at the front, which opened from the centre line. When open, they stood straight forward from the front, and grooved fittings on the inner faces of the doors formed guides between which the extension board, carrying the lens panel, could slide.

Most of these Ross Cameras were covered in hide, stitched at the corners, rather than the more usual black morocco.

Adams and Co produced their 'Ideal' TLR at about this time. This possessed one notable advantage over other TLRs available in England at that time. It could be used for upright, as well as landscape pictures, whereas the others were landscape only, if you wanted to use them in the normal manner of TLRs. The 'Ideal' had a second viewing screen in one side

PORTABLE TWIN LENS CAMERA.

◆◆◆◆◆

FIG. I.

I'S specially recommended for both Stand and Hand Work. It is supported on the chest by a strap passing around the neck (see Fig. 1), and has a rising front and auxiliary Double Swing Back for Architectural purposes, and screw for attaching to a tripod stand (see Fig. 2), for either vertical or horizontal pictures. Its simplicity and a general idea of the construction can be gathered from a glance at the illustration.

The design is based on a modification of the Cameras with full size Finders supplied for years past by Ross & Co., their aim being to produce, regardless of cost, a simple Hand Camera free from any mechanical complications, which would combine ALL the advantages and precision of an ordinary Camera upon a stand.

It is constructed throughout in the BEST possible manner, of Spanish mahogany, and covered with stout, SEWN leather. The whole of the Camera, Lenses, Shutter, Backs, and fittings being black, renders it very unobtrusive in appearance.

The instrument is divided by a bellows body into two compartments, each fitted with a ROSS' RAPID SYMMETRICAL or other LENS, of identical focus, covering the plate well with full aperture to ensure crisp definition, and giving from their length of focus perfect perspective.

The lower chamber is the actual Camera, the upper portion acting as a real VIEW METER and full size FINDER. The image, when focussed on the ground glass (conveniently placed on the top of the instrument), is in an upright position, and an exact counterpart of the picture formed by the lower lens on the sensitive film. Both Lenses are simultaneously adjusted by the milled head on the right

ROSS & CO., Opticians, 111 New Bond Street, LONDON, W.
(CORNER OF BROOK STREET).
MANUFACTORY—CLAPHAM COMMON.

of the camera, so that, with the camera on its side (for upright pictures) you still had a viewing screen at the top of the camera. Light from the viewing lens fell on two reflex mirrors, placed at right angles to each other, to produce the two images, and each screen had a cover to blank it off when not in use. Another point of interest is that the shutters in these cameras were built-in, and not just shutters bought ready-made, and added.

Another TLR which had its own shutter was that made by the firm of Newman and Guardia, and this shutter was the very simple and efficient pneumatic shutter which featured on their 'Universal' series of cameras, which are dealt with in the next chapter, and I shall describe this shutter along with these cameras, for which it was originated. Another feature unique to the N & G was a built in focusing magnifier, which allowed critical inspection of the centre of the image, and could be swung clear when the photographer wished to view the image as a whole. These cameras were fitted with rising and cross fronts, and since both lenses were affected together by these shifts, the effect could be accurately assessed on the reflex screen.

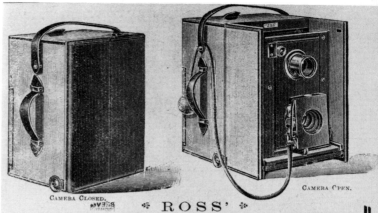

ROSS'
NEW MODEL TWIN-LENS CAMERA
PATENT APPLIED FOR.

THE great popularity of the Twin-Lens Cameras, described on pages 74 and 75, has created a demand for cameras to take plates of larger sizes than those hitherto listed. To meet this want, and for the convenience of many lady photographers and others who prefer to make a medium-size picture, Ross & Co. have devised and patented a NEW FOLDING TWIN-LENS CAMERA of even less weight, and which, when closed, is only two-thirds the size of the original model.

This important improvement has been achieved by discarding the hinged front door and portions of the top and base of the body, and thus decreasing the weight, and utilising the front portions of the two sizes to form folding doors (as shown in the illustration). The lower portion of the inside of these doors have grooved fittings, which form guides for the travelling frame, and thus renders this new form, when ready for use, absolutely rigid. When closed, the doors are fastened by a spring clip.

To set up the apparatus it is only necessary to press this spring and rack out the front, when the doors open automatically and the travelling frame runs into position. The front is then pulled forward and clamped by the curved lever.

This Camera is used in precisely the same manner as the original model, being suspended from the neck by a sling, or mounted upon a stand, as desired.

On the next page will be found the prices of both the original and new models, fitted with either Ross', Zeiss', or Goerz' Lenses.

When ordering, time and trouble will be saved if customers will kindly state clearly which pattern of Camera and series of Lens is required.

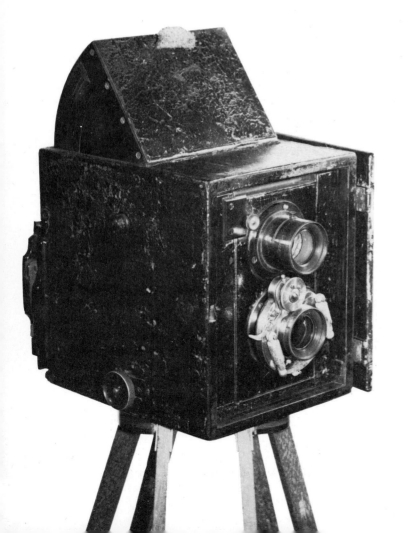

Left, an example of the early model of the Ross hide covered TLR, and above the later 'twin door' model.

Other companies in this period, at about the turn of the century, produced similar TLRs, and most of them announced 'improved models' from year to year, but the basic camera designs did not change very much. In 1905, Ross produced a model with a bellows arrangement over the viewing screen, and a viewing lens, which offered more critical focusing. Their later models, however, had viewing hoods more like those found on SLR cameras. Around 1909 they brought out a model with a revolving back, which was a much simpler solution to the problem of getting the option of either landscape or upright pictures than Adams & Co's earlier double screen model.

But during these years, as you leaf through the catalogues of the day, it is very evident that the number of makers offering TLRs is dwindling, while the variations on the SLR theme are

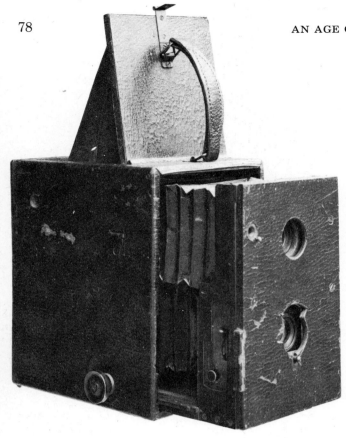

Top, an early model from Adams, and below, a Newman and Guardia version. Both of these are quarter plate size, and measured roughly 8 in × 9 in × 6 in.

becoming more and more numerous. By 1912 Ross is about the only maker left with a TLR on his list.

Probably for no other reason than that they were very bulky, TLR cameras were fading out of the picture. Writers of the day conceded that the TLRs were excellent cameras, but the SLRs could do anything they could do. They were less bulky, and since viewing and taking were both effected by the same lens, they did not suffer from the parallax errors that plagued the TLR at short distances because the viewing and taking lenses were necessarily separated by about three inches for a quarter plate camera, and proportionately more in bigger models.

Some writers, in fact, spoke of the TLR as a sort of photographic dinosaur, rendered extinct by the forward march of evolution . . .

And so it remained, until 1928.

The Birth of the Rollei

The firm of Francke and Heidecke had come into being in 1920. Dr Heidecke, the designer of the partnership had been interested in stereoscopic cameras since 1908, and when the company was formed, their principal interest was in the production of the 'Heidoscope', a stereoscopic camera (of which more later) which used plates, and employed reflex viewing. In 1923 they produced their first stereo camera for use with roll film. This was the 'Rolleidescope', and from this came the 'Rolleiflex' in 1928.

The TLR was a dinosaur no more. Here was the first of a new generation of double cameras which are with us still. Now the tables were turned on the single-lens reflex—now the SLRs were the 'bulky' cameras, and while they were never ousted from the field as completely as the TLR had been some fifteen years earlier, some five years were to pass before an SLR—the Ihagee Exacta—would appear which competed with the Rolleiflex in compactness and sheer convenience of use. In fact, at the end of the Age of Cameras with which this book is concerned, the SLR was still trailing, and the Rolleiflex led the field.

Other makers were quick to follow Franke and Heidecke's lead, but before we look at these

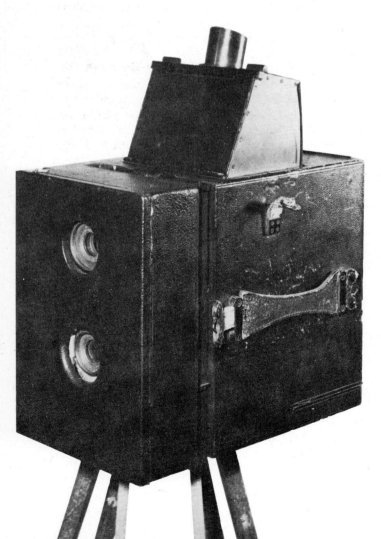

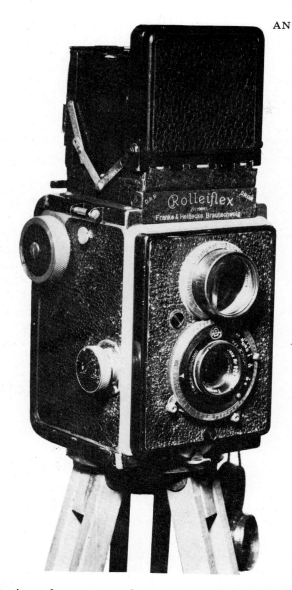

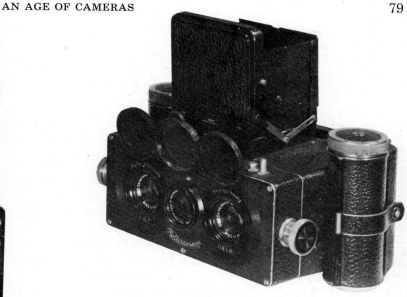

Left, the first model Rolleiflex, and above, the Rolleide-scope. Note the identical components in the focusing hood.

designs, let us trace the progress of the Rolleiflex from 1928 to the end of our period in 1939.

The first model Reoleiflex was a delightful, simple little camera. It employed the then new rim-set Compur shutter, in which was mounted a Zeiss Tessar lens, and the film transport was of the simplest sort, in which the film was advanced by turning a knob, and the numbers on the back of the film were observed through a red window. The film it used was the long obsolete number 117 roll film. This had the same keying as a modern 120 spool, but since it only contained enough film for six $2\frac{1}{4}$ in × $2\frac{1}{4}$ in exposures, the flange diameter was much smaller. So if you acquire one of these now rather rare cameras, you will find that a 120 roll is too big to go in. It will, however, accept a 620 spool, but then you have a problem at the take-up end. A 620 spool has the wrong keying.

Many of these cameras were converted to accept a 620 spool at the take-up end, and this rather lowers their value as collector's items, though one can understand why the original owners had the conversion carried out. If you find an unconverted one in good order, you are lucky. If you want to use it, you will find that it is quite easy to reduce the flange diameter of a modern, plastic 120 spool (even without a lathe) and this will go in the take-up end. A 620 drops nicely into the 'feed' end of the transport, where the spool merely runs against a roller, and is not held by any end fittings. Being simpler, the camera is lighter and more compact than a modern Rollei, and is very pleasant to use. Models were available with two types of Tessar lens, $f/4.5$ and $f/3.8$. These cameras, taking $2\frac{1}{4}$ in × $2\frac{1}{4}$ in pictures, are generally referred to by their metric size, 6 cm × 6 cm.

The second model Rollei, which appeared in 1931, was a baby, and it took twelve 4 cm × 4 cm on VP roll film—127, that is.

Now at that time films did not have multiple numbering. There was no 1–12 numbering on a 127 film, only 1–8. So how to get twelve exposures? In this camera, Franke and Heidecke introduced what was to become a standard Rolleiflex feature. This baby model, with its tiny Compur shutter perched on the front, had automatic crank winding. You started by bringing number one into the red window at the back, and thereafter a measuring wheel made sure that the right amount of film was advanced

each time you cranked. Cranking, by the way, did not cock the shutter, and there was no double exposure prevention. These features came later.

In the baby, you had the option of an $f/3.5$ Tessar, or an $f/2.8$ one, with a 2.8 finder lens on both.

The third model Rolleiflex followed about a year later, and brought crank winding to the $6\,\mathrm{cm} \times 6\,\mathrm{cm}$ model. It used 120 film, for twelve exposures, the measuring wheel device making the presence or absence of 1–12 numbering quite irrelevant. In this model also another Rolleiflex standard feature appeared; shutter speed and aperture could be read off from the top, with the camera in taking position. There was still no linking of shutter cocking to film wind, but the Compur shutter was modified so that one lever effected both cocking and release. Tessar lenses $f/4.5$ and $f/3.8$. The model carried on into 1935, but now an $f/3.5$ Tessar became standard. It was on this third model Rolleiflex that parallax compensation was introduced, though not, I believe, in the earlier models.

Because the viewing and taking lenses are separated by a small distance, they produce very slightly differing images. If the viewing lens is two inches above the taking lens, and their axes are parallel, then obviously the centre of the field of the upper lens is two inches higher than that of the lower lens. This does not matter until you start working at close distances, and then this disparity can lead to irritating errors in framing the picture.

Parallax Correction

Dr Heidecke's method of correcting this error was very simple. There is a mask over the viewing screen, which is coupled to the focusing control. As you focus, the mask moves over the screen, so that what you see is just what the taking lens sees.

1935 saw another development from Franke and Heidecke; the introduction of the Rolleicord. This was a simple, basic roll film TLR, in many ways a return to the model one Rolleiflex. Film transport was by turning a knob, and a measuring roller brought up a succession of numbers, one to twelve, in a window to tell you when to stop. The lens was a Triotar, a simple triplet, and the camera sold for about half the price of a Rolleiflex. These first model 'cords are easily recognized. There is no morocco covering, and the metal is finished in a distinctive chequered design.

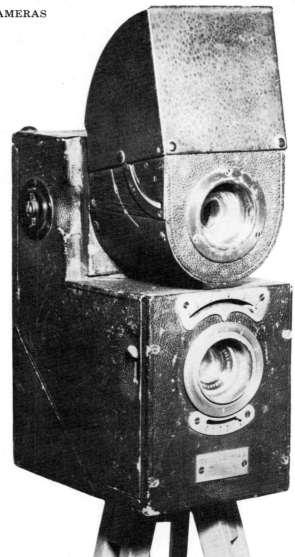

A curious TLR from Newman and Guardia, probably made in the twenties. It can be used as a side by side TLR, with the viewing hood revolved through a right angle. Probably a prototype.

The final step forward of the Rollei designs before the war was the introduction of the automatic models, which had speed and aperture controls worked by milled wheels to either side of the lenses, and in which film transport and shutter cocking were all achieved by operation of the crank. These models came in both sizes—$6\,\mathrm{cm} \times 6\,\mathrm{cm}$, and $4\,\mathrm{cm} \times 4\,\mathrm{cm}$—and were called the 'bayonet models', because of the bayonet rim around the lenses for the mounting of hoods, etc. There were also improved Rolleicord models in 1939.

A number of other makers produced TLRs to use roll film. There was the 'Superb' from

Voigtlander in 1933, a very solidly made job in which the film traversed the camera laterally. This camera is particularly interesting for its parallax correction, which was achieved by tilting the viewing assembly within the camera, so that the lenses for taking and viewing were both aimed at the point of focus at all times. Like many other good cameras, this one was not on the market for very long, while the cheap and cheerful little 'Brilliant' from the same company soldiered on for several years. This was not a true TLR, in that there was no focusing in the viewing lens, and focusing was by 'guesstimate'.

The 'Altiflex', from Schneider in 1938, was another camera that had features of its own. Focusing and shutter release were by substantial levers on the two sides of the camera front. You will find that this makes for very easy and positive focusing, and a shutter release that is big enough, and suitably placed, for operation by the right thumb, is a very convenient thing,

and a positive boon for cold weather photography.

Zeiss Ikon produced the Ikoflex in 1934. The first model of this series had lateral film transport, operated by a lever at the bottom front of the camera. Later models all had vertical film transport by means of the usual winding knob. These cameras were fitted with a condensing lens over the ground glass of the focusing screen, which made for bright viewing, but until the third model, there was no coupling between film wind and shutter cocking, and consequently no double exposure prevention. As was so often the case with cameras of this period before the war, each of the three models that appeared between 1934 and 1939 could be had with different lenses, up to and including an $f/3.5$

Left, the very solid and expensive 'Superb' from Voigtlander, and below, the cheap and cheerful 'Brilliant'.

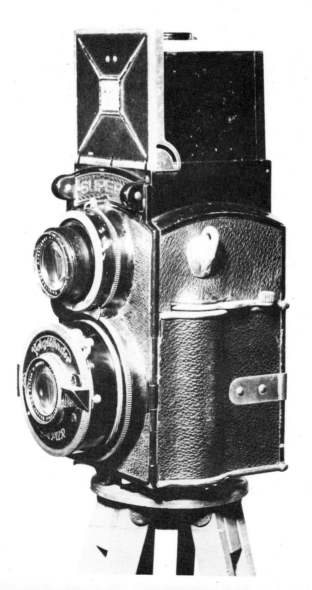

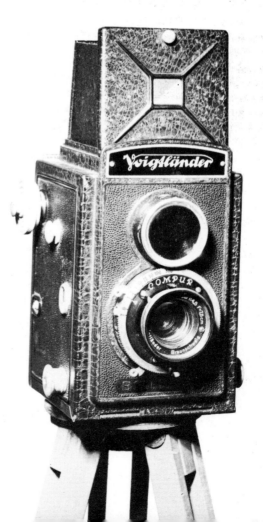

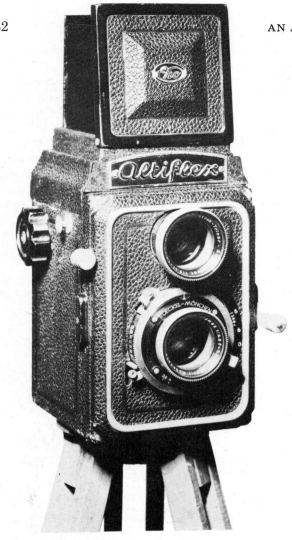

The Schneider 'Altiflex', with its robust and simple levers to operate focusing and exposure, is one of the few cameras that can be used with confidence wearing gloves, or in very cold weather.

Tessar in quality, and different shutters, culminating in the latest model rim set Compur rapid. Prices, in consequence·varied from about £6.50 for the simplest Ikoflex I up to £23.50 for the best model III, which compared favourably with the current Rolleiflex at about £31 using the same lens and shutter, but with rather more sophistication in the area of film transport.

But if the Ikoflex series of TLRs from Zeiss at this time were in what was then the middle to low price range for this sort of camera, that did not mean that Zeiss could not, and would not produce a twin lens reflex of unsurpassable quality, and of a sophistication that has hardly been equalled in this type of camera, even up to the present day.

It was the Contaflex, of 1935. It was, and is, entirely unique among TLRs.

To avoid any possible confusion, let's be clear that this was quite a different design from the cameras which Zeiss have produced since the war under the same name. The more recent cameras which are named 'Contaflex' are all single lens reflexes. This original Contaflex was a twin lens reflex.

The Contaflex

It was a TLR using 35 mm film, and taking the usual 24 mm × 36 mm negative, which was framed horizontally within the camera body. Focusing was unique among TLRs. It was recognized by the makers that the tiny image formed by a standard lens for this format—2 in focal length—was too small for accurate focusing by inspection. So, while the taking lens of this double camera was of two inches focal length, and was only that distance from the film plane at the back, the viewing lens was of a longer focal length, and the longer light path was achieved by keeping the reflex mirror as far back in the camera as it would go, and then making the top of the body slightly taller to get the large sized viewing screen in the right place. So you viewed your image—fully corrected for parallax at all times—on a screen roughly 2 in × 3 in, which was equipped with an improved version of the brilliancy condenser fitted to the Ikoflex. When you add to that the fact that the viewing lens was an anastigmat of $f/2.8$ aperture, you will realise that you had a capability for critical focusing that would be hard to beat.

It is hardly necessary to add that the two lenses, one of longer focal length than the other, were coupled in such a way that their focusing corresponded with complete precision at all distances. Furthermore, the taking lens of this super TLR was in a bayonet mount, so that standard lenses—$f/2.8$ Tessar, $f/2$ Sonnar, or $f/1.5$ Sonnar, could be interchanged at will.

These three standard lenses were offered to make the camera available at a range of prices between sixty-odd pounds, and nearly ninety. But the real purpose of lens interchangeability was to make possible the use of longer lenses—an $f/4$ Triotar or an $f/2$ Sonnar, both at about $3\frac{3}{8}$ in focal length, and an $f/4$ Sonnar at $5\frac{5}{8}$ in focal length. These lenses, in their own high precision spiral mounts, also coupled exactly with the viewing lens, and the viewing screen

was masked down to display their exact fields of view.

To gild the focusing lily a little more, there was a powerful hinged magnifier fitted inside the focusing hood for super critical focusing.

Nor were these features all the camera had to offer. It had a built in exposure meter of very high sensitivity and precision—and great ease of use. You simply operated a lever to bring the pointer to its datum, and you could then read off the full range of possible shutter speeds and apertures.

The shutter was the all-metal focal plane shutter that was also fitted to the Contax range of cameras, which will be described later in this book. It gave speeds from $\frac{1}{2}$ second up to a real 1/1000, and had a delayed action release built in as well. So with the camera on a tripod, you could get yourself into the picture.

In this connection, the Van Albada finder, which was built into the focusing hood as an alternative to reflex viewing, enabled you to see yourself, when you were in front of the camera. The worked surface of the front glass in a VA finder is a semi-reflector, and gave quite a clear and accurate image which could be seen from the front.

If you wished to use your 24 mm × 36 mm format for upright pictures, the VA finder made this possible with the camera on its side, although focusing would still demand the use of the reflex finder.

When you consider all the possibilities this camera offered to the photographer, and the magnificent quality of the workmanship in every detail, the price was not high, although it was a lot of money in those days, nearly forty years ago. Today, the equivalent would be around three hundred pounds, but I doubt very much whether such a camera could be produced at this figure. It might well be as high as four hundred pounds.

The camera was ahead of its time. You have only to read the magazines of the day to realise that the 35 mm format was still regarded with very considerable reservations. Also, the resolution of the optics was greater than the films then available could realise to best advantage. Emulsions were not only a lot slower, but of much coarser grain, and inferior resolution. The professional photographer regarded the $2\frac{3}{4}$ in × $2\frac{1}{4}$ in negative of the Rolleiflex as small, and the Royal Photographic Society had defined a miniature negative as one with an area of five square inches or less.

The day of the true miniature, with its nega-

tive of one and a half square inches, was yet to come.

If the second world war had not erupted in September of 1939, this very fine camera might well have gone on to sire a whole generation of sophisticated miniature format TLRs. As it was, production of the Contaflex was brought to an untimely end, and it was never subsequently revived, as was the contemporary Contax series of rangefinder cameras.

None the less, I think that the Contaflex must be regarded as the high point of TLR design, certainly in the age of cameras which concerns

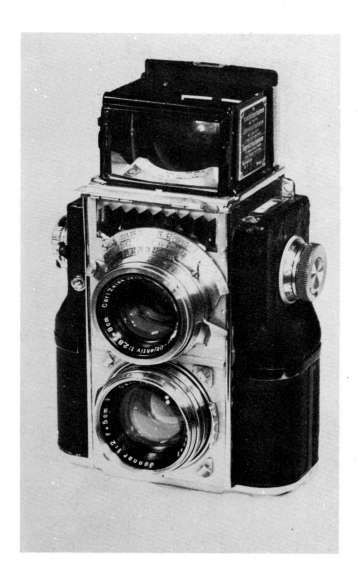

1935 saw the birth of the most advanced TLR ever produced, the 'Contaflex' from Carl Zeiss, not to be confused with the SLR of the same name.

this book, and perhaps of the whole period of TLR history up to the present day.

Two other excellent TLRs of pre-war days were the Foth flex and the Mentorett. In general appearance there was nothing unusual about these two, but both of them used focal plane shutters, which were tensioned by the act of winding on the film. The Planovista, of 1935, was also a focal plane camera, but was of a somewhat unusual configuration, having a horizontal body form, with the coupled reflex finder sitting at the top centre, looking rather like an oversized viewfinder. It was also sold as the Bayerflex.

Another camera from the same makers at about the same time was the Planovista Prima, a simple double camera, with direct viewing of the image of the upper camera on a screen at the back, and no reflex mirror. It folded up very compactly, but in many ways it was a throwback to the Jumelles of forty years earlier.

In the field of TLRs, there were a few cameras which folded flat for compactness. One inexpensive model was the little 'Pilot', of 1932, which used VP film. But I think it is the Weltaflex that must take pride of place among the folding TLRs. This took pictures $2\frac{1}{4}$ in × $3\frac{1}{4}$ in, and had a body containing the film transport which could be revolved in relation to the rest of the camera to give vertical or horizontal pictures.

Another TLR which offered the possibility of upright or horizontal pictures was the French Ontoflex, of 1939. This solved the design problem very simply, if at the expense of compactness, by making a completely separate unit of the film magazine, and simply adding it via a revolving mount on the back of what was otherwise a fairly orthodox looking TLR.

Looking back on the years of TLR evolution from the rebirth of the breed with the first Rolleiflex, up to the outbreak of the second world war, it was in these years that the experimenting took place, and a multitude of different ideas were tried out. Today the TLR almost has the field to itself as far as quality roll film cameras are concerned.

It is interesting to reflect that here was a camera format which had already been condemned as a failure, and consigned to oblivion, until Dr Heidecke revitalized it by rearranging some of the elements of his rollfilm stereo camera, and giving us the first Rolleiflex.

Another view of the twin lens Contaflex, this time fitted with the 80 mm *f*/2 Sonnar lens. As seen here, the camera weighed a trifle under four pounds, and because of this was admirable for hand held shots at low shutter speeds.

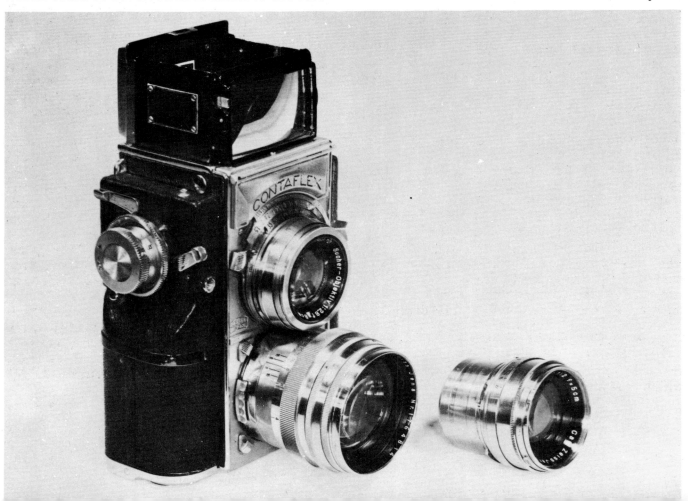

Box Cameras

The very earliest cameras in the story of photography were simple wooden boxes, and many cameras, irrespective of what we call them, may be described as box-shaped.

So it would be as well to define just what sorts of cameras we are calling box cameras in this book. First, they are all cameras of box form. Second, they are all 'straight' cameras, without any form of reflex viewing of the image. Third, they are cameras with shutters which are an integral part of the instrument.

At the beginning of our period, the solid and sliding box cameras of the wet plate era had long been outmoded, and their places taken by bellows cameras. During the eighteen eighties there were a number of small portable cameras of box form made. I think the description which follows of one of them—'Its appearance when carried in the hand is that of an elegant case or cabinet richly covered with black morocco leather.'—underlines the fact that the object of using the box form at this time was often to produce an instrument which did not look like a camera, and which could be used secretly. They were what came to be known as 'Detective cameras'—a much loved description at this time. Other detective cameras were more elaborately disguised, and these will be described later.

As for these early box form cameras, there is very little to say about them. They often consisted of a box, with a hinged lid at the top, which was fitted with some kind of clasp or lock to secure it, and a carrying handle in the top centre. The lens peeped out of a hole in one end of the box, and there was usually a simple viewfinder in that same end of the lid. When you opened the lid, most of the inside was occupied by the camera, which in the better examples could be focused, but which quite often was just a rigid, closed off compartment. The rest of the space inside the box, at the back of the camera section, contained either a small number of double dark slides, or a simple magazine containing a number of plates. Some had simple shutters—'a rotating ebonite shutter, propelled by a steel spring, the tension of which is regulated by a lever operated from the bottom of the case.'—and they made so much of them in their advertisements—'Indeed the whole operative system as regards the placing of the shutter on whole or half-cock, the discharging of the same by touching a button, the regulation of the rapidity of the action, is worked from below the outer case.'—that when one comes upon an advertisement which does not detail the construction and action of the shutter in language worthy of a Tory prime minister of the day, one cannot avoid the suspicion that the camera has no shutter, or at best it is just a manually operated flap.

When one comes across these cameras, the thing that often strikes one first is their utter simplicity. Often, too, they are very cheaply made, with nothing of the 'workmanship' that is so evident in the normal wooden cameras of the day.

Which is one very good reason why such

cameras have become rarities. Many of them were just made as novelties (a word which was much used at the time), and nobody expected them to last.

In seeking early box cameras which were just cameras, and did not pretend to be boxes of cigars, or parcels, and which were intended to be used quite openly, the number one Kodak is virtually the first which can be taken seriously as a practical instrument for taking photographs, and the other early box cameras from the same company were pioneers in this field.

The Coming of N & G

But not long after the birth of the Kodak in America, in 1892 to be exact, the company of Newman and Guardia was formed in London, with premises at number 71 Farringdon Road, not far from such London landmarks as Smithfield meat market, and Saint Bartholomew's Hospital.

Arthur Newman, whom I have mentioned before, was the technician of the partnership, although Mr Guardia seems to have been behind the concept of many of this company's early hand cameras. Guardia, a naturalised Spaniard, seems to have propounded the ideas to which Arthur Newman, with his great inventiveness and ingenuity, gave practical form.

The result of this partnership was a series of very fine, practical cameras, of box form, which were called the N & G 'Universal' cameras. There were, as you will already have gathered, other designs from this partnership, but none more interesting, or more important than the 'Universals'.

These cameras were, without doubt, the most sophisticated box cameras ever produced.

It was for the 'Universals' that Arthur Newman designed his outstanding pneumatic shutter, which was the basis of all his later shutters in a long series of cameras which was to continue evolving for more than thirty years.

This shutter had a single sector-shaped blade of thin steel, with a shaped hole in it. When this moved across, between the elements of the lens, the exposure was effected by the hole in the sector.

The duration of the exposure was controlled simply by the speed at which the single spring-loaded blade of the shutter moved—not, as in a modern between-lens shutter, by the period of time during which the opening persists.

In Arthur Newman's shutter the blade moved

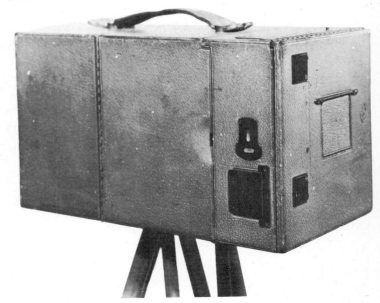

The most sophisticated of all the early box form cameras—the N & G universal. This is the 5 × 4 version of the special 'B' model. This particular example is covered in tan pigskin.

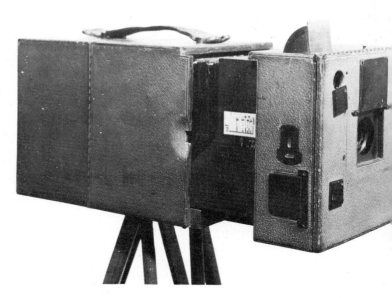

rapidly for a short exposure, and slowly for a long exposure. This variation of speed was brought about by a small piston, connected to the blade, which moved in a cylinder of air. The movement of the piston displaced air in the cylinder, from one side of the piston to the other. There was a screw plug in the transfer passage, through which the air passed, and when this was closed as far as it would go, the minimal leak of air past this plug allowed the piston to move in the cylinder, impelled by its

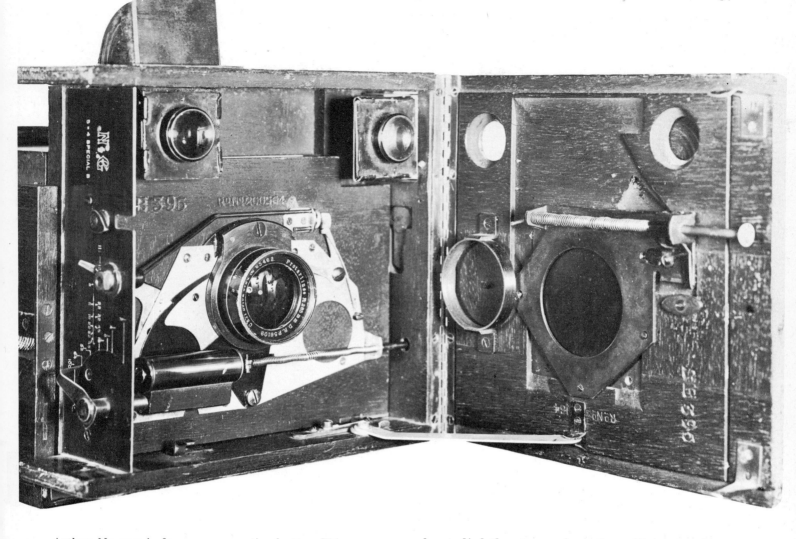

Arthur Newman's famous pneumatic shutter. This was undoubtedly the most accurate and reliable of the early between-the-lens shutters.

spring, at the slowest rate, which gave an exposure of half a second. When the plug was opened as far as it would go, the piston was hardly impeded at all by the air in the cylinder, and the exposure that resulted was 1/100 of a second.

I attach considerable importance to this shutter of Arthur Newman's, because it was the first between lens shutter, built as an integral part of a camera, which was not only reliable, but precisely adjustable for varying exposures.

Provided they have not suffered damage, these shutters work beautifully smoothly to this day. My oldest specimen was made in the first year of production, 1892, and works perfectly. The moving parts of the shutter are robust, lightly stressed, and small in number. I see no reason why these shutters should not soldier on for a very much longer time than they have done already.

With Scott to the Antarctic

An important point, which must have been in the mind of Herbert Ponting, when he chose to take one of these cameras with him on Captain Scott's expedition to the South Pole in 1912, is that these shutters work quite without the need for any lubricant, and are therefore never liable to freezing up.

Herbert Ponting's South Pole N & G 'Universal' camera can be seen in the Science Museum, South Kensington.

In these days when even the most conservative of companies produce totally new designs every few years, it is interesting to observe that in choosing a camera to take to the South Pole,

Herbert Ponting was able to decide upon a design which had already been on the market for twenty years . . .

There were various models of the 'Universal'.

Model 'A' had only limited extension, the front had shift in one direction only, and it was supplied with either a Wray lens, or a Zeiss f/6.3 Tessar. It was made in quarter plate size only.

Model 'B' was made in two sizes, quarter plate, and 5 in × 4 in, or 9 cm × 12 cm, and was fitted with the same lenses as the 'A'. However, it had much greater extension, and the front had two movements, vertically and horizontally.

Special pattern 'B' was the most famous of the 'Universals'. It was designed to make best use of the new Zeiss series VIIa Protars. These were the most famous of the convertible lenses; a VIIa consisted of two components, one in front of the diaphragm, and one behind it. Each of these components was a fully corrected anastigmat on its own. Each component was, in fact, a series VII Protar. So, these cameras had three lenses; two series VII Protars of f/12.5, and the series VIIa which was formed of the two in combination, of about f/7. If the two series VII lenses were identical, then you had what was termed a 'two focus Special B', in which either of the single Protars could be used for the longer focal length, and when used together as a double Protar gave a resultant focal length of rather less than half the single figure.

If, however, the two series VII Protars were of different focal length, then your special B was a 'three focus Special B'.

N & G offered the Special 'B' in these two forms, with the relevant focusing scales, and also with suitably engraved aperture scales, so that the diaphragm could be used accurately under any circumstances.

Either of the two forms was available in three sizes, quarter plate, 5 in × 4 in, and half plate, from stock. So there are a total of six Special 'B' cameras which can be regarded as standard—they are the ones you will find listed in any N & G catalogue of the nineties.

Pattern 'C', made in quarter plate and 5 in × 4 in, was slightly more bulky than other models producing the same sized negatives. This was because of the special feature of the 'C' cameras. The changing box for the plates at the back of the camera was carried in an inner frame, which could be swung about the short axis of the plate, for control of perspective.

After the model 'C', there was no 'D', as you might have expected. The next model listed is

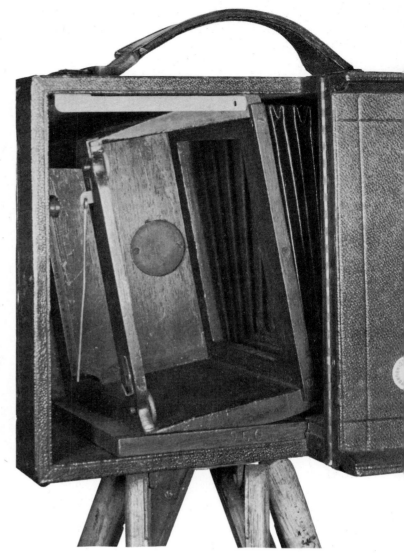

The inner frame of the N & G model 'C' universal, which allowed the focal plane to be tilted.

the 'half plate'. This may be considered as an oversized pattern 'B'. But here there was an option open to you. You could either have the normal model, which was focused for infinity when racked right in, or a compact model, which when fully retracted brought the lens back to a position well beyond its shortest working position.

Putting it another way, the camera had to be racked out before it could be used.

Now you might think that a 'half plate' camera would only come in one size. But you would be wrong.

If I may quote from the catalogue of 1896 'This pattern is made in two sizes—Half plate ($6\frac{1}{2}$ in × $4\frac{3}{4}$ in) and Double quarter ($6\frac{1}{2}$ in × $4\frac{1}{4}$ in). The latter size is specially recommended, because, while giving practically the same size picture, it is a much more pictorial shape, and the instrument itself is considerably lighter and less bulky. Double quarter ($6\frac{1}{2}$ in × $4\frac{1}{4}$ in) being also the best size for Stereoscopic work, this Camera can be used for Double quarter, Quarter plate, or Stereoscopic work by having an "N & G" Stereoscopic front fitted at any time.'

So one may say that there was a third version to the half plate pattern for stereo work, presumably only in the compact version, to accommodate the shorter lenses stereo work would demand.

The next of the 'Universals' was the TLR that was mentioned in the last chapter. Though it was a markedly different overall shape from the other cameras in this series, many assemblies were identical, and even where the woodwork, for example, was formed into components peculiar to this design alone, the constructional methods were unmistakably the same.

The models described so far all seem to have been available from 1894 onwards, with just the 'A' and 'B' models in the two earlier years of the company's history. There was to be one other model, however, which does not appear in the lists until 1899.

A Two Shutter Box Camera

It was called the H.S. (High-Speed) Pattern.

It was fitted with a Zeiss Planar 'working at $f/3.8$'. This was one of the original series of Planar lenses, and was truly symmetrical. A very nice lens, provided there was no possibility of flare. If there was, this lens made the most of it. The Planar seems to be a design which needs coating. Certainly the modern versions of this lens, with their coated surfaces, give no cause for complaint.

But to return to the H.S. It's other high speed feature was the shutter. In addition to a slightly improved pneumatic shutter (still going no higher than 1/100) a focal plane shutter was fitted, which, with variable tension, was alleged to be 'adjustable for exposures of up to 1/1000 sec' which if you think about it, rather left it up to you. The focal plane unit was a 'ready made' one, and to my mind was rather out of keeping with the nicely calibrated and precise pneumatic shutter at the other end.

Of course, when either shutter was in use, the other was locked open.

The cameras detailed above were the standard range, available from stock. But like several other good makers of this period, they catered for 'customers' own requirements', and it is not unusual to find N & G cameras which are basically 'Universals', but have non-standard features.

My 5 in × 4 in Special 'B' for example is covered in tan pigskin, instead of the more usual black morocco, and the metal panel carrying the shutter is made to be taken out, instead of being a permanent part of the wooden rising front.

I also have one small part of a very non-standard 'Universal'. It is a focusing screen, unmistakably belonging to this series of cameras. But the size is only $3\frac{1}{4}$ in × $2\frac{1}{4}$ in.

A tiny 'Universal'. I would dearly like to find the rest of the camera.

A feature of all these cameras was the changing box.

It was contained in a compartment at the back of the camera—a box to contain the changing box.

The N & G changing box, shown with the shutter slide partly withdrawn. Note the doeskin bag for plate manipulation.

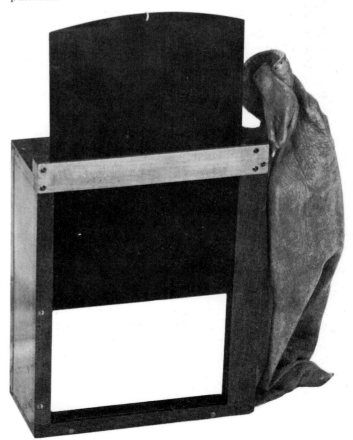

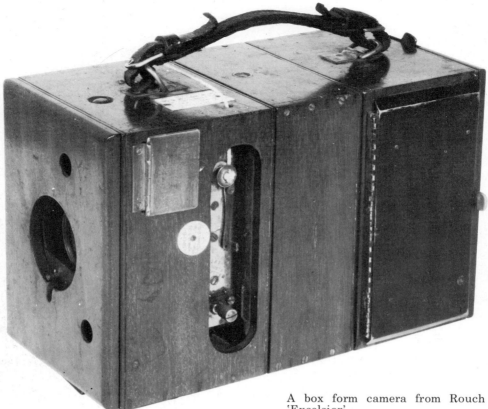

A box form camera from Rouch of the Strand—the 'Excelsior'.

These changing boxes were nicely made of mahogany, with a sliding shutter that could be pulled out on one of the largest sides. The top of the box was a doeskin bag. The plates were held in metal carriers, which covered the backs of the plates, and embraced the two longer edges. The backs of the carriers were raised into two rounded ridges along the shorter edges. After exposure, the slider at the back of the box was pulled upwards, and the rearmost plate was raised into the doeskin bag. It could then be grasped through the bag, and slid down in front of the plate which had just been exposed. These boxes were made in two versions— one for twelve plates; the other for twice the number of cut films.

The final version of this series of box cameras was the De Luxe, of 1905. It was more compact, and had double extension, rather than the very long single extension of the earlier models. It had a revolving back, available in two forms— one, open for use with double dark slides; two, closed for use with changing boxes. The shutter was a redesigned and improved version of the earlier pneumatic shutter, with a speed range of one second to one two-hundredth. Double Protar lenses were fitted, and it was made in one size only, viz, quarter plate.

Similar box cameras, of considerable quality came from Adams and Fallowfield about 1900. They were both well made, and were sold with excellent lenses, but their appearance in their makers' catalogues was brief, and one must conclude that here was a corner of the camera market which N & G had made very much their own.

Falling Plate Cameras

The last decade of the nineteenth century was the decade of the falling plate camera, a form of box camera which was produced in a host of slightly varying forms by a great many makers. They were mostly quite cheaply made, and a great many of them carry no maker's name.

The falling plate magazine was extremely simple, and mention has already been made of it in connection with early TLRs. The basic idea is always the same; at the back of the camera is a number of plates, in metal sheaths, pressed forward by a spring. The top of the plate is held by some form of catch, which when moved allows the front plate only to fall into the bottom of the camera, while the plate behind

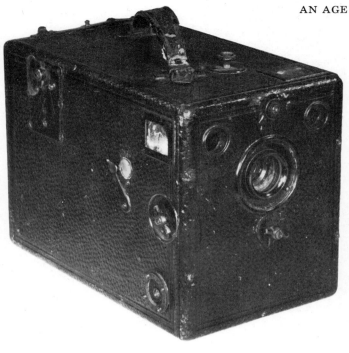

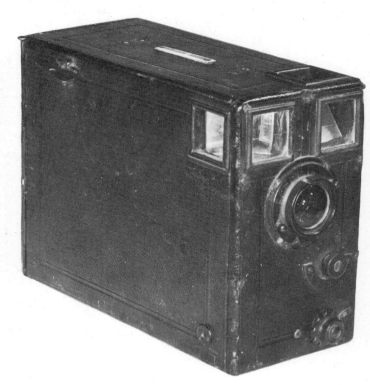

Two typical falling plate magazine cameras. While the roll film patents were held by the Kodak company, this type of camera provided an alternative means of taking a number of shots fairly rapidly.

it moves forward into position for exposure. This falling action is dependent on the design of the sheaths which hold the plates, and there are many variations. The two lower corners are often provided with some form of lugs, which run in guides, and provide the fulcrum on which the plates swing forward and down. The top edges either have cutaways, or tabs, to engage the latch mechanism. The sheaths go in pairs, with these tabs or cutaways in alternating positions, so that when the latch frees one plate, it holds the next.

Often there is no focusing on these cameras. Some can be found which are provided with a series of two or three supplementary lenses, to focus the camera for different distances. Sometimes these are just separate items, to be screwed or pushed on; sometimes they are mounted into a small revolving disc, rather like wheel stops.

The shutters on these cameras are always part of the camera. They are always simple—disc shutters, sector shutters, guillotine shutters, and where any variation of exposure is possible, it is effected almost always by a variation of spring tension.

The only exception I have come across is a rather better-than-usual French camera, where

the shutter incorporates a small disc brake, and speeds are controlled by variation of pressure on a leather washer. Shutter speeds on this device also change with the weather, and the 'calibration' is markedly different on a damp day to a dry one. The makers evidently recognized this, because the speed settings are 'Lente', 'Moyenne', 'Rapide', and 'Extra Rap'.

These rather cheap and cheerful falling plate magazine cameras must have been the means of bringing photography to a great many not-so-well-off people in the nineties. In 1895, you could buy such a camera for about three pounds; by 1901, there were several makes on the market for about a pound.

A better made box form camera that appeared about 1895 was the Frena, from Beck. This was made in several sizes, up to 5 in × 4 in, and featured a special magazine, which was loaded with up to forty pieces of cut film 'like a pack of cards'. Some of these were supplied as 'presentation models' covered in tan leather, and are rather handsome.

Onwards from the eighteen eighties, flexible film had been available, and we have seen how George Eastman made this commodity, which he had pioneered, the basis of his first cameras. Film on a celluloid base had certain obvious

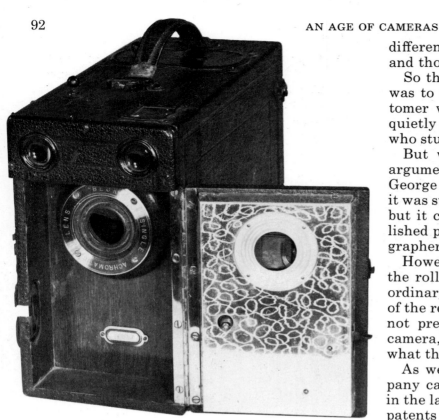

Some falling plate cameras were embellished with fancy
'trimmings' that added nothing to their capabilities.

advantages over glass plates from the point of
view of weight, and in the flat form provided a
good enough substitute for them. However,
there can be no question but that cut film, in
these early days, was not so flat as glass plates.

In the rolled form, film was even further from
the absolute flatness of the glass plate, but
offered great advantages in terms of con-
venience and lightness. None the less, the vast
majority of photographers, and it seems, camera
makers, set their faces against the newer
material. It could never replace the glass plate,
they said. No serious photographer could pos-
sibly contemplate using it, etc. etc.

Flat films, cut to plate sizes, could be and
were used in plate cameras. Backed with a piece
of stout card, they could be loaded into the
ordinary double dark slides, and who was to
know? A few firms, like Newman and Guardia,
making cameras of very high quality, did offer
changing boxes made especially for cut film,
and left the choice up to the customer. Looked
at realistically, there was no real practical

difference between the results with cut films,
and those with plates.

So the obvious course for a shrewd supplier
was to applaud the pioneering spirit of a cus-
tomer who chose to work with cut film, and
quietly approve the conservative wisdom of one
who stuck to glass plates.

But where rolled film was concerned, the
arguments against it were much stronger.
George Eastman's roller slide, or roll holder, as
it was styled in America, had had some success,
but it certainly had not threatened the estab-
lished position of the glass plate among photo-
graphers.

However, for convenience and portability,
the roll or rolled film made a great appeal to
ordinary people who were not overly critical
of the results they got. These same people were
not prepared to spend a lot of money on a
camera, so that a simple box camera was just
what they wanted.

As we have seen, the Eastman Kodak com-
pany catered very successfully to this market
in the late eighties and nineties. Because of the
patents he controlled in respect of roll film,
and the mechanisms for transporting it in the
camera, roll film box cameras remained almost
an exclusively Kodak product for some time.

Roll film Box Cameras

In 1893 came H. J. Redding's 'Luzo' camera in
this field. It consisted of a mahogany box con-
taining what appeared to be a version of East-
man's roller slide, and carrying a rapid recti-
linear lens in the middle of the side facing the
film plane. This same side carried a simple
sector shutter, mounted upon the outside, and
a simple viewfinder was provided. It was made
in six models; $2\frac{1}{2}$ in square, loaded for 100 ex-
posures, $3\frac{1}{4}$ in square, for 60 exposures, and two
quarter-plate models for 48 exposures, the bet-
ter one fitted with a wheel stop. These four
models were all fixed focus. The two larger
models, 5 in × 4 in, for 48 exposures, and the
half plate, which could provide up to 80 ex-
posures, had focusing adjustment, set by means
of a calibrated dial.

Apart from the Kodak box cameras using roll
film, Mr Redding's 'Luzo' was, as far as I can
see, the only one on the English market at this
time, and it seems to fade away around about
1900.

Around about 1903, presumably because some
at any rate of Eastman's patents connected with

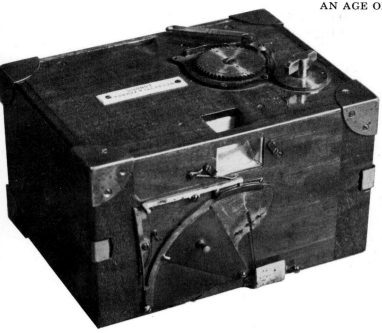

The 'Luzo' was a box form camera, using roll film which appeared at the time when most other makers were confining their popular designs to falling plate magazine cameras.

rolled films and roller slides, the roll film camera began to be an item on the lists of other makers, and quite a number of inexpensive cameras, using roll film were available.

Houghtons, who that year added a roll film model to their range of 'Sanderson' hand and stand cameras, also brought out a box roll film camera, the 'Scout', in two sizes, $2\frac{1}{4}$ in square and $2\frac{1}{4}$ in \times $3\frac{1}{4}$ in. The first model was not only smaller; it lacked certain refinements, such as stops, that were to be found on the larger model. Prices, complete, were 25 and 50 pence, or five and ten shillings in the money of the time.

In 1909, Sinclair brought out the 'Traveller' box form roll film camera, which was a much more expensive instrument than the 'Scout'. In 1910, Houghtons called their box cameras 'Ensigns', and had five sizes available.

Meanwhile, as we shall see in a later chapter, folding roll film cameras were proliferating on all sides.

Kodak and Houghtons were the box roll film pioneers, in that order of importance.

I find it curious that there were so few makers in this field, when the success of the various Kodak models must have made it obvious that there was a big market for this very inexpensive and simple format. If anything, in the years

before the first world war, the success of the Kodak boxes, if it had any effect on the majority of other makers of inexpensive cameras, seems to have been to inspire the production of more and more magazine cameras of the falling plate variety.

Indeed, box form roll film cameras were thin on the ground right on until the 1920s, when some of the continental makers, such as Ernemann and Goerz produced some very simple and effective cameras of this class.

One cannot avoid the impression that many of the English makers chose to ignore the fact that there was a big market for cheap, simple cameras for people who did not want to be photographers, but did want to take 'snaps'.

Looking back for a moment to the 1880s, George Eastman had wanted to build a Kodak factory in England because of the leadership England held in the world of cameras at that time, a leadership that was fading even before the first world war. Looking at the products of English companies between the two great wars, it becomes painfully obvious that, with very few exceptions, these companies were content to soldier on with designs that were twenty and thirty years out of date. Some companies, which had been active in their own particular areas, and whose work before the first world war can only be described as pioneering, seemed to have

Two typical cheap box cameras of the nineteen-twenties.

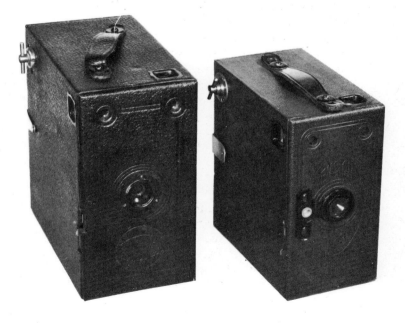

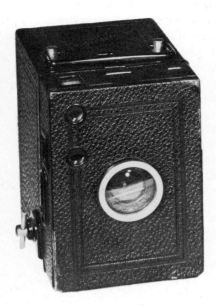 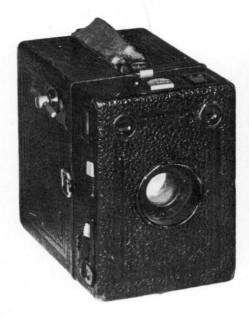 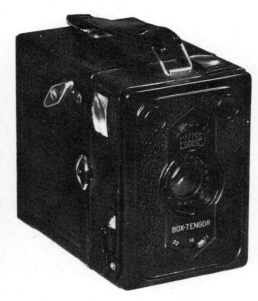

The three basic types of the box Tengor. Each type was available in two or three film sizes.

grown old by the time the war was ended, and to have had neither the ambition nor the energy to produce anything new. In Germany, which had not only been defeated, but had suffered revolution as well, companies such as Zeiss, Leitz, Ihagee, Voigtlander Ernemann and Goerz were faced with the challenge of starting all over again, or going to the wall, and they met this challenge with progressive thinking in every area of camera design.

Continental Box Cameras

In the field of box roll film cameras, perhaps the company of Goerz were most successful. They produced the Tengor series of box cameras.

After the war, it was not until about 1923 that these German companies became active in England once more. The first model box Tengor that I have been able to discover which was sold in this country was the model II. It was offered in two sizes, $3\frac{1}{4}$ in $\times 2\frac{1}{4}$ in, and $4\frac{1}{4}$ in $\times 2\frac{1}{2}$ in. They were, as the company pointed out, box cameras of a rather higher standard, which were still inexpensive cameras. They had an all metal body, which meant that they were noticeably more compact than older cameras of the same negative size built of wood. The single meniscus lens, with which they were fitted, was a corrected doublet. They had a sprung pressure pad to keep the film flat. They had no focusing adjustment, but a supplementary lens for portrait work was provided. They sold at £1.50

and £1.87$\frac{1}{2}$ for the smaller and larger sizes, including the portrait lens.

I suspect that these cameras were the origin of what Brian Coe, the curator of the Kodak museum, refers to as one of photography's 'folk legends'—the cheap camera with the 'wonderful lens'. According to the 'legend', there were cheap cameras, some of which had 'wonderful lenses', which seemed to occur by grace of some sort of optical parthenogenesis. The fact of the matter was that all of these lenses on the Goerz box cameras were of better quality than usual for a cheap camera, and if you happened to get one in which the slight manufacturing variations in the actual focal length of the lens suited the random variations that occurred in assembly, then you had a cheap camera that would give you amazingly good results.

It was not that some had 'better' lenses than others. It was just that some, when assembled were set 'just right', and some weren't. At the price these cameras were produced, there could be no checking of individual cameras.

The next model of the box Tengors turns up in 1927, the year after Goerz, Ernemann, ICA and Contessa Nettel had amalgamated with Zeiss Ikon. So the third model Tengor, made in

rearranged, and the size of the finders was increased. The earlier 3 in × 2 in model was dropped, and in its place came a 'large baby', taking 16 pictures on 120 film.

Finally, just before the outbreak of Hitler's war, the $4\frac{1}{4}$ in × $2\frac{1}{2}$ in size was dropped, and an alternative model of the $3\frac{1}{4}$ in × $2\frac{1}{4}$ in was offered, with double exposure prevention, together with a super-baby. This was fitted with a Novar lens, in place of the usual achromatic doublet, and continuous focusing was possible by means of an adjustable front cell.

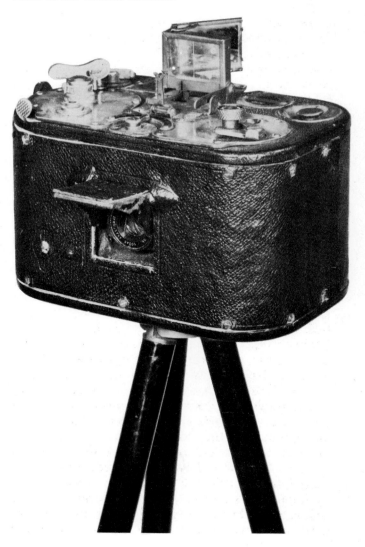

The number '0' Graphic. This rather complex box camera used roll film, and had a focal plane shutter similar to those in the Graflex cameras.

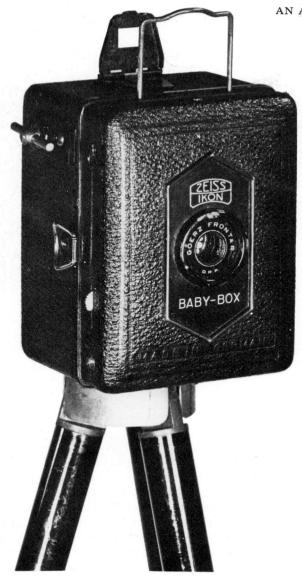

The 'Baby box' Tengor. This picture shows the actual size of the camera.

3 in × 2 in, $3\frac{1}{4}$ in × $2\frac{1}{4}$ in and $4\frac{1}{4}$ in × $2\frac{1}{2}$ in negative sizes bears the Zeiss Ikon name. It was substantially the same, except that it had two supplementary lenses, which were built into the camera, and made it an 'all-distance' camera. The two supplementaries were carried on a strip of metal, and were brought into play by pulling it upward from the top of the camera.

1930 saw the introduction of the baby box Tengor, which took 16 pictures on a VP roll, and in 1933 came a new model of the ordinary box Tengor. This was substantially the same as the previous model, although the controls were

Detective Cameras

If you look through the advertisements of camera makers during the years from about 1885 up to 1914, you cannot but notice the constant recurrence of the term 'Detective Camera'.

I rather suspect that 'Detective' was an 'in' word of this period. It was the era to which belonged the first of the famous detectives of fiction, Sherlock Holmes, Dr John Thorndyke, Arsene Lupin, and my own boyhood favourite (in his later years!), Sexton Blake. In real life, in America, the operatives of the Pinkerton agency were in full cry. The detective was the popular hero, who vied with engine drivers in the ambitions of small boys.

The word was selling books, and it may well be that camera marketing men of the day thought that it would sell cameras. However, there is no evidence whatsoever that any of the cameras that were sold under this tag were ever used by officers of the law in the detection of criminals. Photography was being used for the recording of crimes and criminals, but the cameras used were of the sort we should describe as 'field cameras'.

Other types of cameras are definable in constructional or optical terms; not so Detective Cameras. About the only definition I can offer is to say that they were cameras whose makers claimed that they could be used without their being noticed.

The term was very widely and loosely applied, but one can say that there were four main types of camera involved.

1. Box form cameras, which either looked like cases, or could be wrapped as a parcel for secret use.
2. Cameras which were small enough to pass unnoticed.
3. Cameras which were designed to be concealed in some part of the photographer's clothing.
4. Cameras which were deliberately designed to look like something else.

Some of the cameras in the first two categories were good cameras, capable of serious work. Cameras belonging to categories 3 & 4 were, almost without exception mere novelties, which might take a picture given ideal conditions.

A certain A. R. Dresser, Esq, had this to say about his detective camera in 1885;

'This summer I have been working a very great deal with an American detective camera, and I have had so much pleasure from it that I should feel quite lost without one now. For a trip where you are going to be away for a few days and have no chance of changing plates, how handy to be able to have a camera that you can carry in your hand, and are able to use without having to focus or use a cloth. The one I use now has a roller slide which holds forty-eight exposures, and, besides, I have a bag to go over my shoulder to carry six double backs (quarter plate), and so am ready for two or three days work.

'I found my American detective very good and by far the best I had been able to procure, but found many small faults, and so I set to work to

Two forms of triple extension. Above, two in series from the front, below, one extension from the front and one from the rear.

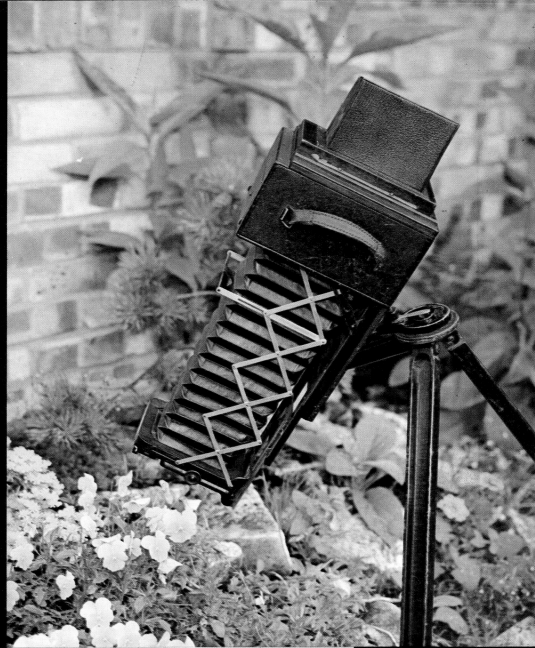

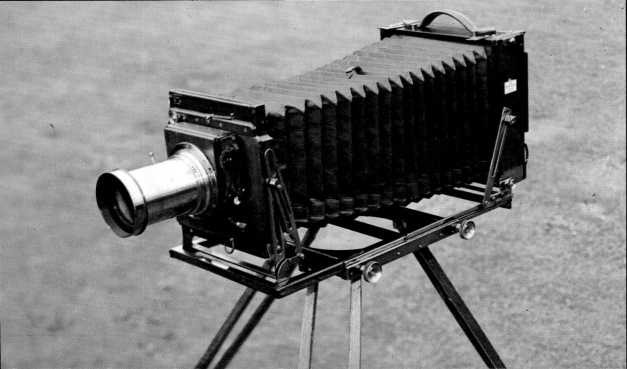

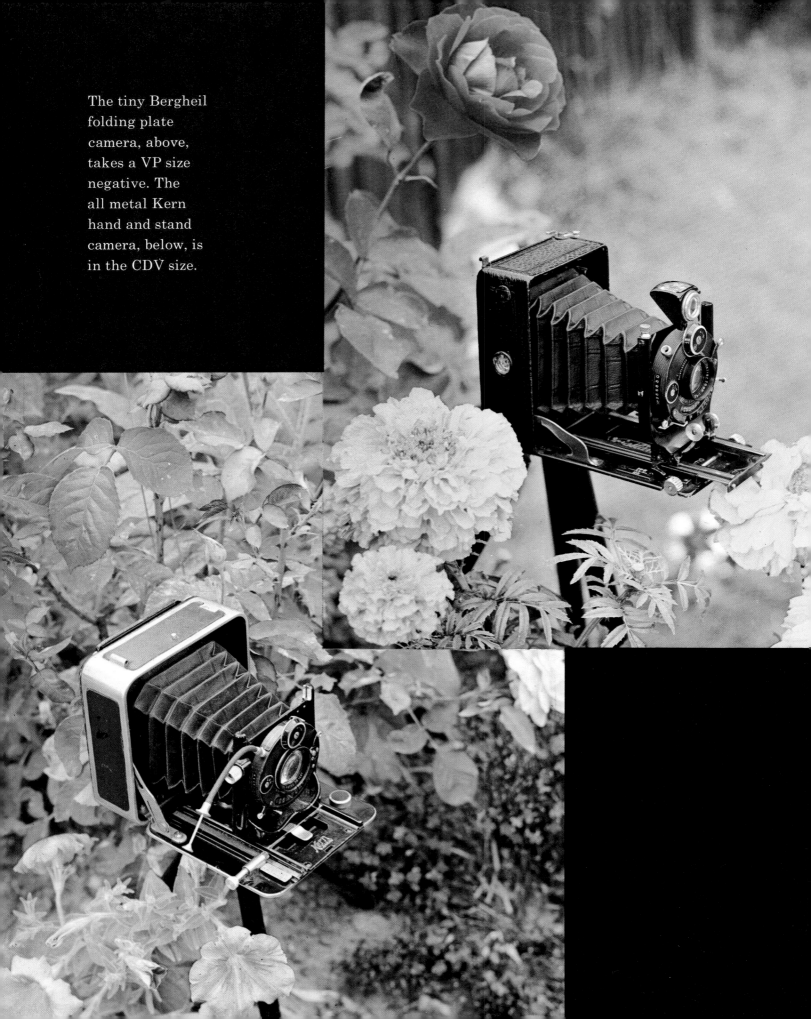

The tiny Bergheil folding plate camera, above, takes a VP size negative. The all metal Kern hand and stand camera, below, is in the CDV size.

try and alter them, and now (thanks to Mr Thistleton, 1 Old Quebec street, Oxford street, who carried out my ideas) have a detective camera as perfect as I am able to make, and find it works as well as could be wished, having the advantages of having every object from twelve feet in front of the lens to far distance in focus at $f/12$, covers clean to the edge of the plate, has a wide angle lens, a shutter that gives from 1/100 of a second to any time, said shutter and stops are worked without having to open the case, with a plan of being able to alter focus if required from outside as well; and all this in a small space and very light.

'I think in the future there will be a great demand for quarter plate detective cameras, if the dealers in such goods do not spoil the sale by asking, as they have done so far, such high prices.'

Although Mr Dresser does not describe his camera, it is clearly one of the box form cameras discussed in the last chapter. Mr Dresser, obviously was an experienced photographer, and was able to overcome the shortcomings of his detective camera. In this connection it is not uncommon to find old cameras, most often 'fixed focus' jobs, that could never have provided a decent picture, and were in need of just the sort of attention that Mr Dresser describes. I have come across such cameras, in very good condition, which certainly had never been tampered with by their original owners, which had probably proved disappointing, and subsequently been put away and forgotten.

There is little to be said about the first category of detective cameras that has not been said in the previous chapter, except to add that in these early days, when the ordinary person tended to think of a camera as an imposing construction of polished mahogany, mounted upon a tripod, a camera which was a simple dark-coloured box probably would pass unnoticed.

The second category—the tiny cameras—is an interesting one. Primarily, these were miniature cameras, and it may be that the 'detective' tag was an afterthought. The idea of a 'detective' camera was an appealing one, so if a camera was small enough to be used secretly, why not call it a detective camera?

Marion and Co of Soho Square, in the 1880s, were making their 'Academy' series of cameras, and also their 'metal miniatures'. In some of their advertisements of the period—I have one before me now—they put these cameras, along with their 'Detective $\frac{1}{4}$ plate' and 'Brooke's

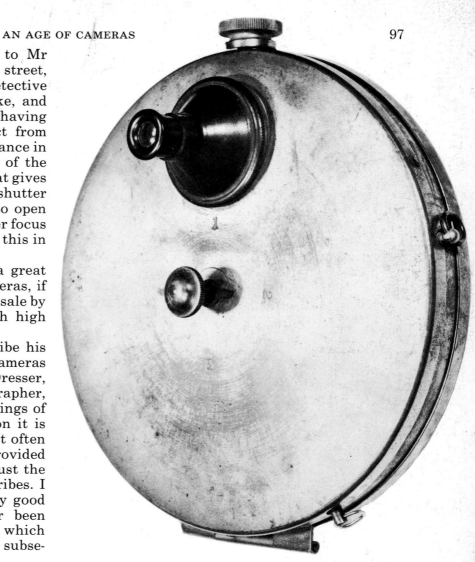

The Stirn 'buttonhole' camera of 1888.

Patent Lantern Camera for plates $3\frac{1}{4}$in', under the heading of 'Detective or Hand Cameras'.

The use of the word 'or' in this connection by a firm of the calibre of Marions is interesting. They were not a catchpenny concern, and possibly they were prepared to apply the term 'detective' to any small camera which could be used in the hand, possibly without the use of a focusing cloth.

The 'Academy' cameras, described in the chapter on double cameras, might have been used with preset focusing for secret pictures, but one can hardly think that it would pass unnoticed if it was held before the eyes for inspection of the image, and focusing, especially in the large size (quarter plate).

However, the metal miniatures, which were simple 'single' cameras, without magazines, and with a dark oxidized metal finish, were quite unobtrusive. Especially the smallest size, which was about the size of two ordinary boxes of matches stacked together, could be hidden in the cupped hands—provided that those hands did not interfere with the working of the gravity shutter.

In the third category of secret cameras, possibly the best known, and certainly the most workmanlife is the Stirn camera of 1888. It was the invention of Robert D. Gray, of New York, who sold the patent to Stirn. Stirn's brother, in Berlin handled the European selling of the camera, which proved very popular and successful. It took six exposures, each about two inches in diameter, on special circular glass plates. The fact that you were obliged to use the company's own plates (or very nearly so) must have helped the commercial viability of the camera. Externally, the example illustrated here is quite standard, but internally it is different from any other I have seen.

These cameras were designed to be worn on the chest, hung from a strap around the neck. The tiny rapid rectilinear lens then projected through a button-hole in your jacket or waistcoat. Exposure was made by pulling on the ring beside the hinge at the bottom of the camera, when the disc shutter, which had six apertures in it, flicked round a sixth of a revolution. When you turned the central knob to move the plate round one sixth of a turn to make another exposure, you also tensioned the shutter.

Clearly, you could pre-wind the central knob to tension the main spring to any extent you wished, and with practice and familiarity get the exposure you needed. Each exposure used one sixth of a turn of tension; each movement forward of the circular plate restored that tension. So your exposure would remain constant.

In the 1888 list of J. Robinson & Sons, of 172 Regent street, London, W. , the price of the camera, with six plates (36 exposures) was £1.75. Extra packets of six plates cost just under 14p.

The non-standard feature of my specimen is that it does not take the usual circular plates, but has a revolving inner frame, which carries four small square plates ($1\frac{3}{4}$ in × $1\frac{3}{4}$ in). I cannot think that this frame is a standard feature, although it is nicely made, and looks as though it 'belongs'. Possibly whoever owned it had a Mr Thistleton among his acquaintances who altered it for him. Or possibly the supplier did

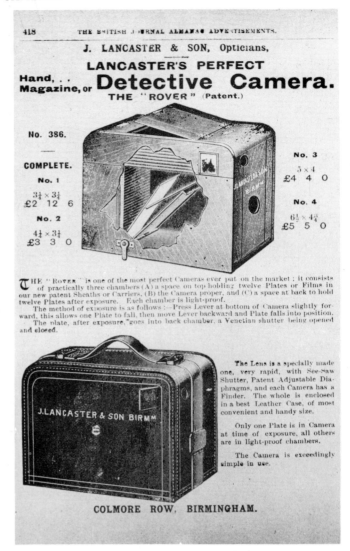

A typical 'carrying case' type of detective camera.

the job. Or possibly the makers supplied it as a special order. One should never lose sight of the fact that in those days, when cameras were not mass produced, but made in quite small 'batches', the bespoke job could always be fitted in. One thing that points to this last possibility is the fact that there are two serial numbers on this camera, 9600 and 38391. This camera turned up in Amsterdam, and it would be interesting to discover whether there are other similar cameras to be found on the continent.

Other category three detective cameras are quite varied. One was made to be worn as a belt under the jacket, others fitted inside hats, and

were used with the hat held respectfully against the chest.

In the fourth category there are some odd items to be found. In 1887, James Lancaster of Colmore row in Birmingham introduced their Watch camera, which looked like a gentleman's pocket watch, and pulled out in use on a series of short telescopic extensions. It was supplied for two, three, or four guineas, 'according to quality, metal, and finish.'

Another watch camera was Houghton's 'Ticka' of 1906, which used a tiny roll film, instead of the single round plates of the Lancaster camera. The lens of the 'Ticka' was concealed in the winding button of the 'watch'.

Lancaster also made cameras which looked like ladies' handbags, some of them rather ornate. These date from the late 1890s.

Possibly the best cameras in category four were those that were disguised as binoculars; certainly they were the most expensive. Goerz made one such, which looked like a pair of

There were a number of cameras on the market built into watch shaped bodies.

Probably one of the most involved of the detective cameras—the Watson binocular.

ordinary opera glasses. The London firm of Watson made a stereoscopic version, which was rather more complex and devious, and which they described as 'the only real Detective Camera'. In use it was held to the eyes, like an ordinary pair of field glasses, but the two lenses were at the side of one of the lens barrels, so that your picture was taken at right angles to the direction in which you were looking. Cameras of this sort enjoyed a considerable vogue in the early years of this century.

These last cameras are quite rare now, and though they cannot be said to have made any serious contribution to photography, they do indicate the thought that was being expended, even at this early date on small negative, easy to use, quick action cameras. The binocular cameras, well made as they were, represented a false trail on the track that led eventually to the modern breed of miniature cameras.

But at this point in time, the Leica was still twenty years away....

The Roll film Boom

Just as the advent of easily obtainable dry plates, in releasing photography from portable dark rooms, and the need for carrying around bottles of silver nitrate, gave the art a tremendous boost, so the coming of flexible film made an even greater impact.

The Kodak of 1888 had been, to the ordinary person, not so much a major advance in simple photography, as something which made possible the taking of a picture at the mere pressing of a button. More than that, thanks to George Eastman's decision to keep developing and printing in his own hands in these early years, a pleasingly high rate of success was achieved by Kodak snapshotters, and many ordinary people who had no taste for the alchemies of photography, developed a taste for the simplified art.

The roller slide, or roll holder was really a convenience for those who already owned plate cameras and wanted to make use of the new flexible material. The Kodak number one provided that material in a camera, ready to use. The second generation of Kodaks put the loading of the camera with film into the hands of the public—but it was a public newly converted to photography by the popularity and success of the Kodak number one.

However, the loading of these cameras with film still involved the use of a dark room. Film at this stage was still 'rolled film', not roll film.

Roll film, or cartridge film, backed with paper, and protected by its own leader of light proof paper, could be handled in daylight— loaded into the camera in daylight. It was then conveniently controlled in the camera by means of the winding key and the numbers in the red window, and finally it could be removed from the camera—in daylight—in order that the man at the chemists could develop and print the results.

While roll, or cartridge film, removed the last need for a darkroom from amateur snapshotting, the careful loading of the roll into the camera did provide a small ritual that the initiated could enjoy. The unfolding of a 'folding pocket Kodak' provided another one. It was one of those minor mystiques that we, who enjoy photography, but do not have to earn our living by taking pictures, are addicted to.

There was a latent potential in photography that first began to be realised with the coming of the folding pocket Kodak.

This potential lay in pride of ownership. The camera was becoming a fascinating artifact, which changed its shape intriguingly as its owner opened it. It was something which could be discussed with other camera owners; the possession of a camera could be envied.

Of course, the beginnings of this had already existed before the coming of the F.P.K., but had been limited by the solid form of the older cameras which amateurs could afford. Now it was that these cameras, which blossomed from flat boxiness into a real 'camera' shape, with bellows, and simply made adjustments, and a viewfinder which encapsulated a minute and shining world, set in motion a factor in amateur

photography which has persisted and grown ever since.

It was the amateur's pride of ownership of his equipment. It is something which has its counterpart among golfers, and cyclists, and fishermen, to name the merest sampling of a long list of activities.

Various patent involvements inhibited other makers from following Kodak's lead, a lead which they would follow at the earliest possible moment.

As we have seen, the earliest F.P.Ks were cameras in which the lens panel was moved forward to working position by sprung struts, and which did not have a front 'lid'. There were later versions which retained the strut construction, and had a lid as well.

But the design which settled down to dominate this field, and which persisted thence forward for many years, was the design in which the lid formed the base on which the front panel, carrying the lens, was moved for focusing.

It was this type of construction that was adopted with various minor modifications by almost every maker of cameras in Europe.

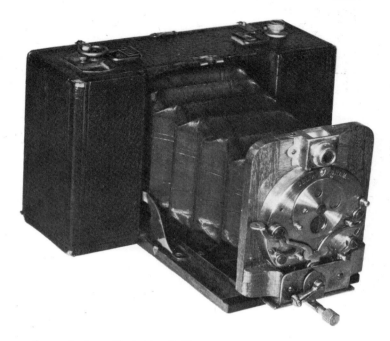

An early 'non-Kodak' roll film camera, probably by Emil Busch.

One Design, many Makers

Among the very earliest in the field, on this side of the Atlantic, was the firm of Emil Busch, in Rathenow. Their cameras appeared around 1900, at which time the company had been optical manufacturers for a century. They were already well known to photographers for their lenses, which were of the well-tried rapid rectilinear, landscape, and Petzval types, which being extremely well made, performed as well as lenses of those early types ever could.

The early Busch cameras had a front board, or lid, which was hinged along one side of the camera, rather than across the width of the body, so that set up as opened, they were right for landscape pictures. They featured screw focusing, operated from the front of the front board.

These cameras were marketed in England, about the turn of the century, while other companies such as Ross, were offering the Kodak cameras, albeit fitted with their own lenses.

Meanwhile, in about 1902, Houghtons entered the field with the first of their Ensign pocket roll film cameras, and their inexpensive 'Scout', which took negatives measuring $3\frac{1}{4}$ in $\times 2\frac{1}{4}$ in and sold for one guinea. In the following year, Lancaster were in the field, with their 'Filmo-

graph' series of cameras, while cameras by continental makers, such as Voigtlander, began to appear on the English market. Roll film cameras from W. Butcher and sons, of Camera House, Farringdon Avenue, appeared under the 'Carbine' name, a name which the company was to use for many years to come. Beck arrived on the scene with their 'Cornex', presumably named for Cornhill, where the company had its shop.

From now, up to the beginning of the first world war, the number of designs of pocketable roll film camera which the amateur had to choose from continued to increase. Even such old established and conservative houses as Ross and Dallmeyer had entries in the field.

Our old friends, Newman and Guardia, did not produce a folding roll film camera until about 1912, and then, as might be expected from this company, they produced something quite different in detail from any other company. In general format, it followed what had become the standard line, but it had many details which were strictly Arthur Newman, and gave clear evidence that he had thought long and hard about the shortcomings of other similar cameras on the market.

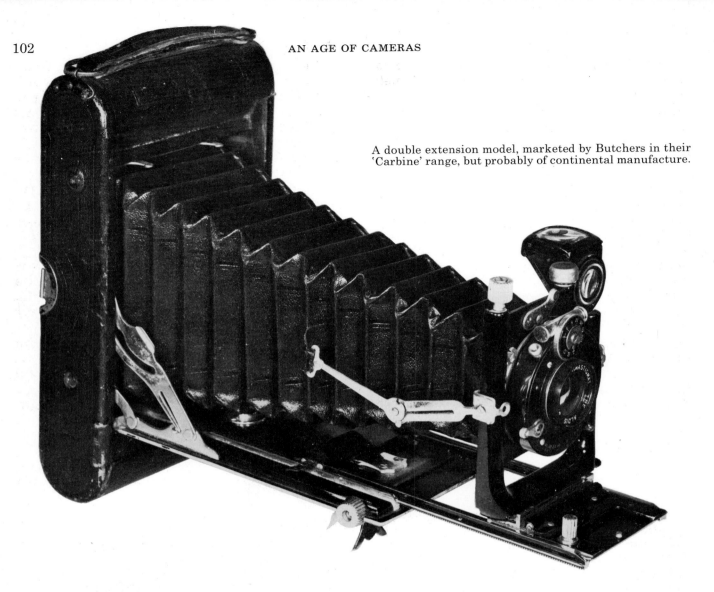

A double extension model, marketed by Butchers in their 'Carbine' range, but probably of continental manufacture.

This was the beginning of the roll film 'Sybil' series of cameras. Unlike the products of other firms, they did not include a 'ready made' shutter, purchased from a company specializing in shutter manufacture. The 'Sybil' cameras carried one of a number of variations of Mr Newman's well tried and reliable pneumatic shutters. The lenses were the best from Zeiss—Tessars and Protars. Furthermore, the camera was designed to allow these lenses to give of their best.

Arthur Newman gave much thought to the way his cameras opened for use. He rejected out of hand the normal procedure of sliding the front standard, carrying the lens and shutter, forward upon a focusing track on the inside of the hinged front lid. In this arrangement, it was up to you to locate the standard in the infinity position by sliding it forward on the track. It needed care to do this, and an avoidance of haste and undue force, for even holding the front standard correctly, you exerted considerable leverage on the channels in the base of the standard—usually formed by folding the metal —whereon the standard slid and was located upon the focusing track.

These channels were liable to open up a little in use, so that the standard could rock a little on the track, and the pull of the bellows on the lens panel then caused the standard to lean back a trifle.

Your pointer might be indicating infinity on the baseboard focusing scale, but with the standard leaning back like this, the centre of the lens might easily be a millimetre or more behind its correct position. Furthermore, due to the sloppiness of the base fit of the front standard, the error could vary.

It is not uncommon to find cameras, in which the backward lean of the front standard is easily visible, and does not need a set-square to show it up.

Under these circumstances, fitting your camera with the best lens in the world was a complete waste of money, because it was impossible to locate it with any meaningful precision.

Roll film De Luxe

Arthur Newman discarded all reliance on the focusing track for the uprightness of his lens bearing panel, and instead fitted nicely made trellises of flat metal strips, which ensured that the lens plane, and that of the film, were at all times precisely parallel. On the baseboard he fitted the gentlest of guides, which did no more than ensure that the front panel moved in a straight line, and played no part in keeping it upright. When the infinity position was reached, a very positive spring catch engaged the base of the front, and the lens was positioned with an accuracy, I would guess, of plus or minus not more than a thousandth of an inch.

Furthermore, when extended, these beautifully light cameras have the rigidity of a block of wood. In consequence, the very fine lenses with which they were fitted in these days before the first world war, could give of their best. And did.

Focusing adjustment is made by a lever, moving across the front of the baseboard, which moves the front standard precisely and easily. These cameras were beautifully and individually made, and there is not another roll film camera of this period to match them.

However. The best model, with Zeiss Protar lens, taking quarter plate negatives on roll film, cost £25.50. The best version of the Ensign series in the same size was just over £10, and a number 3 Special Kodak, which was their quarter plate R.F. model, with a Zeiss Tessar lens, cost about the same.

In passing, it is worth noting that in these days before the first world war, the price of a camera of the quality of the N & G roll film Sybil was six month's wages for a great many people.

A very similar camera to the N & G Sybil came from Adams, just about a year before the war broke out. It was the roll film 'Vesta', and it mounted either a Zeiss Tessar lens, or a Ross Homocentric, in one of Deckel's 'Compound' shutters. It cost about twenty pounds.

Two N & G folding roll film 'Sybils'. The one on the left dates from before the first world war, the one on the right from the nineteen-twenties.

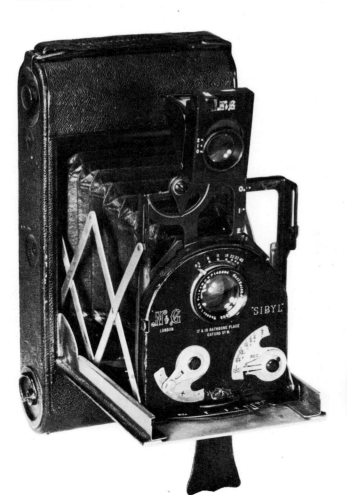
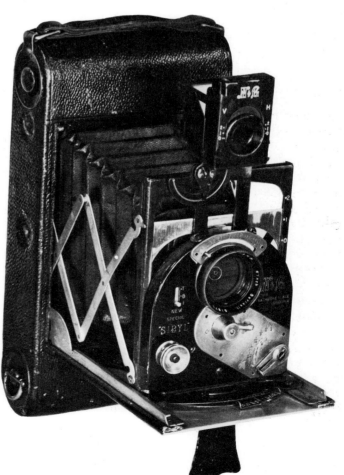

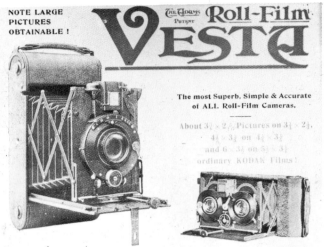

NOTE LARGE
PICTURES
OBTAINABLE !

THE ADAMS PATENT **Roll-Film**
VESTA

The most Superb, Simple & Accurate
of ALL Roll-Film Cameras.

About 3¼ × 2½ Pictures on 3¼ × 2½,
4¼ × 3¼ on 4¼ × 3¼
and 6 × 3¼ on 5½ × 3¼
ordinary KODAK Films!

A high class and perfected Roll Film Camera has long been asked for, and we now have pleasure in introducing an absolutely unique instrument of its kind.

Although only using in the No. 1 Model the ordinary stock 3¼ × 2½ Film Spools, a charmingly proportioned picture of about 3¼ × 2½ is obtained. In No. 2 Model an ordinary stock 4¼ × 3¼ spool is used, yet a similar prettily sized picture measuring about 4¼ × 3¼ is secured. In the Stereo Model the ordinary 2½ × 4¼ spool is used, yet large pictures each measuring 2½ × 2½ are obtained. In Post Card, ordinary 5¼ × 3¼ spools are used, but size of picture obtainable is about 6 × 3¼. Although the Vesta permits of these large pictures upon smaller sized films, the Cameras are NOT made larger in consequence. The Adams Patent Vesta is the ONLY Roll Film Camera affording this immense advantage. It also means a great saving in cost of film.

The Adams Lazy-Tongs or Trellis Bar system ensures parallelism of lens and front of Camera with film. Our Patented Device also permits of an extensive rising front, horizontally **and** vertically, and that **without** straining the Trellis Bars. The expense of a first class anastigmatic lens, such as those fitted to the Vesta is largely wasted unless used in conjunction with a system as above described.

The Film Spool Winder is strongly made and there is no back lash whatever, and the Camera back fitting is designed to keep the film perfectly flat.

The Adams 'Vesta', ordinary and stereo models. Note the inverted 'Compound' shutters.

The roll film pocket cameras of the part of the twentieth century prior to the first world war constitute a group of very collectable instruments of varying quality and characteristics. Most of them made use of shutters that were the products of specialist manufacturers. They were mostly pneumatic shutters, in which the period of opening was controlled by the movement of a piston in a cylinder, and it is worth stopping here to consider the varieties of these shutters that emerged in what was the heyday of the pneumatic shutter.

First, because it was simplest, the Newman shutter. The ones you find on his 'Sybil' cameras are simpler than those on the 'Universal' series of cameras. In the Universals, the speed of the piston, and therefore of the shutter blade, was controlled by the rate at which air leaked through a by-pass from one side of the piston to the other. In the Sybils, the rate was controlled by the rate at which the air was allowed to leak out of the cylinder. The rate of movement of the blades corresponded with the exposure—slow for long, quick for short. In the Universals, the lens had to be capped, or the dark slide left in during the act of cocking, or tensioning the shutter, because in doing this, you moved the shutter aperture across the lens.

In the Sybils, the arrangement was different. The blade was double ended, with a gap between its two lobes, so that it rocked one way for one exposure, and the other way for the next. There were two positions for the tensioning lever, marked '+' and '0'. Corresponding marks on the two ends of the blade could be seen through the front elements of the lens, and if the mark on the blade, and that indicated by the position of the setting lever, were the same, then the shutter was cocked. It did not open during cocking, since all that you were doing was moving the spring that would move the blade when you released it.

More Pneumatic Shutters

There were other shutters in which pneumatic cylinders controlled exposure. The one you will meet most often is Bausch and Lomb's 'Unicum'. In these shutters, which were made in several sizes, it is the length of stroke of the piston in the cylinder—or to be more strictly accurate, of the cylinder over the piston,—that controls exposure. The blades are linked to the pneumatic piston and cylinder via a variable linkage, controlled by the exposure setting. For a long exposure—one second—the linkage is such that

The early form of the N & G 'sybil' pneumatic shutter

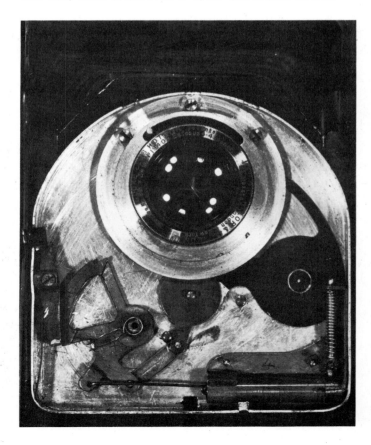

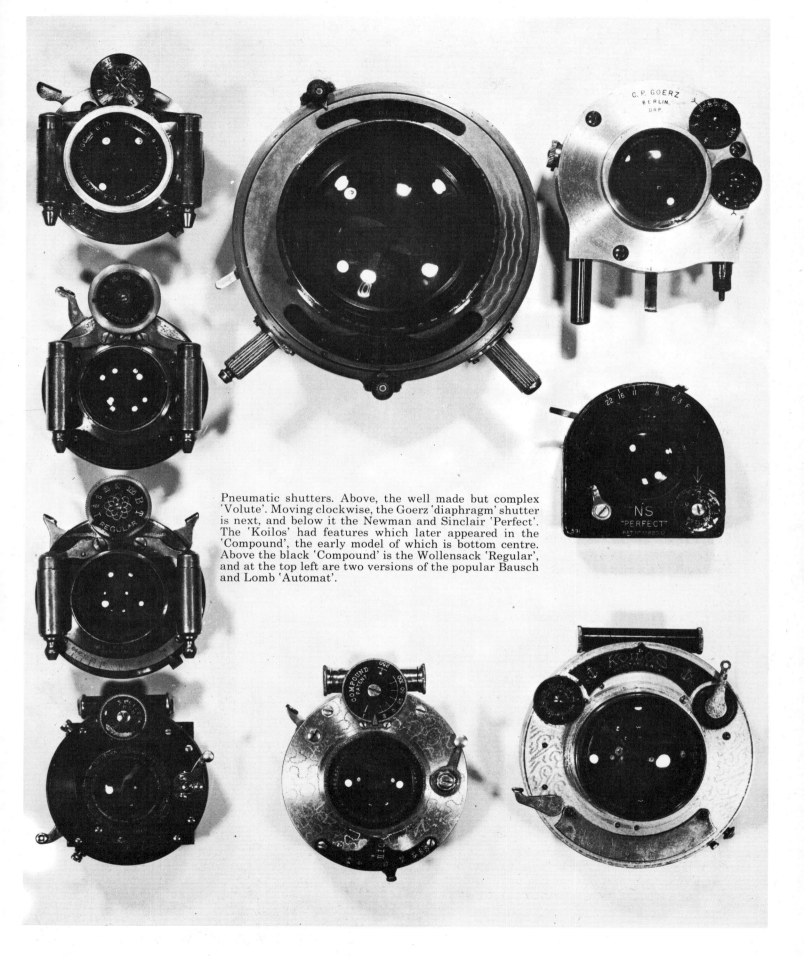

Pneumatic shutters. Above, the well made but complex
'Volute'. Moving clockwise, the Goerz 'diaphragm' shutter
is next, and below it the Newman and Sinclair 'Perfect'.
The 'Koilos' had features which later appeared in the
'Compound', the early model of which is bottom centre.
Above the black 'Compound' is the Wollensack 'Regular',
and at the top left are two versions of the popular Bausch
and Lomb 'Automat'.

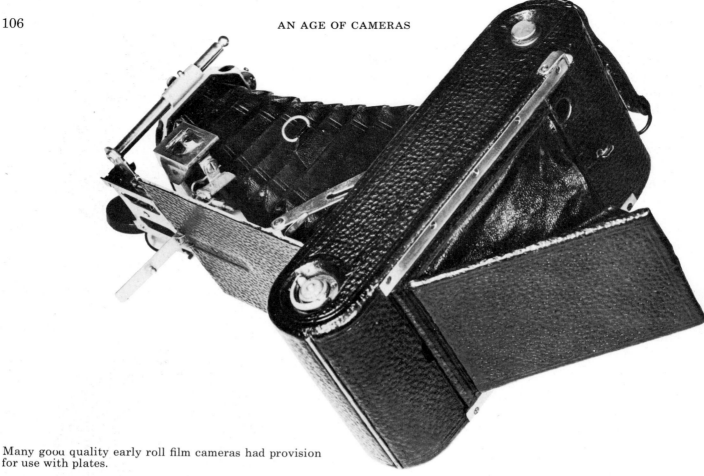

Many good quality early roll film cameras had provision for use with plates.

the movement is maximum. For the shortest exposure—1/100 sec—the linkage is such so that the movement is nil.

These shutters were an improvement in principle on Arthur Newman's shutter, since what was controlled was the interval between opening and closing, and the shutter blades moved equally briskly whatever the exposure. However, they had the inherent fault that the open arrangement of the cylinder and piston made them very vulnerable to the effects of dust, or anything else that might be deposited by the atmosphere. For proper working they must be clean and dry—no oil. One often finds them out of order, when all that is needed to put them right is careful cleaning.

The same was true of the early 'Automat' shutters by the same company, which one finds on early Kodaks. The later models however have the piston moving within an enclosed cylinder, and these were very reliable. The early Wollensak shutters also had the defect of exposed control cylinders, as did those by Thornton Pickard, and some continental makers who produced similar shutters.

All of these shutters have two cylinders. Only

one is concerned with exposure control. The other is a simple air-operated servo cylinder, to operate the release, by means of a rubber tube pressed on to the bottom nipple, terminating in a rubber bulb held in the hand. Sometimes you will find that the hole through the nipple has had a thread cut in it, in order that an ordinary wire 'antinous' release may be used.

With the 'Unicum' generation of shutters, design had reached the point of having, in theory produced the ideal type of shutter—rapid blade opening and closing, and control of the intervening interval—but the construction and arrangement aspects of these shutters left a lot to be desired. There were too many moving parts out in the open—too many possibilities of random error and failure.

The obvious next step was to case in the moving parts, and by rearrangement, it was found possible to pack all the works inside a flat circular box no bigger than the one which had contained just the shutter and diaphragm blades in the original 'Unicum', and there is one model, by Bausch and Lomb, which achieves just that.

Most of these pneumatic shutters, however,

do have the control cylinder outside the case—
at the top—although the action is enclosed,
and random dust and other atmospheric matter
cannot settle on the moving parts, and interfere
with the proper working of the shutter.

The Compound

The best of these shutters was the famous
'Compound', which appeared on the English
market about 1909 in its improved form, which
is the one you will come across most often, and
I propose to deal with this version before the
original one. It is finished in black enamel all
over, and has two levers on the front. On all
versions, the lever at three o'clock is the setting
lever, and the one at either eleven or seven
o'clock is the release lever. The ones with the
eleven o'clock position are the earlier examples
of the improved 'Compound', and on the larger
ones you will find that they have a built in
pneumatic servo cylinder for rubber bulb re-
lease. The later ones with the release lever at
seven have no such cylinder, and are equipped
for an ordinary antinous wire release.

There is a further control on 'Compounds', in
the form of a small button just under the bottom
centre of the lens. With this button on the 'I'
position, the 'instantaneous' speeds work, and
the cocking lever is engaged, and must be
depressed to tension the shutter.

With the button at 'B', the setting lever is
locked, and the release lever on its own opens
the shutter, which remains open as long as the
release lever is down.

With the button at 'T', the shutter operates
as for 'B', but requires a second pressure to close
it.

On shutters made for the continental market,
the letters 'M', 'B', 'Z', take the place of 'I', 'B',
and 'T' on the English ones.

The earlier 'Compound' shutters, made in the
early years of the century before 1909 do not
crop up very often. They are similar in arrange-
ment to the earlier improved version, but have
an unpainted aluminium body. On these earliest
'Compounds' of all, the 'IBT' button moves
vertically, and is marked '012'. '1' equates with
'B' and '2' with 'T'. However, there is no mech-
anism to lock off the cocking lever, as there is
on the improved models, so that if you set for a
time exposure, and the cocking lever happens
to be down, you won't get a time exposure, but
an 'instantaneous' one.

This one design defect apart, even these early

Compound.

Dial-set Compur.

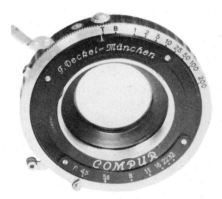

Rim-set Compur.

and rather rare 'Compounds' are excellent shutters.

In the largest sizes of all (about 2 in throat diameter) the improved version of the 'Compound' is still made and used to this day.

I have described these shutters at some length, since they are the ones you will most often find fitted to quality folding roll film cameras of the period between 1909 and the first world war.

A somewhat similar pneumatic shutter of the same period was the 'Koilos', and there was another shutter, bearing the same name, which preceded it, which was not pneumatic, but controlled speed by means of a variable friction brake. This shutter belongs to the early class of shutters where rate of blade movement is linked to exposure.

Before leaving the pneumatic shutters, mention must be made of two others, the 'Volute' from Bausch and Lomb, and the Goerz diaphragm shutter. Both these shutters, which were very well made, have the peculiarity that the shutter blades are also the diaphragm blades.

In other between-lens shutters, there are two sets of blades—one set that opens and closes to make the exposure, and a second set which can be hand set to give any desired aperture within the scope of the lens.

All Purpose Shutter Blades

In the 'Volute' and the Goerz shutters, one set of blades did both jobs. Suppose that you set $f/16$ as the aperture you wanted. When you pressed the release, the shutter blades would open that far, and no further, and then close again.

This was a fine idea, and if you should be lucky enough to discover one of these shutters in perfect working order, then you will find that it is a very good shutter indeed. Duration of exposure was controlled, as in other pneumatic shutters, by a piston moving in a cylinder.

Now, if you stop to consider the matter, you will see that this control mechanism was expected to produce the exposure set by you for any aperture. Whether it was a small aperture, demanding only a minimal movement of the blades, or the biggest possible aperture, demanding the maximum movement of the blades, the exposure should be identical. It says a 'lot for the way these shutters were designed and made that this was achieved at all. However,

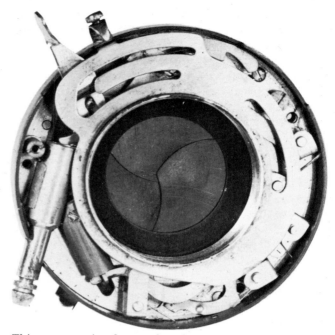

This pneumatic shutter has its working parts packed inside the case, but the principles involved are the same as in those shutters with external air cylinders.

as friction built up in the large number of moving parts, due to wear, and dirt, blade movement was slowed up, and it was slowed up a lot more on big apertures than on small. So your effective exposure varied with aperture, and the effect would obviously be far greater on the larger models of these shutters than on the smaller ones.

I have one big 'Volute' which has obviously had a lot of use. When set for the shortest exposure—1/75 sec—and the smallest aperture, $f/64$, it is still just about right. But as you set bigger and bigger apertures, with the same exposure setting, the actual exposures get longer and longer, until at the maximum aperture, $f/8$, the exposure is nearer 1/5 sec than 1/75.

A further factor which aggravates this deterioration of performance in the larger shutters, is that the larger 'Volutes' have more blades, and therefore more moving parts, than the smaller ones. The well worn example in my collection, which has a two inch throat diameter, has ten blades which are expected to open and close to the exact amount demanded by the aperture setting, and always in the identical time that is set on the speed scale. I think the designer was a very brave man.

Speaking broadly, cameras with pneumatic shutters may be dated to the years before the first world war. The particular shutter that goes with a particular camera varies. Even

companies like Kodak, who were producing cameras in large numbers, offered their better models with a choice of different shutters.

After the first world war, the general appearance of folding pocket roll film cameras did not change substantially. The columns which supported the lens board in many earlier designs vanished, and their place was taken by a 'U' shaped standard of cast metal, or, in the cheaper models, by a flat metal pressing, which was lens board and front standard all in one.

The better designers tackled the problem of wear and straining in the fit of the front standard on the focusing track, and cameras appeared with the base portion of the standard markedly elongated in a forward direction. This meant that this part became too long to go into the body of the camera when it was folded flat, and to overcome this, the front portion of the base, which projects out of the body when the front standard is as far back as it will go, is hinged. In the fully collapsed position, this hinge, and the one on the 'lid', are in line, and so the lid can be closed.

This went a long way towards curing the 'lean-back' trouble which had spoiled many an excellent camera in earlier times.

Arthur Newman stuck to his excellent trellis arrangement, and continued to improve the details of his folding roll film cameras.

However, the sheer excellence of his pre-war efforts depended only partly on the soundness of his designs, and the workmanship that went into them. The quality of the splendid negatives which they produced owed just as much to the exquisite Zeiss lenses with which they were equipped.

Before the '14–'18 war, Zeiss did not produce roll film cameras, and it was said that they provided Newman and Guardia with the pick of their suitable lenses, because they knew that the N & G cameras were capable of realising their maximum potential. And this was something that applied to all the types of cameras N & G produced.

After the war, Mr Newman would have no truck with anything German. 'The British Camera with the British Lens' said his advertisements.

Sadly, there was no British lens that compared with the Zeiss lenses of pre-war days, and discerning photographers, who had found that extra quality they sought in Arthur Newman's cameras, were now disappointed.

I have been told that Zeiss offered N & G very advantageous terms after the war if they would

once more use their lenses. But in vain.

I have been unable to confirm this story, mainly because the Zeiss museum, and the associated archives were all destroyed in the second world war which idiot politicians imposed on this century.

So an N & G camera with a Zeiss lens is pre 1914. There were also some fitted with Cooke triplets in this period, which can be identified by their unpainted, 'early' looking brass mounts. Otherwise, English lenses in N & G cameras makes them post war.

Now before I am accused of being anti-English-optics, let me hasten to add that as time went on, some excellent English lenses were fitted to these cameras, but the lenses that were available in England in the early years of peace did not bear comparison with the earlier Zeiss products, and the reputation of N & G cameras suffered accordingly.

Meanwhile, by about 1922, Zeiss Tessar lenses were reappearing on other makes of camera in England, and in France as well.

Cameras were improving in detailed design, which in most cases was aimed at making the camera more easily used by ordinary people.

Pneumatic shutters were now 'old shutters'. The firm of Deckel replaced their 'Compounds'

This roll film camera by Dallmeyer is fitted with the shutter seen opposite.

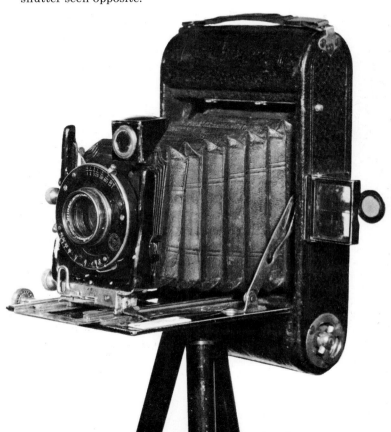

with the first of the 'Compurs'. These early 'Compurs' look just like their pneumatic forerunners, but have no cylinder assembly on the top of the case. For the sake of convenience, I shall refer to these early 'Compurs' as dial-set, and the later pattern as rim set. I believe that the dial set Compur appeared on the continent of Europe just before the first world war, but it was not sold in England until the early twenties, and made its first appearance on the English market as a part of continental cameras from such companies as Goerz and Voigtlander. The newer rim-set Compur appeared about 1925, and one of its earliest appearances was on the very rare Compur Leicas, which appeared that year. However, the dial-set Compurs went on being fitted to cameras well after the rim-set model was available. One further point which is worth noting about this series of shutters is that the very large sizes were not made in Compurs, and in this area, the Compound is still used.

Escapement Shutters

In the Compur series of shutters the pneumatic device which determined the time of opening of the blades was replaced by an escapement—or rather by two escapements. These are comparable to the escapement in a watch, but, of course, they 'tick' at a much more rapid rate. One escapement serves for the longer exposures, and the other, more rapid escapement, controls the short exposures. Just as in a watch, the escapement controls the rate at which the power of the spring is allowed to escape, so in a Compur shutter. Whichever escapement is engaged must perform the correct number of oscillations called for by the exposure you have set before it will allow the blades to snap shut.

I have described this series of shutters at some length because you will find them on so many of the better class roll film cameras (and others), and they do provide a useful starting point for dating a camera.

From about 1923 onwards considerable numbers of excellent folding roll-film cameras came to England from Germany, from such makers

Two models of the famous 'Icarette'. The later model, on the left, was made after ICA became absorbed into Zeiss.

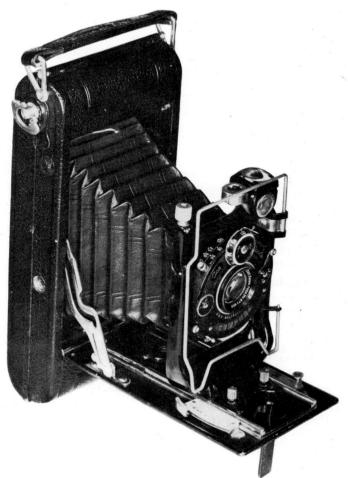

as Goerz, Ernemann, ICA, and Contessa-Nettel, all of which amalgamated under the Zeiss Ikon banner in 1926. Other makers on the continent —Ihagee, Voigtlander, Agfa, Krauss, Meyer— continued on their own, and as the years passed by, new names were to be added—or old names in new guises. Companies amalgamated, and new companies were formed, often by the very men whose work had been vital to the success of the original company. Dr Nagel's work had been the mainspring of Contessa-Nettel design; a few years after the Zeiss Amalgamation, cameras bearing the name of the new Nagel company appeared. Dr Rudolph, who had been a part of Zeiss, found new outlets for his talents with Meyer. And so on.

As to the cameras themselves, several trends can be noted in the twenties and thirties.

First, the bigger roll film cameras were gradually dropping out.

Second, the self erecting cameras made a come-back. I say come-back, for they had originally appeared in the form of the first folding pocket Kodaks.

Third, cameras with coupled rangefinders appeared.

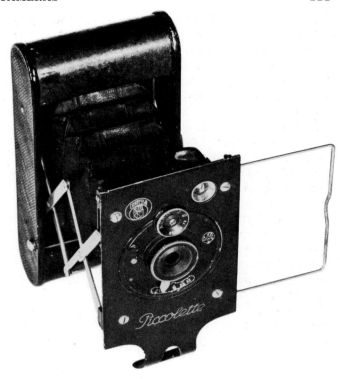

The neat little Contessa Nettel 'Picolette' of the early nineteen-twenties.

To take these points in order. Considering 1924 as a representative early post-war year, under the headings of roll and cartridge films, films for roll holders, and films for 'old pattern Kodaks', the Kodak company were listing no less than forty-three varieties. I say varieties, rather than sizes, because many of the forty-three provided negatives of identical size, but had different spoolings.

Of these forty-three, about half were available in either six or twelve exposure spools, or six or ten exposure spools.

The smallest negative size these catered for was the tiny $1\frac{1}{2}$ in \times 2 in size of the original pocket Kodak. The largest was 7 in \times 5 in for roll holders (which could, of course, be used on plate cameras, or the biggest cartridge Kodaks) and rolls for some of the Graflex cameras.

By 1929, the corresponding number was twenty-seven.

In 1939, the number had dropped to about twenty, and of those, most of the larger ones were a matter of special ordering for use on older cameras.

As far as the actual cameras were concerned, in the new models produced towards the end of our period, very few used a bigger negative than $2\frac{1}{4}$ in \times $3\frac{1}{4}$ in.

The re-appearance of the self erecting camera was interesting. It was an admission of the fact

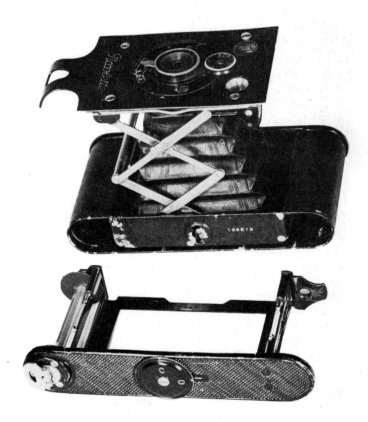

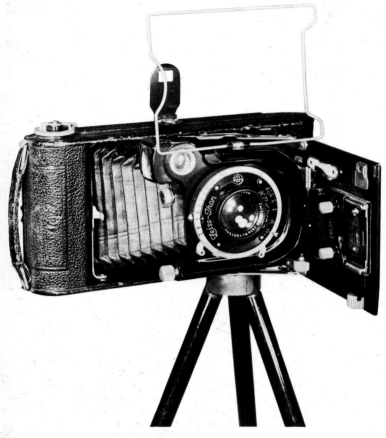

The Zeiss 'Lloyd', a late example of a roll film camera with plate capabilities.

These were the simplest forms of focusing, to be found in self-erecting cameras from the cheapest to the best. Some, however had a sliding movement, operated by screws or levers, superimposed on the self-erecting system.

Which brings us to the third of our three trends; the advent of coupled rangefinder cameras, which in this era were also self-erecting cameras.

As we have seen, the original coupled rangefinder camera had come from Kodak, just after the first world war. Rather oddly, having tried a rangefinder camera, Kodak seem to have abandoned the idea. Certainly one does not find a developing series of RF cameras from Kodak in the twenties and thirties, as one might expect, although the original design remained in the Kodak list until 1932.

Coupled Rangefinders

About this time, coupled rangefinders begin to appear in miniature cameras, about which we shall have more to say later, but as far as roll film rangefinder cameras were concerned, the lists remained blank, until about a year later, in 1933, when the first of the Super Ikontas came from Zeiss. It gave $3\frac{1}{4}$ in $\times 2\frac{1}{4}$ in negatives, and it was a fairly orthodox looking self erecting folding roll-film camera—until you came to the rangefinder.

Rangefinders—optical rangefinders, that is—all use the same principle. The object being focused is viewed from two points simultaneously, and the two images are brought together by a suitable arrangement of mirrors. The two viewpoints are a few inches apart, and one sighting line must be swung towards the other, if they are to both 'look at' the same object. The amount of this swing is a measure of the 'range' of the object—its distance from the camera.

The obvious way to bring the two sighting lines to bear on a single object is to tilt one of the mirrors in the system, and this is the method usually adopted, and there are a number of ways in which this range-finding swing of a mirror can be coupled to the focusing movement of the lens.

Now lenses can be focused by moving them bodily, or by changing their characteristics. This last is usually done by moving the front element of the lens in relation to the other elements, which produces a rapid focusing action. This is what we have already referred to in connection with the focusing of self-

that had been obvious for years—you cannot have a camera which has to be pulled to the working position by the user, who may be timid and gentle, or ham-fisted, and guarantee that the task will be done correctly. Neither can you guarantee that the camera will retain its potential accuracy with the rougher sort of handling that it is quite likely to get.

But if the camera is designed to spring to the correct open position at the touch of a button, then as long as it is sufficiently robust to stand up to the power of its own springs, and is properly designed in the first place, then you can expect it to function as an accurate camera for the whole of its working life.

Furthermore, focusing movement can be divorced from such vulnerable mechanisms as front standards moving on focusing tracks, and be confined either to the movement of the shutter unit in some form of helical device, or to the much smaller movement of the front cell of the lens alone.

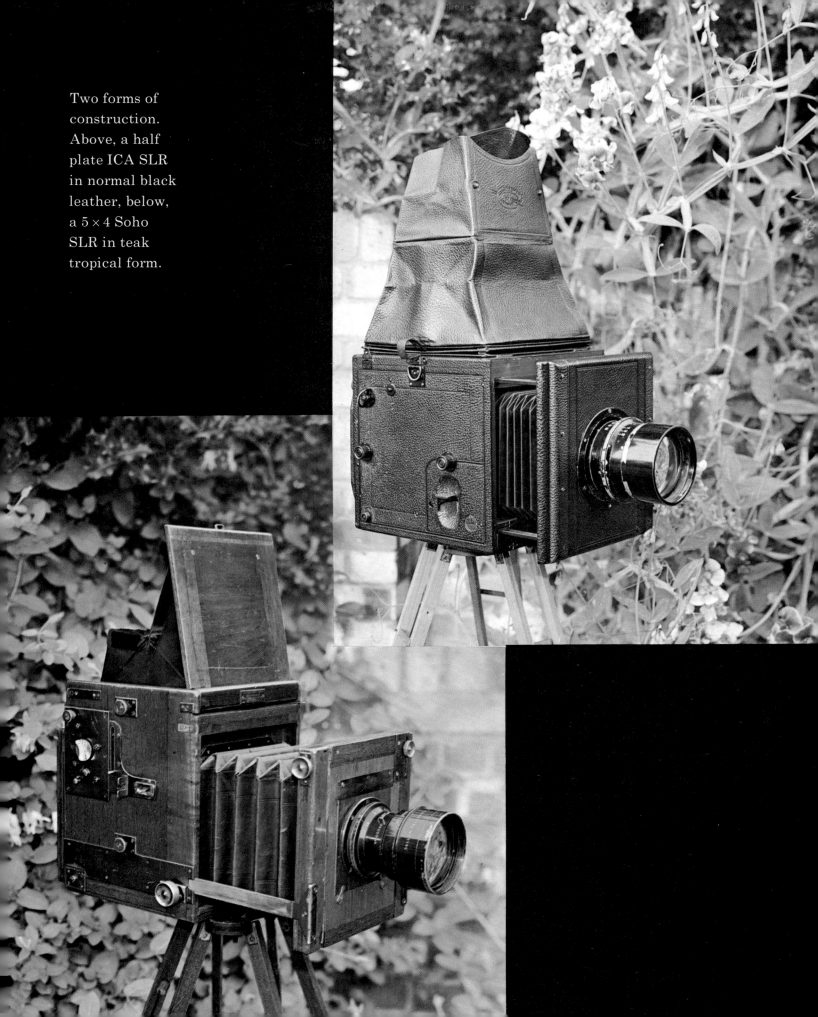

Two forms of
construction.
Above, a half
plate ICA SLR
in normal black
leather, below,
a 5 × 4 Soho
SLR in teak
tropical form.

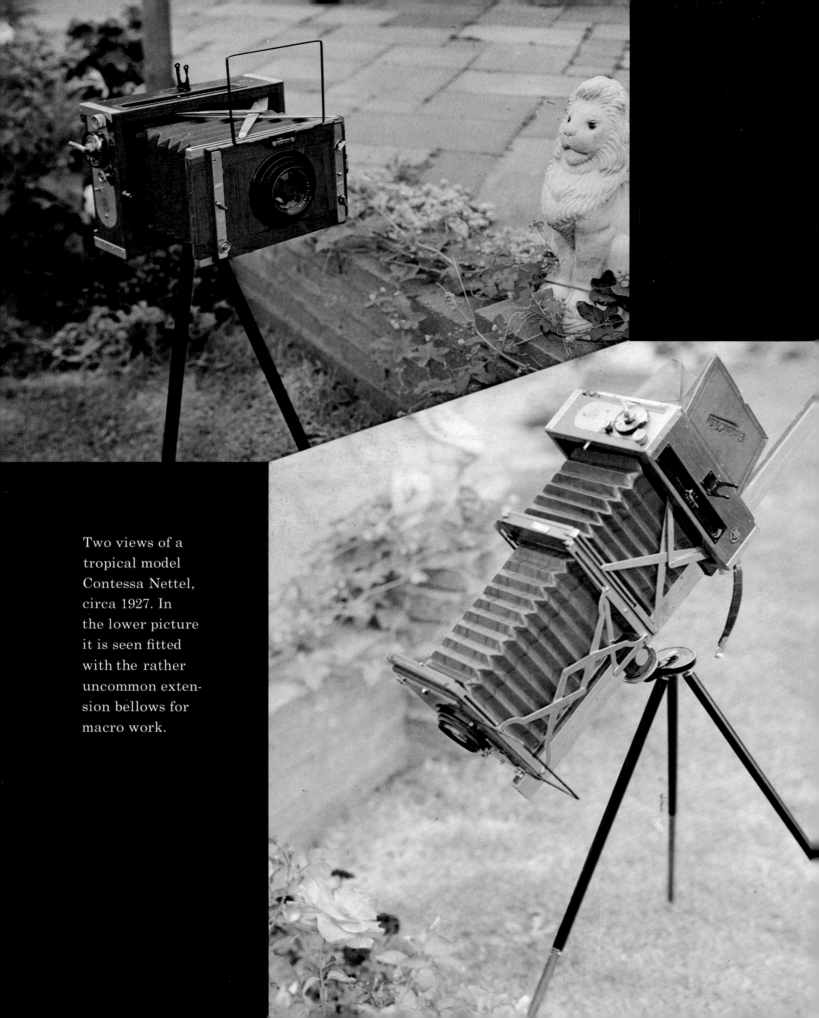

Two views of a
tropical model
Contessa Nettel,
circa 1927. In
the lower picture
it is seen fitted
with the rather
uncommon exten-
sion bellows for
macro work.

erecting cameras, and it is called front cell focusing.

If the front cell of a Tessar, or similar lens is revolved about one turn in a screw mount, it can be made to adjust the focus of the entire lens over the whole of a useful focusing range—from a few feet to infinity.

Zeiss mounted a tiny, innocent looking round glass 'window' alongside the lens. The front cell of the lens revolves for focusing, and if you look closely at the small 'window', you will see that it, too, is revolving.

If you look even more attentively at this window, you will be fascinated to discover that the two sides of the 'window' revolve in opposite directions.

This is a simple and subtle optical device. The two tiny discs of glass which revolve are optical wedges. Their sides are not parallel, but at a slight angle to each other. Now if you put the two wedges together, so that the thick edge of one corresponds with the thin edge of the other, then they will add up to the equivalent of flat glass, which does not change the direction of light.

But if you revolve these two circular wedges from this 'neutral' position in opposite directions simultaneously, then you will reach a point where, after 180 degrees of turning, the two thick edges will be together, and, of course, the two thin edges. Effectively, your two wedges are now adding up to the equivalent of a narrow prism, which does change the direction of light.

So, as your two discs are revolved, light passing through them has its direction gradually changed, which is exactly what you need to swing one of your two sighting lines, so that it looks at the same thing as the other. And since the lens is changing its setting as it revolves with the two small disc-wedges, the coupling between focusing and rangefinding is complete.

Looking at your subject through the rangefinder, you will see it 'in duplicate'. So you adjust, until the two images become one, at which point your lens is arranged to be correctly in focus.

Provided it is not tampered with or accidentally damaged, I can see no reason why a range finder of this form should not remain accurate indefinitely.

Within a couple of years from the introduction of the first Super Ikonta, these cameras

The 'Ikonta' and the 'Super Ikonta'. The rangefinder of the Super Ikontas was by far the best rangefinder ever to be fitted to a roll film camera.

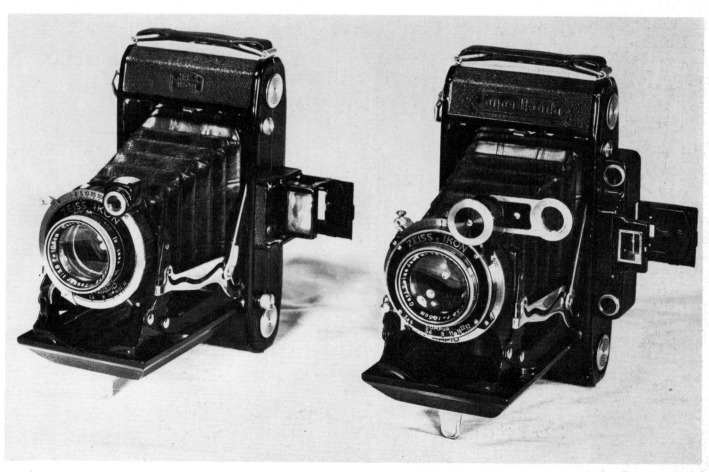

The Voigtlander 'Prominent'—not to be confused with the later 35 mm camera of the same name.

were available in models providing four negative sizes—$2\frac{1}{4}$ in \times $1\frac{3}{4}$ in (16 on 120), $3\frac{1}{4}$ in \times $2\frac{1}{4}$ in, $4\frac{1}{4}$ in \times $2\frac{1}{2}$ in, and $2\frac{1}{4}$ in \times $2\frac{1}{4}$ in.

This last size, the square Super Ikonta, was probably the most popular, and certainly the one which was later developed to the greatest extent. It had automatic wind, while the other models all used 'red window', and it could be supplied fitted with a built in light meter.

Of the other Super Ikonta models, various slightly changed models appeared. One simple indication of 'early' or 'late' in this range is the shutter release. On the early models it is on the front of the camera. On the later ones it moves back to the body.

Various lenses were offered—all of the standard focal length, but of varying quality and speed. They ranged from a 4.5 Triotar (a simple triplet) to a 2.8 Tessar.

In my view, this range of cameras represents the apex of design and performance in folding roll-film cameras, not only of the period which concerns this book, but of any period.

When they were produced, lenses were not coated, but one frequently finds Super Ikontas on which this final embellishment has been lavished. They are a delight to own and use.

About the same time Kodak produced the 'Regent', a very nice coupled RF camera using the same lens as Zeiss, but moving the complete lens to focus. There is really nothing to choose between Zeiss and Kodak in performance where these cameras are concerned, and the Kodak, with its sleek shape, is the more elegant. But the very smoothness of this camera worries me. I always have the feeling that it might slip out of my hands. Definitely a camera to use on a strap.

Another fine rangefinder camera of this era which is most worthy of note is the 'Prominent' from Voigtlander. A fine, nicely engineered camera, with many ingenious features, including a built in optical exposure meter. This camera is the complete antithesis of Kodak's 'Regent' with its smooth streamline shape.

The 'Prominent' bristles with fascinating bulges.

I suppose that this era, just before the last war, marks the apex of the folding roll film camera, which had held the field as the most popular of formats for amateur use for more than thirty years. Since the war, it is the

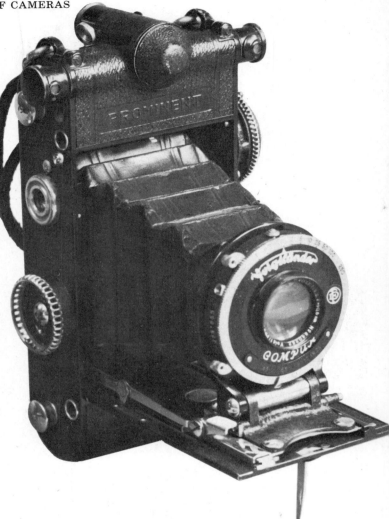

miniature, and particularly the SLR, which has dominated the amateur field.

I cannot leave the folding roll film cameras without mentioning one final design, which I think must have been the very last of this class to be produced within our period. It is the rather rare 'Suprema', which came from the Nagel works at Stuttgart, which by this date had become part of the Kodak organization. Production of them had only just begun, when war broke out, and only a very few ever 'escaped' from Nazi Germany.

Since the war the folding roll film camera has passed into obsolescence, although a surprising number of them are still in use. As far as I am concerned, they form a very interesting part of my own collection, for they are fun to use, and most of mine are still in excellent condition.

Looking back to my first camera, a folding 'Brownie', I remember being fascinated by the numbers in the red window. Stupid, I suppose, but they still fascinate me.

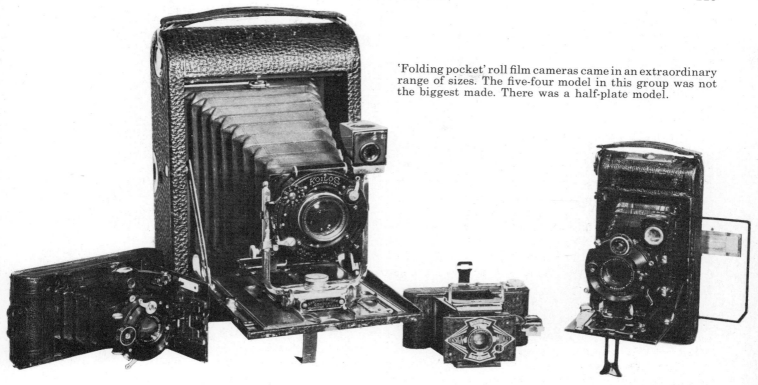

'Folding pocket' roll film cameras came in an extraordinary range of sizes. The five-four model in this group was not the biggest made. There was a half-plate model.

The rising front was a feature of many early roll film cameras, though the feature could only be used by guess-work, if roll film was loaded into the camera. Only the N & G has a rising front on the viewfinder.

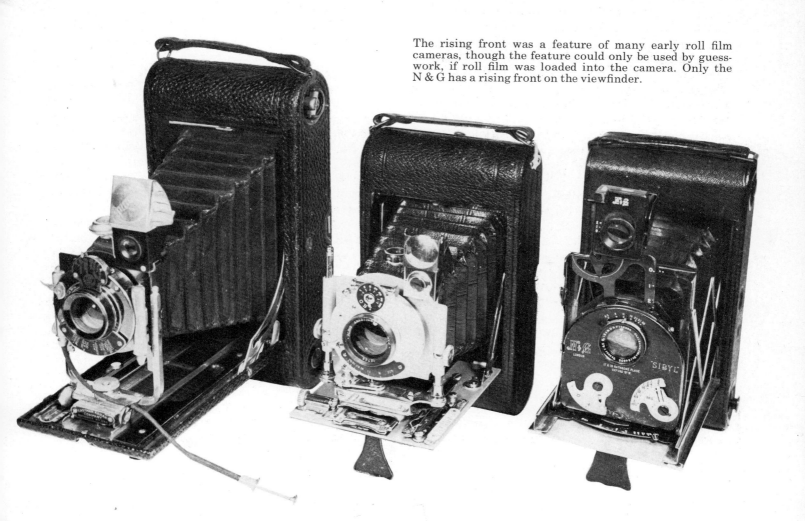

Folding
Plate

The term 'folding plate camera' is one that could be applied to a great many cameras; it could be applied, for example to most of those described in chapter two of this book.

However, it is applied particularly to a specific type of camera which emerged onto the photographic scene in the early years of this century. In many ways, it may be regarded as a 'hybrid'—an offspring of the early folding roll film designs, with strong leanings towards the 'hand and stand' variety.

The term seems to be a modern one, for looking through various maker's lists of the years between the beginning of the century, and the first world war, I find them described as pocket cameras, folding cameras, folding cameras for plates, and, of course, just cameras.

First, then, it would be as well to define just what these cameras are. They resemble compact hand and stand cameras, but the body is never square. It is always just a shade larger than the plate size which the camera is meant to hold.

In a hand and stand camera, the body is substantially square, and carries either a revolving or a reversing back to allow the choice of landscape or upright pictures. Beyond the square form, it may sometimes be 'tallbody'.

In a folding plate camera, the entire camera is turned on its side for landscape pictures, or held upright for upright pictures, exactly as one does with a modern miniature camera, or, for that matter, one of the old folding roll film cameras.

I once heard these cameras described as 'roll film cameras for plates', which though it may sound somewhat facetious, is extremely apt, since there cannot be the slightest doubt that these cameras are a strange offspring of the folding roll film design.

I have yet to find a camera which comes in this class which pre-dates the earliest folding roll film cameras.

Soon after the first folding roll film cameras came on the market, around about 1900, several makers produced cameras of a very similar character which had no mechanism for the transport of roll film through the camera, but just the simple arrangement necessary to accommodate a plate-holder.

Some of these makers then went on to produce roll film cameras which were greatly similar, or even identical in the arrangement of the focusing track on the front board, and the lens standard, to the folding plate cameras they had already produced.

So, while in the case of many makers, roll film versions followed plate versions, which is rather what one might expect, these particular plate cameras took their form from the original folding roll film jobs. This was my reason for dealing with the roll film cameras first, even though I was aware that in the case of some makers, it would seem to be putting the cart before the horse.

A case of this inversion was the inventive Arthur Newman. His Sybil series of cameras appeared first as folding plate cameras, in 1906. They were made entirely in metal, and were very compact and light. One size only was made

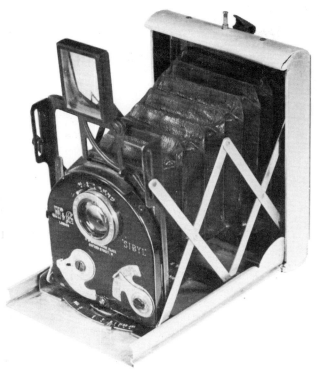

The first N & G model which carried the famous name of 'Sybil'.

at first—for $3\frac{1}{2}$ in × $2\frac{1}{2}$ in plates—and in the nicely designed single metal plate holders that were supplied with the camera, the whole width of the plate was utilized for the image, and only about $\frac{1}{8}$ in was lost by the narrow rebates that held the plates by its ends. This gave an actual image size of $3\frac{3}{8}$ in × $2\frac{1}{2}$ in, which compared very favourably with the 4 in × 3 in image which one usually got from a quarter plate in a wooden holder, which had a $\frac{1}{8}$ in rebate all round.

This was achieved in a camera which measured $3\frac{1}{2}$ in × 5 in × $1\frac{1}{8}$ in when folded, and weighed just one pound. It was really pocketable, and six plates, ready for use in their metal holders could be carried in a neat leather wallet in your other pocket.

The earliest models of these cameras can be picked out by three points: 1) the body has rounded ends; 2) the lens is a 6.5 Cooke series III in a brass mount; 3) there is no tripod bush on the camera.

This last was a disadvantage, for if you wished to use the camera on a tripod, you had to make use of a folding 'cradle' of wood.

The later, square ended folding plate Sybils did have tripod bushes, but because of the light-ness of the whole camera, they are the shallowest I have ever come across. I am looking at one now—there are barely two turns of the screw thread. Most Sybil users, I am told, preferred to use the 'cradle', for there was always the risk of straining the rather light camera body if you did mount it on a tripod directly.

Folding plate Sybils were made in two other sizes; quarter plate, and 'Baby'. This last gave negatives just over VP size, viz $2\frac{5}{16}$ in × $1\frac{3}{4}$ in.

By 1912, when the roll film Sybils were introduced, N & G were also making the Sybil De Luxe, which had double extension, and was fitted with a double Protar lens, and the Imperial Sibyl, with an improved shutter, and various other refinements. There was also the postcard Sybil, and, using the same body, the stereo Sybil. Most of these models were available with a choice of lenses.

In 1912, the company introduced a roll film model to correspond with every variation of the folding plate version.

Counting from their list, I make it a total of forty-six variants on the Sybil theme prior to the first world war. Arthur Newman never did things by halves.

The Sybils, as I have said, were expensive cameras.

Efficient and Inexpensive

At the other end of the price range, the Houghton company produced some excellent inexpensive folding plate cameras.

As far as I can discover, their first in this field was the 'Tudor'. Quarter plate—double extension—rising and swing front—Busch $f/8$ rapid symmetrical lens—complete with one double dark slide, price £1.37$\frac{1}{2}$. Or in the currency parlance of the day, twenty-seven and a tanner.

This was just the first of a long series of folding plate cameras from this company, of which the best known are probably those made under their Klito brand name. These were offered with various qualities of lens and shutter, and ranged in price from £1.25 up to about £6.00.

I have been surprised by the number of photographers of my father's generation who have told me that their 'first good camera' was a folding plate Klito. From what I have been able to judge myself, they were wonderful value for money, and capable of first class work, especially if you ignored the always-to-be-

This version of the Newman shutter is to be found on the postcard and stereo 'Sybils'.

suspected focusing scale, and focused your picture on ground glass.

It was at this time that Houghtons introduced their envelope system for plates or cut films, which is an admirable device.

You had an adaptor, which cost fifteen bob (75p) for quarter plate. It was fitted with a focusing screen, and a sliding shutter on the front, like the sliding shutter of an ordinary plate carrier. The back opened like a door, and the focusing screen came with it, mounted on springs. Within the door was a second door, to allow you to inspect the focusing screen when the main door was closed.

You put the adaptor onto your camera, in place of the ordinary focusing screen, and with the shutter open focused the image. Now you closed the sliding shutter, and opened the door at the back. Flat films were supplied by Houghtons, each in a black paper envelope (ten for fifteen pence).

The front of the envelope was a sliding shutter of thick black paper, with a strip of wood glued to the bottom edge. This envelope went into the adaptor, and you closed the back. The sprung screen held it firmly in exact register, and a slot

in the sliding shutter engaged that strip of wood; when you opened the sliding shutter, you also opened the envelope.

You then made your exposure. When you closed the shutter on the adaptor, you also closed the envelope, and could safely remove it from the adaptor.

Simple. Effective.

With care, you could reload the envelopes, but being of paper, they did deteriorate with use. I still have some, but they are getting sadly tatty.

But they were nice. One adaptor and twelve cut films or plates in envelopes took up much less space and weighed a lot less than six double dark slides.

These old accessories are as collectable as the cameras themselves, and if anything, rarer. One of the joys of finding an old camera, complete in its original case, are the extra bits and pieces that turn up once in a while.

Another extra for the folding plate cameras was, obviously, the roll film back.

Roll film Backs

These carried and transported roll film entirely behind the camera, which meant that before reaching the gate for exposure, the film had to be turned 180 degrees around a roller.

Modern roll film backs for such cameras as the very expensive Hasselblads and Linhoffs do just this, and it is generally acknowledged that this keeps the film flatter than the more ordinary roll film camera arrangement.

The pictures in this book were mostly taken on 120 roll film, using such a back, some using a Linhoff, and some, just for the fun of it, using a variety of vintage folding plate cameras with equally vintage RF backs.

One of my favourites is a Zeiss folding plate camera, over forty years old, which uses 9 cm × 12 cm cut film or plates in its ordinary backs, and has an RF back for 120 as well. This type of camera is an excellent collector's item, and a pleasure to use, and no collection should be without one.

I have friends who are collectors of ancient guns, and I have often thought that cameras have the same sort of appeal as these weapons, with none of the disadvantages. The technology of cameras is at least as interesting as that of firearms, and the quality of workmanship can be just as high. With a vintage camera, one can take shots with perfect freedom. With an

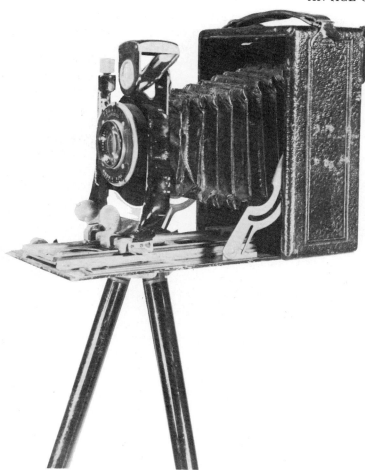

ancient gun, you *can* fire it, having due regard for the requirements of the law. But when you do, that lovely gun barrel will be a little less perfect with each bullet that hurtles through, whereas you can allow light to nip through your most precious lens with perfect safety. And you have no worries with the law, or a possible dangerous accident.

Forgive the digression.

Returning to folding plate cameras, one continental company that made them for many years was Goerz. Their Tenax series of folding plate cameras are beautifully made cameras, and include the Autofoc Tenax series. These have a pair of spring loaded steel tapes running alongside the focusing tracks, and when you open the front, the lens standard moves with great dignity to the working position all on its own. These, as far as I know, were all made before the first world war.

A small point of dating about these Goerz folding plate jobs. If the focusing screen is fitted with double doors, opening from the centre, instead of the usual single door, then you have a pre-world-war-one camera.

Inexpensive folding plate cameras of very good quality were turned out by such companies as Houghtons in the nineteen twenties.

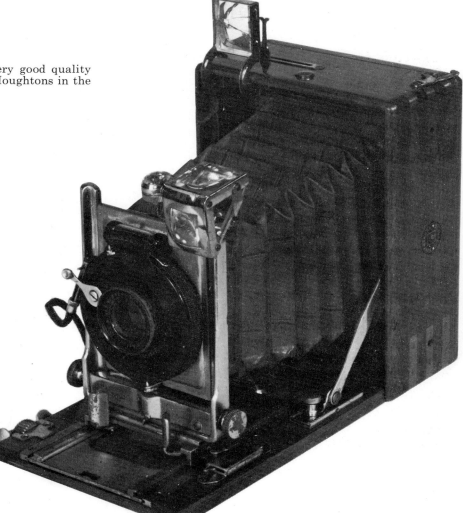

A fine 'tropical' by Ernemann.

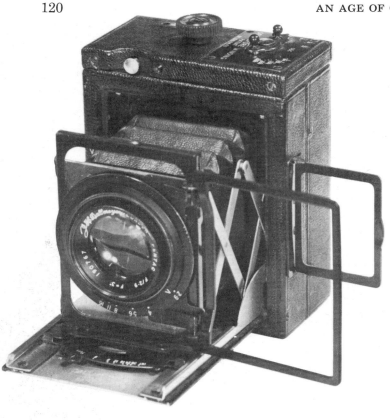

The folding plate cameras bearing the Zeiss name that were made in the late twenties, after the company embraced a number of other famous continental companies, are all excellent, and if you want a folding plate camera to use, as well as to show in your collection, I suggest that you should do some seeking in this area.

One rather special little folding plate camera is the Bergheil, from Voigtlander. It takes a VP size negative—$2\frac{1}{4}$ in \times $1\frac{3}{4}$ in—and has a Heliar lens in a Compur shutter, either dial set, or rim set according to whereabout in the nineteen-twenties the camera was made. The front standard locks with perfect precision in the infinity position, and you must disengage a register pin, as well as release a friction lock to refold the camera. The focusing is very precise, can be locked at any setting, and at the full extent of the camera's double extension, gives you an image the same size as the object you are looking at.

Mine is the ordinary model, finished in black morocco, but they were made with leather covering and bellows in other colours, and on the De Luxe version, the metal parts were gold plated!

I'm very fond of my little 'ordinary'. It may not have gold plating, but it has got a telephoto lens, in addition to the standard Heliar. You unscrew the elements of the Heliar from the shutter, and replace them with the elements of a very pretty little Tele-dynar.

With this latter lens, you must employ ground glass focusing. Using the standard lens, you can get excellent results using the focusing scale, which says something for the precision with which the whole camera is constructed.

But you've still got to guess the distance!

An unusual folding plate camera was the 'Baby speed' by Dallmeyer. It was fitted with a Newman and Guardia focal plane shutter, and was used on its side for horizontal pictures.

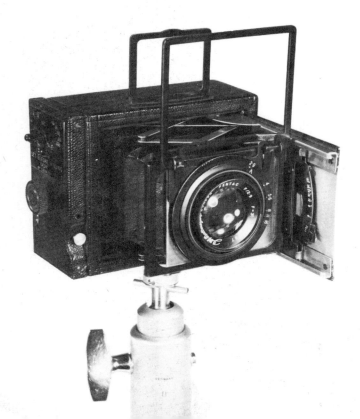

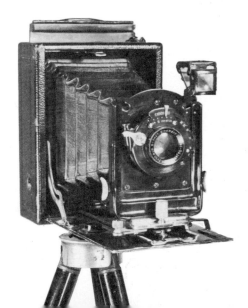

An inexpensive Ernemann folding plate camera.

A very fine 9×12 cm 'Maximar' by Carl Zeiss, complete with roll film back and plate holders with adaptors for cut film in a range of sizes up to 9×12 cm.

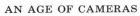

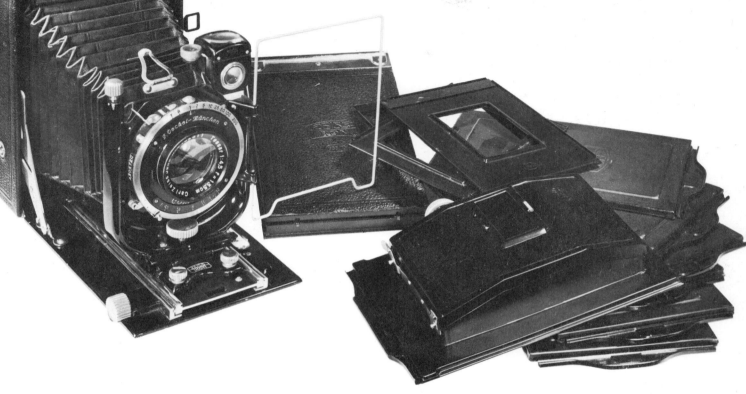

Below, another 'Maximar', and right, the 'Clack' by Reitschell, the compound shutter of which dates it before the first world war.

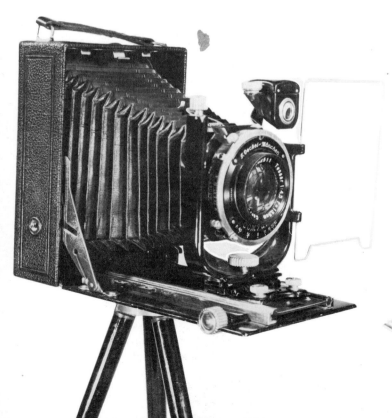

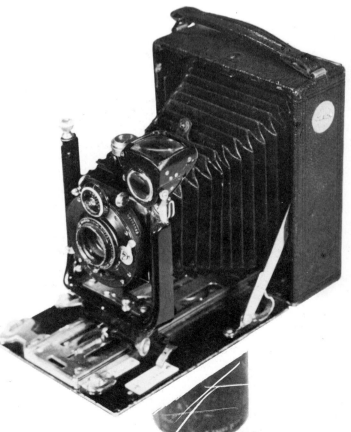

Cameras with Two Eyes

The theoretical possibility of stereoscopic pictures—pictures which, if suitably viewed gave an illusion of three dimensions—had been understood for many years before photography arrived. Stereoscopic drawings had been produced, which demonstrated the effect with simple geometric figures.

Almost from the very beginnings of photography, stereoscopic pictures were taken. It was almost as if some photographers took the attitude that while they were taking the trouble to produce a photograph, they might just as well make it a stereoscopic pair.

Certainly stereoscopic viewers, together with sets of slides which could be bought ready made, enjoyed a great vogue in the wet-plate era, before our period begins.

With the advent of dry emulsion, interest in stereoscopy bloomed anew, for now it was something rather special which the amateur could do for himself.

We see the world around us in three dimensions because we have two eyes. Because our eyes are separated by a small distance, they record two slightly differing views of the same scene. It is because we perceive an image made up of both views simultaneously that the scene around us possesses depth, and objects appear to be solid.

So the requirement for a stereoscopic camera is that it must take two pictures at once. In its simplest terms, it is a pair of cameras, linked together, with their lenses roughly the same distance apart as the human eyes.

It is a double camera—a Jumelle—but unlike the twin lens reflex that we have already considered, both cameras are used for taking.

However, you can take a pair of stereo pictures with any camera, by taking two separate shots, and moving the camera laterally by a short distance between them. But this is only practical for still life subjects. It is quite useless for people, or for any living creatures.

In the early part of our period many ordinary wooden stand cameras were adapted and used for stereo photography. All that was needed was that the following requirements should be met.

First, that the front of the camera should be wide enough to take two lenses, side by side, at the right separation.

Second, that the camera should be fitted with a 'septum', or partition, which divided the light-tight chamber into two compartments.

Third, that the camera was of suitable size. The ordinary half-plate camera—in any case by far the most popular size at the time—was ideal. The septum would divide it to give two pictures roughly 3 in wide by 4 in deep, and the distance between the negative centres—three inches—suited the required lens separation admirably.

Of course, you could use a larger camera, but you either had to fit a reducing back, so that you could use a smaller plate than the camera was designed for, or waste an awful lot of plate area.

In fact, I have never seen a camera larger than half plate adapted for stereo work.

Obviously the two lenses that you used had

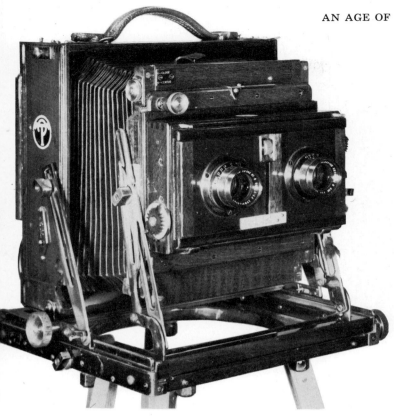

A half plate 'Special Ruby' set up for stereo use. Very few half plate cameras had a front panel wide enough to take the paired lenses for stereo photography.

holds the plate holder, at the back of the camera.

These little cutaways were for anchoring the septum in position, which usually took the form of a small spring roller blind, which adjusted itself immediately to focusing movements.

Various shutters could be bought, some which fitted in front of the lenses, and some behind. The 'in front' type were sometimes interlinked sector shutters, sometimes simple 'see-saw' arrangements, which crossed one lens moving in an upward direction, and the other downward.

But the one you are most likely to find on these 'half plate conversions' is a double version of the simple roller blind 'mouse trap' shutter, which fitted behind the lenses, and carried those lenses on its front board.

In these a single wide blind coped with the needs of both lenses at the same time, and the nicely made stereoscopic shutter of this form which was made by Thornton Pickard also had a front panel divided in two down the centre, and fitted with a simple screw adjustment, so that the inter-lens distance could be altered. It was found to be an advantage to increase the distance between the lenses for subjects at a greater distance.

Stereo Sizes

There was one very great practical advantage to using a half plate camera for stereo work. Because this size of camera was far and away the most popular among amateur users of plate cameras, the plates were always readily obtainable.

If a camera shop stocked only one size of plate, then that size would be half plate.

Special stereo size plates were not always to be had on demand.

By the early eighteen nineties, many cameras were being made especially for stereo work, using special stereo plates, which measured from $4\frac{1}{4}$ in \times $6\frac{1}{2}$ in (double quarter) in the widest proportion, to about 3 in \times 7 in in the narrowest —all these in the larger range of sizes.

Around the turn of the century, the Jules Richard series of cameras appeared, using much smaller plates, some less than 2 in wide by $4\frac{1}{4}$ in long.

These cameras are important, for what Richard produced was more than just a camera. It was a system of stereoscopic photography.

In the Richard system, diapositives—trans-

to be identical, and most of the lens makers of the day would supply you with 'a matched pair of lenses for stereoscopic work', for a small extra charge.

The only other point to be taken care of was that the focal length should be suitable. The ones usually fitted to half-plate cameras used for this sort of work are about five inches focal length. Shorter lenses do enhance the effect of depth in the pictures when viewed, but constructional limitations make the shorter lenses rather awkward to use on half plate cameras.

You will frequently come across ordinary single lens half plate cameras, with wide fronts, that were supplied as 'suitable for stereo work'. One way of discovering whether your single lens half plate was such a camera is to remove the lens panel, which will be long horizontally and rectangular, and look at the board of the front standard which is now uncovered. You should find two small squares cut out of the wood in the middle of the long horizontal edges of the opening, and a similar pair of cut out squares in the inner edges of the frame which

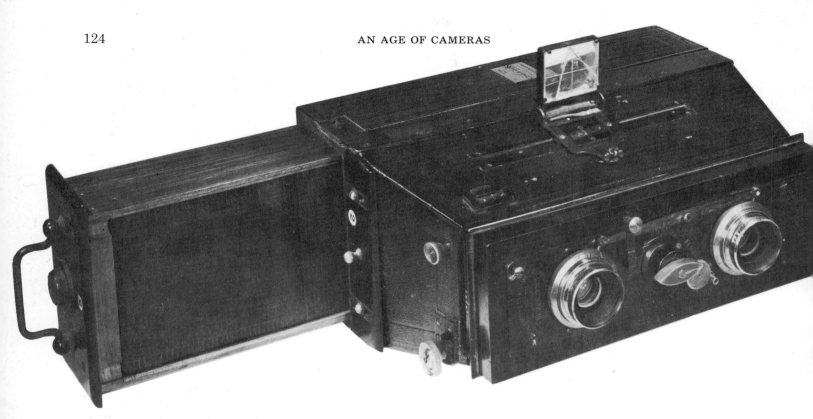

An early Stereo camera by Mackenstein of Paris. Note
the wooden changing box. Cameras of this shape were
sometimes called 'Stereo-jumelles'.

parent slides—were produced, and in the early
stages, the camera was arranged so that it
could be used as a viewer. This arrangement
was carried on in the cheaper models, but the
company also made special viewers, culmina-
ting in table and pedestal models, which con-
tained magazines of slides for viewing, which
could be brought into position automatically.

So far as the cameras were concerned, the
company's main product was the Verascope,
probably the best known name in stereoscopic
cameras. The early models were all of the small
size—45 mm × 107 mm—but later there were
other models at 60 mm × 130 mm and 70 mm ×
130 mm. All of the Verascopes except some of the
very late models made in the middle twenties
have fixed focus lenses, providing a sharp
image of everything at a distance of ten feet or
more. This absence of a focusing adjustment
seems to have been an article of faith with this
company, and one cannot help feeling that
some of the potential of these beautifully made
little all metal cameras was being thrown away
by the deliberate omission of a simple focusing
arrangement. The cameras were offered to the
public with a variety of excellent lenses, and
they were not cheap—the best model cost over

fifty pounds in 1920—and I find it a little hard to
understand why the company chose almost to
make a virtue of this omission.

Apart from the Verascope, the company also
made the Glyphoscope, an exceptionally simple
and cheap stereo camera, which could also be
used as a viewer, by removing the shutter panel
from the front of the camera. This dual use was
also a feature of the earliest Verascopes.

The third variety of stereo camera from Jules
Richard was the little Homeos, which took its
pictures on 35 mm film. It measured $6\frac{1}{2}$ in × $2\frac{1}{4}$ in
× $2\frac{1}{4}$ in and was of compact, solid all metal
construction. This was the latest of the Richard
cameras, and appeared in 1925.

With the exception of the Homeos, the Richard
stereo cameras were basically plate cameras,
although very nicely made roll film backs were
available to fit most models.

The simplest way to use the cameras was with
a single metal slide, holding one glass plate.
However the desirability of some form of
magazine was obvious, and so these cameras
were equipped with changing boxes. These
held twelve plates, and a simple mechanical
action removed the exposed plate from the
image plane, and brought the next one into
position.

These automatic changing boxes are a feature
of many plate stereo cameras, apart from those

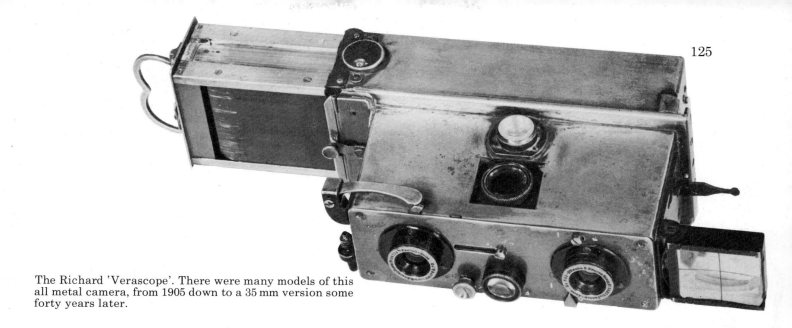

The Richard 'Verascope'. There were many models of this all metal camera, from 1905 down to a 35 mm version some forty years later.

made by Jules Richard, and are also used on single cameras.

Changing Boxes

The twelve plates are carried in separate sheaths of thin metal, which cover the back of the plate, and embrace the two long edges of the plate. One short side is also closed, at the end which faces away from the handle of the changing box.

In these sheaths, the plates can slide over one another without rubbing the emulsion.

The plates in their sheaths are loaded into the drawer of the changing box, either through an opening at one end, or by a mechanism which opens the drawer top.

The drawer is arranged to slide in and out at one end of the box. So that the plates shall not be fogged when the drawer is out, there is a 'blind' which covers the top when the drawer is in the out position. This blind is sometimes of paper thin steel, and sometimes made of tiny wooden strips mounted on fabric.

Each time the drawer is pulled out, the top (exposed) plate remains in the box, and drops to the bottom of it when the drawer is right out. Now when the drawer is pushed in, a new plate slides into position, while the exposed plate slides under the bottom of the pile.

The 'Glyphoscope' by Richard. Left, as a camera. Right, with the shutter unit removed, for use as a transparency viewer.

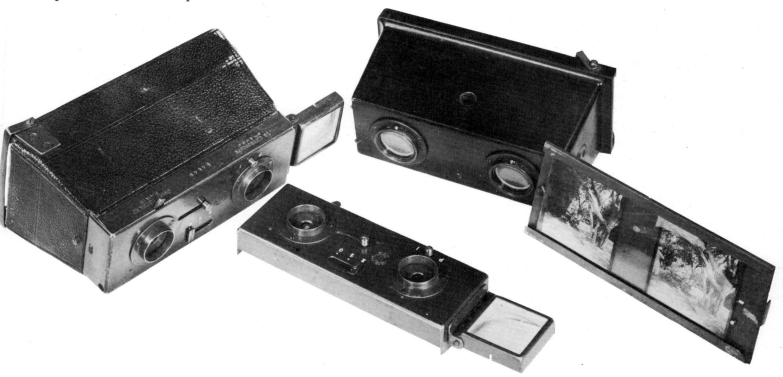

The ICA 'Polyscope', in which one lens could be centred (as here), when the camera could be used for landscape work.

If you find one of these changers, it may well have some old glass plates in it. They will probably be useless photographically, but do not discard them, for they serve to demonstrate the working of the box.

If you try to operate these changing boxes without plates in the sheaths, they often jam, since the sheaths, being made of very thin metal do not always stay flat. When they jam, it is quite easy to damage them.

Its worth 'loading' the sheaths with suitable pieces of stiff card, if you have no plates.

The changing boxes for the Richard cameras, and for many other similar cameras, are made of metal, but those for some of the earlier, larger cameras, are wooden. If you find one in working order it is worth taking care of, for such a changing box is an example of a now extinct commodity—a precision mechanism, made in wood. It represents a type of craftsmanship—both in the making, and in the knowledge of woods—that would be difficult, if not impossible to find nowadays.

Of the same solid format as the Verascope were many other similar cameras—the Heidoscope of Franke and Heidecke—the Polyscope from Ica—the Veragraphe from Tiranty in

Paris—the Stereoflectoscope from Voigtlander—the Ontoscope from Cornu—the Simplex from Ernemann—the Steroco from Contessa Nettel, and many others.

Apart from these, other types of camera had their stereo counterparts. Among the less expensive were the falling plate magazine cameras. These were very popular among the less wealthy stereo enthusiasts of the nineties. Lancaster, for example, offered such a camera of simple box form in 1896 for two guineas—£2.10.

Falling Plate Stereo Cameras

In these simple cameras, the septum dividing the camera in two would obviously get in the way of the exposed plate which was being dropped into the camera bottom. So you will find that it takes the form of a 'door' of thin metal which can be swung sideways, to allow the plate to drop. Since these cameras were fixed focus, the rigidity of this 'door' did not matter.

The folding roll film camera had its stereo versions, and the Stereo-weno from the Blair camera company is typical of these. This became the basis of a Kodak camera when Blair became part of that organization. These cameras had pneumatic shutters, with a single timing cylinder controlling both sets of shutter blades.

The Rolleidescope, for reasons we have noted in the TLR chapter, might well be considered as the stereo version of the TLR—if you care to interpret the initials as 'three lens reflex'. These lovely cameras, which appeared in 1923, also used a pneumatic shutter—a double version of the Compound—which is a delightful piece of mechanism, and mine, after fifty years, is still perfect.

At the time of the early models of this stereo Rollei, there was no one to twelve numbering on 120 film, so the one to eight numbers were used in an ingenious manner. The red window is long, and the numbers are brought to different points along its length, indicated on the white inner face of the sprung window-cover. This gave five pairs and a single. This long window is a mark of the early models of this camera.

The other form of reflex—the SLR—also had its stereo versions. There was, for example, a very nice stereo version of the famous Soho.

The 10 cm × 15 cm version of the Contessa Nettel, which will be considered in the next chapter,

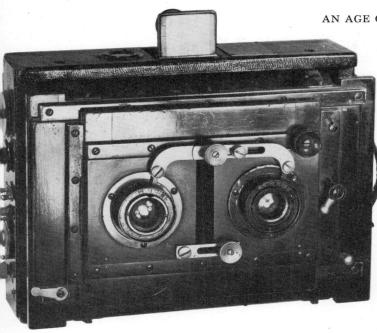

The stereo version of the famous Goerz 'Anschutz' camera. Again, here was a camera which could also be used for landscape work.

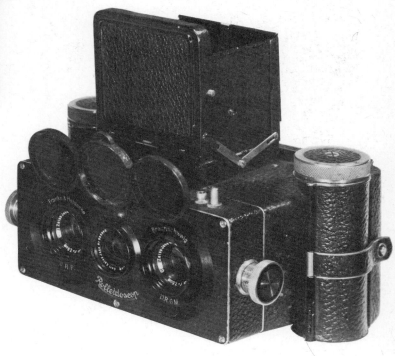

The 'Rolleidescope'. This derived from the earlier plate-loaded 'Heidoscope', which must be regarded as the direct ancestor of the Rolleiflex.

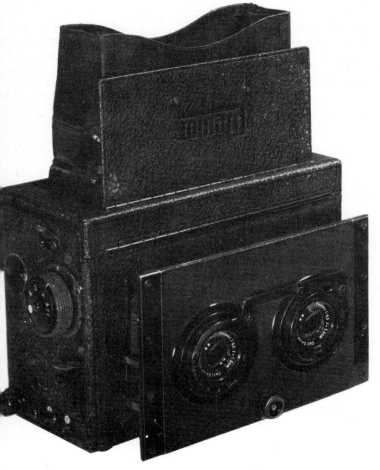

Most types of camera had their stereo versions. Here is a stereo 'Press reflex' by Mentor. Both images were available for inspection.

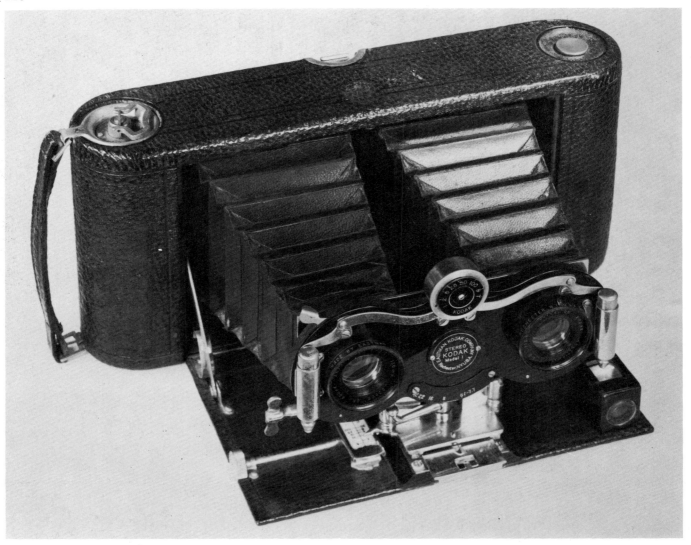

Even in stereo versions, Kodak cameras still had the
unmistakeable Kodak look to them.

could also be converted for stereo work, as
could other similar cameras.

The famous Goerz Anschutz camera, also
included in the next chapter, was supplied in
special stereo models, as was the Tenax folding
plate camera from the same company. In the
same class was the stereo Sybil from Newman
and Guardia, while, as we have noted the half
plate Universal was also made in a stereo
version.

Many makers of folding plate cameras pro-
duced stereo versions, mainly in the years of
this century before the first world war. Voigt-
lander and Ica produced, around 1910, cameras
with a central third lens, which could be used
without the septum to give wide single land-
scape shots.

Under their Palmos name, Zeiss produced a
stereo folding plate camera which was unique.

It was specially designed for short distance
work, when lens separation ·becomes critical,
and linear cams in the baseboard made this
adjustment automatically when the camera was
focused.

But perhaps the rarest of all stereo cameras
I have seen is a custom built Leica. In the brief
glimpse I had of one of these cameras, it ap-
peared to me to be compounded of two Leica
standards, within a single body, and since the
standard is dated in 1933, I think we can include
this camera in our period.

I was informed that only six of these cameras
were ever made. . . .

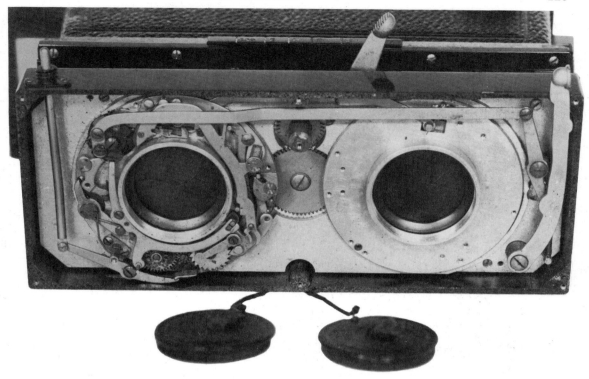

Above, the double Compur shutter of the ICA Polyscope.
It is really a normal Compur mechanism, with a 'slave' set
of blades added.

Below, the double Compound of the Rolleidescope features
two complete mechanisms which share a single pneumatic
control cylinder (bottom centre).

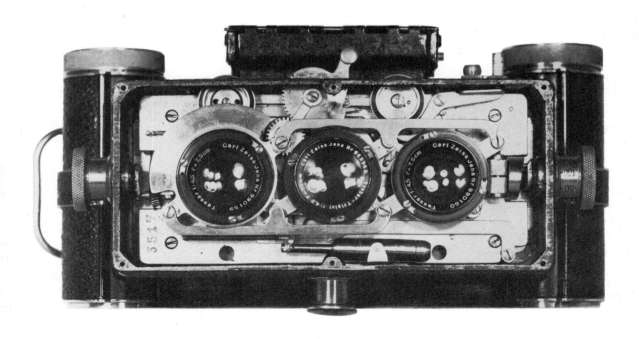

Struts and Lazy-tongs

The two sorts of cameras to be considered in this chapter are somewhat similar in appearance, very similar to handle, and made up between them the main competition to the big single lens reflex in the field of Press photography.

The strut cameras have front boards which are held rigidly at the correct distance from the film plane by a system of struts, which can be either folded, or disengaged, to collapse the camera. Front is joined to back in these cameras by bellows, whose sole function is to complete the light-tight chamber of the camera. These bellows take no part in focusing. They merely form the sides of what may be considered as a collapsible box.

Focusing is achieved in these cameras by means of the lens mount, which contains some form of helical device by means of which the lens can be moved smoothly and precisely along the fore and aft axis of the camera.

Most of these strut cameras employ focal plane shutters, but there are exceptions.

The second class of cameras to be considered here have the separation of the lens panel and the film plane determined by a simple lattice of metal strips, forming lazy tongs. Like the struts, they can be disengaged for folding.

Bellows are part of the construction, but in this case they do move for focusing, which is achieved by use of the lazy tongs.

If the lateral distance between opposite points in a lazy tongs lattice is altered, then the overall length of the lazy tongs also changes.

So the lens can be rigidly mounted in the front panel, and by means of a simple screw mechanism added to the lattice, focusing can be achieved smoothly and precisely.

Again, most of these cameras use focal plane shutters, but there are exceptions.

Both these classes of cameras have a long and honourable history of service in photography, and include some famous names.

One of the earliest successful folding portable cameras for amateur use was a strut type camera. It was the Eclipse camera by J. F. Shew & Co of Newman Street, in London.

This camera is made of wood, and the struts in the folded position cover the bellows, and have cutaways to accommodate the lens.

The early models, which appeared in 1886, had fixed lenses, and no adjustment for focusing could be made. Since the strut arrangement made it certain that the lens was correctly positioned in relation to the sensitive plate each time the camera was opened, these cameras gave excellent landscape shots, with everything acceptably sharp from about twenty feet to infinity. Later models, made, as far as I can tell after 1888, were fitted with focusing. I say 'as far as I can tell', because with cameras of this period, very often the only evidence of date is to be found in the surviving advertisements. The fact that a maker like Shew did not mention a particular feature—focusing, for example—in his advertisements before a certain date, does not necessarily mean that he had made no focusing cameras up to that time. Often these

features were available to customers who asked for them.

In the 1880s, many camera suppliers were quite small concerns. The cameras were built in small batches. You could have 'made to order' features, 'for a small extra charge'.

The shutters on these cameras were, apart from the 'out and in' blade type shutter which worked in the stop slot, probably the earliest 'between lens' shutters. They took the form of a rotating disc, placed midway between the elements of the rapid rectilinear lens, and powered by a simple flat spring. Right alongside this shutter disc, and concentric with it, was the usual wheel stop.

These are pretty little cameras, usually with bellows of claret coloured leather, and in an era when most makers were content to follow the usual baseboard type designs, originated by such pioneers as George Hare, this design is interesting, and, because of its practicality and convenience, important.

Mr Shew was blazing a trail which other makers would follow, and which he would stick to for at least twenty-five years, for there

The little quarter plate Shew 'Eclipse', above, could be folded, and carried in a jacket pocket. However, three double dark slides, loaded with plates in the other pocket would weigh more than the camera itself.

After the 'Eclipse', the Shew company produced several versions of their 'Xit' cameras. Left is the postcard 'Xit' nicely re-inforced with aluminium. Below, the 'Eclipse' folded.

followed many strut cameras from this company, all using struts in the form of hinged wooden sideboards. After his original Eclipse series of cameras, in quarter and half plate sizes, he hit upon the name 'Xit' which he used with variations to designate all his subsequent strut cameras, the variation being usually the name of shutter used, e.g. the focal plane Xit, or the Koilos Xit, though there were also such versions as the Aluminium Xit, the Post Card Xit and the Five guinea Xit. I cannot discover that there was ever such a thing as the 'Roll film Xit', though you will sometimes come across these cameras fitted with Eastman roller slides.

The company drops out of the picture at some time during the years of the first world war.

Anschutz

We have noted that the strut type camera may be considered as a collapsible box camera, and this fact becomes abundantly clear in the case of one of the most famous names of all in the strut camera field.

This name is Anschutz, probably best known as Goerz Anschutz, but originally just Anschutz, after the inventor, one Ottomar Anschutz.

The original Anschutz camera, patented in 1888 was a simple wooden box, with a brass mounted lens at the front, and a focal plane shutter built into the back. Subsequently—I think at the time when the Goerz company took over the manufacture of the Anschutz cameras

in 1892, the box was made collapsible, and the struts were added to hold it rigid.

This camera is of great importance in photographic history, for it was the first camera that was put into production, and offered to the public, which incorporated a focal plane shutter.

Ottomar Anschutz a German, was a naturalist, first and foremost, and became a photographer because he recognized in photography the best possible means of recording his observation of living creatures. To that end he designed for himself a camera using a focal plane shutter.

Now photographic historians point out—quite correctly—that the focal plane shutter was invented by William England as long ago as 1861, and that Anschutz, to whom the invention is often attributed, was not the inventor. I think this is all rather beside the point. The point is that Anschutz patented a camera in 1888 which offered, for the very first time, the possibility of the kind of high speed photography which natural history, zoology, and ornithology demand.

Two versions of the Goerz 'Anschutz', half-plate and five-four. This design must be regarded as the classic strut camera.

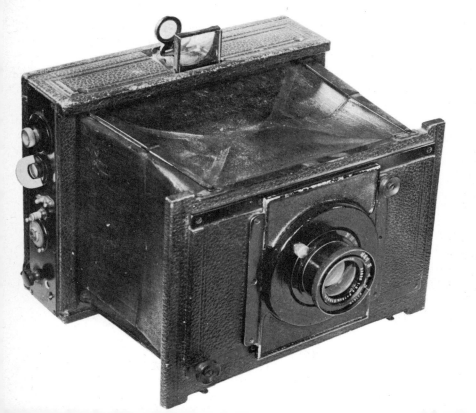
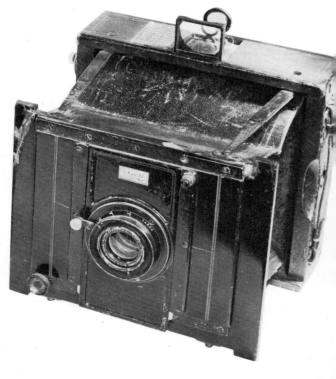

I think that the shutter he designed was the result of his own original thinking, and that it is most unlikely that he was even aware of the pioneer work of William England twenty-seven years earlier.

The Anschutz shutter consisted of a fabric blind, in which was a slit. The slit was formed by cutting across the blind, sheathing the two edges with thin brass strips, and joining them together with fine cord. This was just a single piece of cord, running through holes in the ends of the brass edging strips, and having a slider at one end, which could be moved along one blind edge. By this means the width of the slit could be altered, thereby varying the exposure.

This alteration of slit width by direct manipulation of the blind itself is a feature of the earliest Anschutz pattern of focal plane strut camera. These shutters were not self-capping—the slit remained open during winding—and so the dark slide containing the plate had to remain closed until you were ready to expose.

Spring tension on these shutters was variable in a series of steps, and by combining slit width and tension, a skilled photographer could get just the exposure characteristics he needed. But this only came with experience. There was no ready made calibration on these shutters.

Anschutz Improved

This basic form of shutter remained on the Anschutz cameras up to 1906, although there were many improvements in the detail design during this early period.

In 1906 a new Anschutz shutter was introduced. It was self capping, and slit width was controlled by an external setting knob. Settings of slit width and tension were tabulated, and you had a wide range of possible shutter speeds.

It was a very good shutter indeed—except for the slit width calibration on the setting knob. Why did they have to use such minute figures on scales in those days? Or did photographers have better eyesight before the first world war?

It occurred to me, as I sat here typing those last words, that it was quite some while since I handled a Goerz Anschutz camera, and so I got up and crossed this room, and took one from the shelf. It's been sitting up there, undisturbed for some months now, and it was originally made before the first world war. It is a 10 cm × 15 cm model, with a 180 mm Goerz Dagor f/6.8 lens, which has acquired a natural blooming

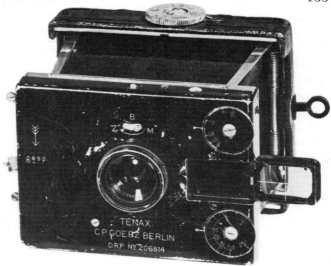

The strut 'Tenax' from Goerz. The company used the name 'Tenax' for several different cameras.

over the years. The shutter blind is the original one, and it just whispers across. There was never anything violent about the action of those Anschutz shutters—maybe that's why so many of the press photographers of the day preferred them.

One of these days I must get round to taking a few pictures with that particular treasure. It's difficult when you have a room full of vintage cameras, most of them in working order.

Life is too short to do all the photography you'd like to. . . .

Looking at the 1912 Goerz list, this particular model was made in quarter plate, 5 in × 4 in, 10 cm × 15 cm, and half plate. The older type, with internal shutter adjustment, was still on sale in a tropical version, and I am told that the simpler shutter was considered less likely to go wrong under conditions of heat and humidity.

There were also two stereo models, using 10 cm × 15 cm, and 9 cm × 18 cm plates, both with the later type of shutter.

These stereo cameras could also be used for landscape work, with one lens slid to the central position, and the septum removed.

Nor was that the end of the Goerz strut cameras. There were the two sizes of baby Tenax—styled Vest pocket (1¾ in × 2¼ in) and Carte de Visite (2½ in × 3½ in). These were fitted with cam focusing operated from the camera body, and had specially made compound shutters in rectangular cases.

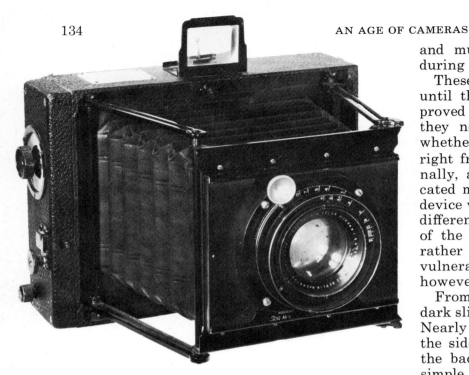

The Zeiss 'Palmos'. This particular example in the 10 × 15 cm size is fitted with a Goerz 'Celor' lens, which is not standard. The normal lens was a Tessar.

The single metal slides for these cameras are unique. They are the only ones I have ever come across that do not load through the front sliding shutter, but through a separate door at the back.

Another favourite strut camera among pressmen was the Zeiss Palmos. This, according to the records I have, appeared in 1902, but I cannot confirm this as, sadly, the Zeiss archives and museum were destroyed in an air-raid during Hitler's war.

These cameras remained in the lists right up until the thirties, and though they were improved in detail—mainly in the early years—they never had a capping shutter. I doubt whether this was a disadvantage. Slit width, right from the earliest models, was set externally, and these shutters were very sophisticated mechanisms, employing a double spiral device within the winding roller to achieve the differential movement between the two halves of the blind. Part of this mechanism was a rather slender slotted rod, which could be vulnerable to rough handling. Properly used, however, these shutters were most reliable.

From the pressman's point of view, the double dark slides on these cameras were the best ever. Nearly every other DDS slid into position from the side. The Palmos type simply snapped on the back, and dropped off at the touch of a simple catch. For fast changing, they were unexcelled.

The Robust Ernemann

Another famous press strut camera was the Ernemann. A massive all metal job, this, that stood up to the toughest handling. The clout of the shutter is a little disconcerting, and after my first shots with an Ernemann I was quite surprised to discover that it had not caused any deterioration of image quality by camera shake whatsoever. The clout is quite easily felt, but

Two of the very sturdy Ernemann strut cameras. The weight of these cameras makes them sit well in the hands, and they are capable of fine results even at low shutter speeds.

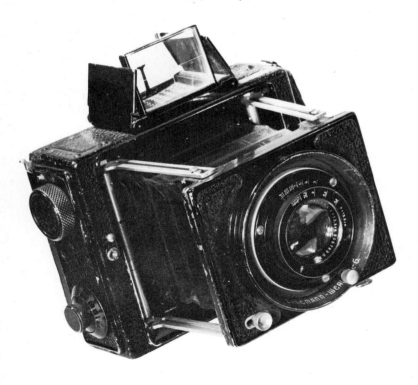

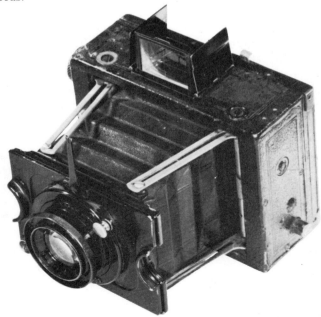

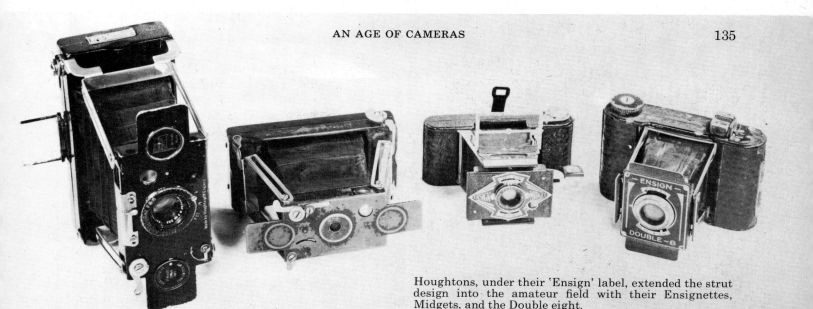

Houghtons, under their 'Ensign' label, extended the strut design into the amateur field with their Ensignettes, Midgets, and the Double eight.

does not occur until the shutter closes at the end of its travel, and is caused by the two quite substantial metal edges of the self-capping shutter coming together.

These cameras date from the nineteen twenties, and culminate in the model which was current at the time of Ernemann's absorption into Zeiss Ikon. The camera was than made in VP, $3\frac{1}{2}$ in × $2\frac{1}{2}$ in, and quarter plate. These models were available with the f/1.8 Ernostar, which was a man-size piece of glass. The front element was around three inches diameter on the quarter-plate model.

These, however, were not the earliest Ernemann strut cameras. They were building some just before the first world war, and they appear from pictures I have of them to be much more lightly built than the later models, though I have never come across one.

I do not know whether the shutters were self capping, though I suspect that they were not, and the advertisements of the time are not helpful on this point.

However, they do make a point of the fact that the tropical model was fitted with 'ant-proof bellows'. . . .

Before leaving Ernemann strut cameras, mention must be made of the 'Lilliput'. This was VP, with a simple front shutter, no focusing and had its struts in the form of two hinged plates inside the bellows, which made it, more than any other, a 'folding box' camera. It sold, in 1914, for $37\frac{1}{2}$ pence, or in the money of the time, seven-and-six.

In England, the redoubtable firm of Houghtons went into the strut camera business in 1909. Their product was the Ensignette, a roll film camera, aimed at the amateur market, in contrast are the continental strut cameras, which as far as I can discover were all plate jobs at this time.

Strut Cameras for Amateurs

'A complete self-contained roll film camera, which measures under 4 in × 2 in, and is scarcely more than $\frac{3}{4}$ in in thickness is what messrs Houghton have achieved in this instrument, which, fitted with a single lens, is issued at the moderate price of 30s.'

That is what the current Almanac of the British Journal had to say about this £1.50 camera, which continued in their lists in various improved forms right up into the middle twenties. A larger size was also produced, giving a 3 in × 2 in negative, on the rarely met 129 size roll film.

In 1934, the company produced yet another tiny roll film camera for the amateur market—the Midget, which was little bigger than a box of matches. There were two models—non focusing, and focusing, which sold for £1.50 and £2.50 respectively.

Houghtons followed this about a year later with the Double-8, another tiny strut camera which took sixteen pictures on a 127 roll.

There were many other strut cameras on the market, particularly in the years between the wars, but they did not contribute anything

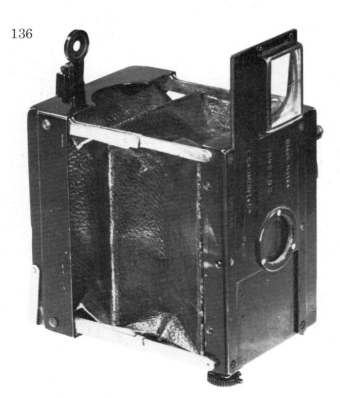

The 'Blocknotes', a rarity among the small strut cameras. Note the sliding panel carrying the finder, which drops and covers the lens when the camera is not cocked ready for use.

really new to the picture we have already seen.

With one possible exception, which is French, and dates from 1905. It was called the Blocknotes, which is a name I have never really understood. It was made in two sizes, VP and CdV. It was fitted with a built in pneumatic shutter, which was cocked by pulling up a plate which ran along the centre of the front panel. This also uncovered the lens, and brought the direct vision finder up to working position. When you had made your exposure, the slide dropped, so that you could immediately tell whether or not your camera was ready for use.

These Blocknotes cameras were very compact when folded, but heavy, being built almost throughout of brass. They were well made, and expensive—over twelve pounds.

There were many other makes of strut camera on sale, especially in the period between the two wars, but in one way or another, they were all derivative types, adding nothing to the features originated by the pioneers in this field.

Which is not to say that many of these were not excellent cameras. Many of them were marketed by firms who were dealers, and had no manufacturing facility. As with other types of cameras that were sold by reputable dealers

as their own product, one gets the feeling that many of these instruments had a common origin, though who actually made them is very difficult to determine. There may be records in existence which give this information, but so many companies in the camera trade have been the subject of take overs, that records of original 'founder' companies have become submerged under the strata of various amalgamations.

To me, one of the fascinations of collecting vintage cameras has been the digging out of some of the masses of information which has become buried and forgotten in a remarkably short space of time. It have tried to set down this information in the present book. However, if all that I have succeeded in doing is writing a guide book to all the research that is yet to be done, I shall have achieved something.

Some amalgamations of companies are, refreshingly, clear from the very names they traded under. Houghton amalgamated with Butcher in 1927, and the new company was called Houghton Butcher.

And turning to the second class of cameras which is the concern of this chapter, the cameras which use a lazy tongs mechanism as a means of effecting focusing, and of making the camera conveniently collapsible, the very same thing is true of what must be regarded as the most notable cameras in this group.

There were the Contessa cameras, and there were the Nettel cameras, both using the same type of construction, and eventually they came together as the Contessa-Nettel cameras.

Lazy-tongs

The lazy-tongs idea is a simple one. Take two strips of metal of equal length, and put a pivot pin through their middles so that they form an 'X'. Now, if you move one pair of ends, the other pair of ends will move in just the same way. Furthermore, the lines joining the ends you are moving, and the ends which are moved, will remain parallel at all times, while the distance between them varies.

Next consider the beginnings of a camera— a mere front and back joined by bellows. Take two 'Xs' of metal strips, and put one at the top of the camera, and one at the bottom. Pin all four left hand ends through holes, at left top and bottom of the back, and ditto at the front. Allow the other ends to slide in slots, and add an axle to couple the left rear of one top strip

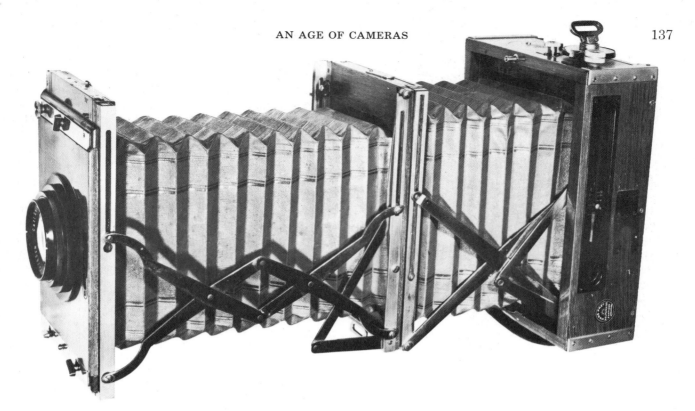

to the corresponding bottom strip, so that these two strips, one above and one below, are coupled together. Now you can move the back of the camera relative to the front, and your lazy-tongs will adjust to this movement, and also keep back and front always parallel to one another.

Provided that the length of the crossed strips is not greater than the length of the camera back to which they are attached, you will be able to fold your camera flat, or extend it to practically the length of the strips.

Add a simple mechanism of leadscrew and nut to the rear ends of one 'X', and you have a precise focusing mechanism. Connect the end which attaches to the nut via a catch, and you will be able to detach your lazy-tongs from the focusing control mechanism for quick folding.

This mechanism, or some simple modification of it, is to be found on all Contessa, Nettel, and similar cameras. These cameras can be folded flat, and returned to 'open order' with great ease. Furthermore, if you leave the focusing screw set to a required value, you can be certain that when you open the camera, it will be at the setting you need.

There is one further point to be noted about the lazy-tongs type of mechanism. As it is described above, it is quite adequate for small, light cameras. But, while the rigidity of lazy-tongs is absolute in the plane of the 'X', it is very poor at right angles to it. So, as you apply the

A Contessa Nettel lazy-tongs camera, shown fitted with the rather rare extension bellows. Below, looking into the back of the camera, the third set of lazy-tongs can be seen.

mechanism to bigger and bigger cameras, the tendency to a certain up and down floppiness becomes more and more marked—or would do so if nothing was done about it.

The answer is a third 'X' system of metal strips, at right angles to the other two.

This third 'X' system is to be found inside the bellows, and because it has to keep up with the other two in a much more confined space, it takes the form of two or more 'X' joined together.

Altogether, the mechanism provided a rigid means of maintaining parallelism between the front and back of the camera, and means of smooth accurate focusing.

If the strut cameras were collapsible box cameras, then these are adjustable, collapsible box cameras.

Both main types, the Deck Rouleau Nettel, and the Contessa Ergo, appeared on the English market about 1909. I think it is quite probable that they were around earlier than this in Germany, but I do not know. In their amalgamated form, as the Contessa–Nettel, they were being sold and used right into the nineteen thirties. They were highly esteemed cameras for about twenty-five years.

I would not think that the strut and lazy-tongs cameras were ever as popular or widespread in their use among pressmen as the big press

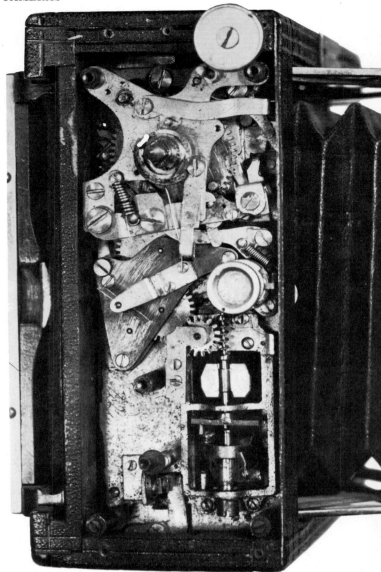

Below, a nice quarter plate 'Deck Rouleau Nettel' from about 1910.

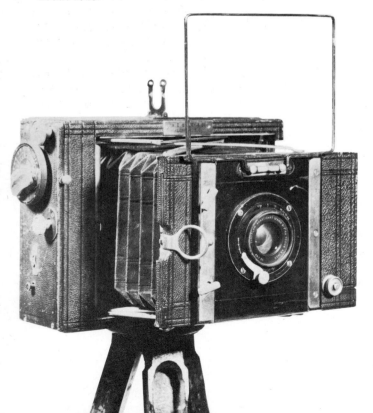

Above, the shutter speed control mechanism of the D R Nettel. The long vertical spindle is the low speed governor.

reflexes, but one other thing is certain. Talking to photographers who followed the news in those days, they were either 'flat folding' or reflex men. They did not switch from one type to the other unless they had to.

The shutters in both Contessa and Nettel cameras were focal plane, and very similar despite detail differences of construction.

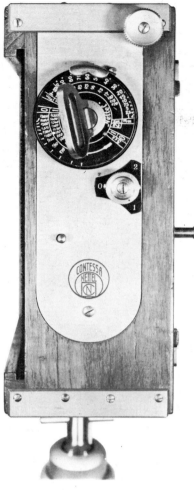

On the left, the older and newer forms of Contessa Nettel shutter speed control. On the older models (above), two settings must be made. On the later models, one setting controlled both slit width and blind speed to give the required exposure.

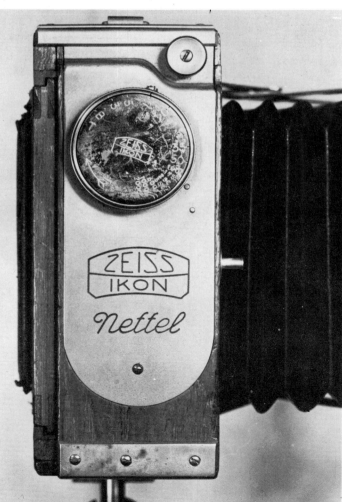

Deck Rouleau

First, they were both 'Deck Rouleau', or as it is sometimes rendered 'Deck Rullo'. That term is not just a fancy name. It can be translated approximately as 'covering roller blind'. So Contessa and Nettels had self capping shutters; the focal plane slit remained closed during winding.

This fact apart, these shutters were the most complex and advanced made in those days. Taking the earlier versions of both makes first, exposure was controlled by a double setting. Slit width could be controlled by a scale on the winding knob—or rather on a dial attached to the winding key. The actual crossing speed of the blind could also be controlled, and a second smaller knob carried out this function. It had three positions, marked '0', '1' and '2'. These positions corresponded with three precisely controlled crossing speeds for the blind. Set at zero, the blind crossed at full speed under the unrestrained power of the spring. On the narrowest setting of slit width, you could get an exposure of 1/2800 second. When you turned the knob to one, an inertial governor was brought into play, which slowed the blind speed considerably, and gave you much longer exposures for the same slit widths. On the range of exposures that were given by the 'one' setting, 1/800 second was the shortest.

When you turned the knob to position three, a much more powerful inertial governor was engaged, and on this setting the blind merely strolls across, giving you a low range of speeds from 1/2 sec to 1/30.

There was also, of course, a setting on the dial for time exposures.

If, instead of setting your focal distance by 'guesstimate', you wished to focus precisely on the ground glass screen with which these cameras were always fitted, there was a 'focusing button'. You pressed it, and wound, and the shutter opened to the full width of the plate, so that you could see the entire image.

This system of three blind speeds, combined with a choice of slit widths from about 3 mm up to the full narrow measurement of the plate,

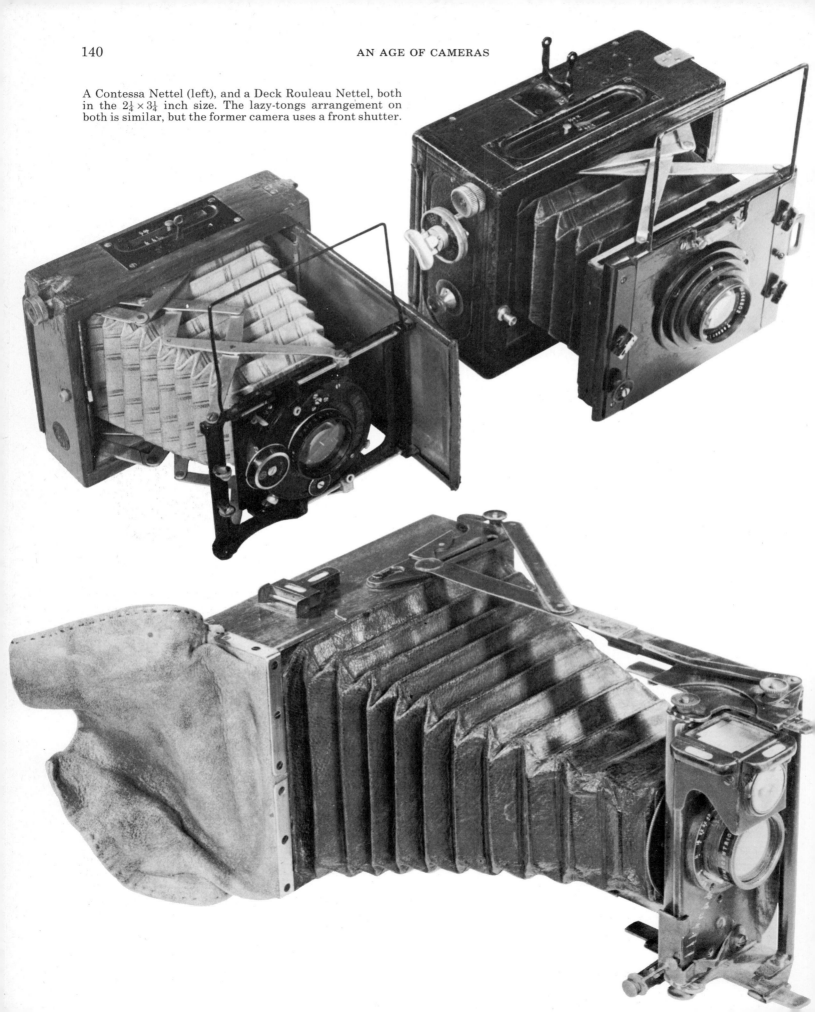

A Contessa Nettel (left), and a Deck Rouleau Nettel, both in the $2\frac{1}{4} \times 3\frac{1}{4}$ inch size. The lazy-tongs arrangement on both is similar, but the former camera uses a front shutter.

The Agfa 'Karat' was a very compact and sturdy little strut camera, that was made with various qualities of lens and shutter.

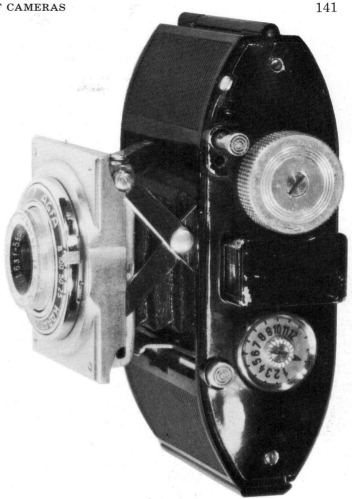

gave you the most incredible range of shutter speeds, and obviously low speeds of one range tended to overlap the high speeds of a lower range. Also, many of the speeds were ridiculously close together. But then, in those days, makers seemed to take pride in offering their customers 'a wide range of shutter speeds'.

In the final model, that was made after the two companies had first amalgamated, and then, a few years later, become part of Zeiss Ikon, the exposure setting system was greatly simplified. It was all done on the winding knob. The speeds were arranged in groups, and when you chose a speed by setting the white dot on the rim against it, you were selecting both a slit width and a speed of blind movement at the same time.

Also, on these late models, somebody woke up to the fact that some of us had been having trouble reading the figures—dozens of them— that were packed together on the old type dials. The late models had good big readable figures.

And if you think that isn't important, then you've never lurked in the shadows, say at the side of a stage, with one important live shot to take, that you couldn't repeat, hoping and praying that you'd got the exposure right from what the settings felt like, because you couldn't read the figures. . . .

You had a choice of backs on these cameras. You could remove the focusing screen completely, and slide a double dark slide in its place, or you could just hinge up the focusing screen on its sprung inner frame, and tuck a single metal slide underneath it.

All of these cameras were fitted with open wire finders, in my view still the best ever for sports work.

In this range of cameras, there were some with front shutters—the smaller ones—though

On the left is the Newman and Guardia 'Nydia', which appeared about 1902. It is the most outstanding design of a number of similar cameras which used this variation of the strut theme. Note the changing box back.

there were $2\frac{1}{4}$ in × $3\frac{1}{4}$ in cameras in both styles. The little VP Contessas, as far as I can discover, were all front shutter jobs with Compound or Compur shutters, according to period.

The possibility—an obvious one—of linking the lazy tongs to a coupled range finder, led to the final development in this class of cameras— the Plaubel Makina series of cameras, which were only made in the $2\frac{1}{4}$ in × $3\frac{1}{4}$ in size.

The original Makinas, in 1925, had no range-finder, and were like Contessas, although the focusing screw was transferred from the back to the front of the Camera. The first range finder model appeared in 1933, and was steadily improved in detail right up to the end of our period, and still current after the war.

Before leaving this class of cameras, I'd like to return for a moment to that one knob setting focal plane shutter of the late Contessa Nettels.

We shall be meeting it again, greatly reduced in size, in the Contax cameras of the nineteen thirties.

The Coming of the Miniature

In the early days of photography, all negatives were big. Prints taken from them were mostly contact prints, the same size as the negatives.

For two reasons image quality was not high enough for any considerable enlargement to be made. The first reason was that the tone resolution, and the sharpness of the available lenses was not high.

The second reason was the emulsions. They were grainy, and even a moderate degree of enlargement made this obvious.

One item which one can find in catalogues of photographic equipment in the eighties and nineties of the last century makes this point clear. It is that massive article, 'the enlarging and reducing lantern'.

These lanterns consisted of a massive horizontal construction of square bellows, with a lens mounted on a panel in the middle. At one end, you mounted your negative, say 15 in × 12 in. You could then adjust the separate lengths of bellows on either side of the lens to get the image size you wished on a focusing screen at the other end. This, you then replaced with a sheet of printing paper in a carrier like an ordinary dark slide. You opened it, and let daylight shining through your negative make your print, which might well be smaller than the negative.

By the turn of the century, there were some very fine lenses available, but there was still the problem of grain. Fast, narrow gauge film was being used for cinema work, and here grain was of no consequence, for even though the enlargement of the image on the cinema screen was enormous, what you saw was really a subjective image, compounded by your eye out of sixteen separate images flashing past every second. Also, you were viewing the screen from a distance.

But beyond considerations of grain, the images obtained by early emulsions which were fast enough for cine work did not resolve tones very well.

So, when Oscar Barnack started work on a camera to use cine film for ordinary still photography, before the first world war, he was faced with the serious limitations of the available film stock—something which no amount of quality in his lenses, or precision in his camera, could overcome.

He was well aware that lenses of shorter focal length—lenses which would only cover a very small area of emulsion—had great advantages over the larger lenses needed to cover bigger areas.

First there was the obvious fact that fast, big aperture lenses for small negative sizes could be made with less labour than for big. There was less glass to be ground and polished. The lens was more portable.

Second, the shorter focus lenses have a greater depth of field. That is to say that, for a given aperture, a greater depth of subject matter is sharply represented in the picture using a short focus lens compared to a longer lens. This depth of sharpness is a quality of enlargements made from such negatives.

To take a very simple example. Take a lens of 2 in focal length, covering a negative measuring 1 in × 2½ in, adjust it for perfect focus at twelve feet, and close it down to $f/8$. Then everything from 8 ft to 20 ft from the camera will be acceptably sharp.

If you carry out exactly the same exercise with a lens of 4 in focal length, covering a negative measuring 2 in × 3 in, then at $f/8$ your image will be acceptably sharp for subject matter from only 11 ft to 13 ft.

However, although depth of field becomes greater as focal lengths become shorter, depth of focus—which is quite a different thing— does not.

Depth of field relates to the subject matter of a picture. Depth of focus relates to the photographic image. Depth of focus is the 'thickness', at the image plane, wherein acceptable sharpness of image is to be found. This 'thickness' gets smaller as the focal length of the lens gets less.

What it amounts to is that a short focus lens must be positioned in relation to the film plane with greater precision than a longer lens. That this is so is very evident if you consider the focusing movement of lenses. In shifting focus from 3 ft to infinity, a lens of 28 mm focal length moves just about one millimetre. A lens of 85 mm focal length (roughly × 3) moves through more than ten millimetres to make the same focusing adjustment.

So, the shorter the focal length of the lens, the greater the precision called for to focus it accurately. But when it *is* focused accurately, the image possesses greater depth of field than the image produced by a longer lens of a correspondingly larger camera.

But, to get the most out of a small lens working on a small emulsion area, the camera must be made not only with higher precision, but with a higher order of precision.

Oscar Barnack

Oscar Barnack must have realised from the word go, that the sort of thinking which applied to the design of larger cameras, was not a great deal of use for the purposes he had in mind. His camera would have to be designed in such a way that the settings of focus would be accurate within a tolerance of something like plus or minus a thousandth of an inch.

The end product of his work was a solidly and precisely built little camera that was the proto-

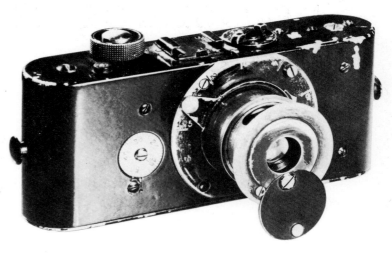

The Barnack Leica. In this design, precision guaranteed negative quality, and made the small negative a reliable source of greatly enlarged positive prints.

type for the first Leica—the first successful high precision miniature camera.

Meanwhile, the first world war had come and gone, and in the general acceleration of technical progress which always seems to take place when killing on a large scale is the order of the day, photographic emulsions had been considerably improved.

Aerial photography had been used for reconnaisance, and to this end small details were often required to be greatly enlarged. So for purposes of war, emulsions of improved grain and resolution quality were produced.

Emulsions of comparable precision to Oscar Barnack's workmanship and optics were now available, and in 1925 his camera was launched on the market by the old established firm of scientific and optical instrument makers, Ernst Leitz of Wetzlar in Germany. They called it Leica, for 'Leitz Camera'.

The importance of the event was comparable with the launching of George Eastman's first Kodak, in 1888. This fact is clearly reflected in the attitude of camera collectors to these two cameras. Examples of Oscar Barnack's first Leica, and of George Eastman's number one, are treasures indeed.

It is interesting, too, that skilled apprentices at the Wetzlar works of Ernst Leitz are sometimes set the task of making replicas of Oscar Barnack's original camera. These beautifully made copies of the prototype usually find their way into museums, and you can see one of them in the photographic section of the Science Museum at South Kensington, in London.

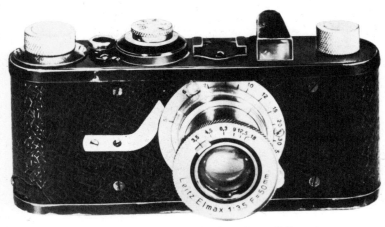

The Leica one. Note that the lens is an 'Elmax'—not an 'Elmar'.

Leica Number One

The first model Leica was of the simple, round-ended, rectangular form that later was to become so familiar. The lens in its focusing mount, could not be removed from the camera. Most of these early models are fitted with a lens called an Elmax—similar to the familiar Elmar, and of the same aperture, $f/3.5$—and of similar configuration and character to the Zeiss Tessar. The camera had a focal plane shutter, with a range of speeds from 1/20 to 1/500 of a second. The Leica 1 had no coupled rangefinder, but a rangefinder could be bought as a separate accessory. There were no eyelets for neckstraps on these cameras. The action of winding on the film also set the shutter, so that double exposure was impossible.

The second Leica, which appeared in 1926, is called the Compur Leica. This has a diaphragm shutter instead of the focal plane type, and the shutter must be set as a separate operation to winding the film. Consequently there is no double exposure prevention on this model. Otherwise it is similar to the Leica 1.

The earlier Compur Leicas have the old style dial set Compur shutter. Later ones have the rimset type, and I am told that some were made with the Luxus shutter, instead of the Compur, but I have never seen one of these.

If the Compur Leica possessed an advantage over the number one, it is that the diaphragm shutter gave exposures up to one second. Otherwise it lacks the convenience and ease of use of the number one. It is, if anything, rarer.

In 1930, a further model of the number one became available, now with the lens in a screw mount for interchangeability. However, the screw threads on these 1930 Leica ones were not standardized. The Leica standard thread first appeared in 1931.

In the following year the model known as the Standard Leica was produced, and later examples of this were the earliest Leica design to have eyelets for a neckstrap.

Also in 1932, the Leica II came on the market. It was the first model incorporating a built in coupled rangefinder, but once again there were no eyelets for a neckstrap.

On all these focal plane Leicas, the range of shutter speeds was 1/20 to 1/500 of a second.

The Leica III appeared in 1933, and this was the first focal plane model incorporating the slow speeds. The range now became 1 second to 1/500 of a second. Eyelets for a neckstrap were fitted as standard and a 1.5 magnifier was added to the rangefinder eyepiece.

The IIIa in 1935 was as the III, but with the addition of a top speed of 1/1000 of a second.

The IIIb followed in 1938, and had the eyepieces for the rangefinder, and the finder, put very close together, so that the pupil of the eye can switch from one to the other without moving the camera appreciably.

The only other model of Leica which comes into our period is the Leica 250, which appeared in 1937. Basically it was a IIIa with the ends of the body enlarged to form two big cylindrical film chambers, which would carry ten metres of film. It was designed for the convenience of reporters, who might want to take large numbers of pictures in quick succession, without

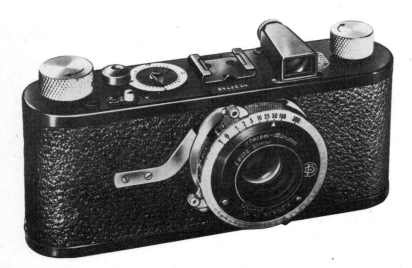

The 'Compur Leica'. In this design there was no double exposure prevention.

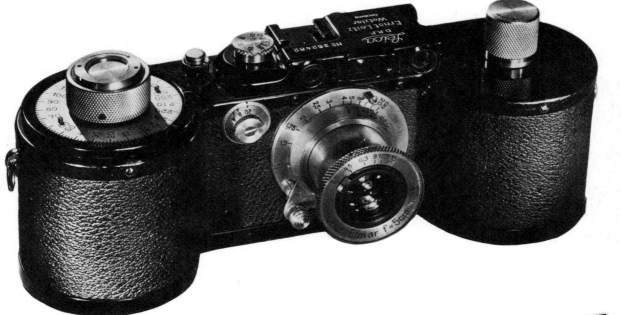

the need for changing films. This arrangement allowed 250 or more exposures at one loading.

By 1939, the end of our Age of Cameras, about a dozen standard lenses were available for the Leica interchangeable models, and those up to 135 mm focal length were coupled with the rangefinder. The longest lens, however, of 200 mm focal length, was supplied with a reflex focusing device, which, in effect converted the Leica to an SLR for long telephoto work.

Oscar Barnack was not the only designer of cameras to turn his attention to the use of 35 mm film, but starting work as he did, as early as 1912, he must be regarded as the pioneer, even though there were a few designs using cine film on the market before the Leica. There had been one from a New York firm called the Tourist Multiple, just before the first world war, and the Swiss firm of Simons produced another, using a Compur shutter, in 1922. There was a somewhat similar one from Krauss of Paris, two years later, which carried enough unperforated 35 mm film for 100 exposures.

But the real competition for the Leica did not come on the scene until early in 1932.

It was the first of the Contax series of Cameras from Carl Zeiss.

The Contax cameras were beautifully made, complex, and highly sophisticated instruments. They cost rather more than their Leica counterparts.

I have read, somewhere, that the Leica shutter, and the patents connected with it, covered all the simplest methods of solving the problem, and that Zeiss had to make their shutter much more complex to avoid infringing Leica patents.

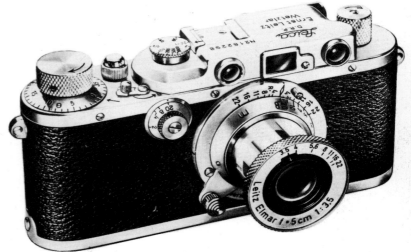

Top, the Leica 'Reporter', circa 1941. Centre, the Leica IIIa of 1935, and at the bottom a Leica Ic.

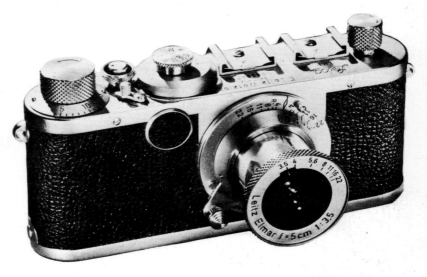

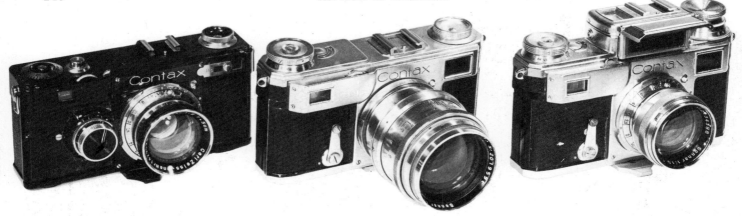

The pre 1939 Contax range. Left to right are models one two and three, within which designations various types are to be found.

I cannot entirely believe this, although there must be some truth in it. But the Contax shutter design has many features which to me, at any rate, point clearly to another reason for its particular nature. The ancestry of the Contax shutters would seem to be the much larger Contessa Nettel shutters which had been under the Zeiss mantle for some years.

The Contax Cameras

All the Contax cameras, from the very first model, had coupled rangefinders. All of them made use of the same series of interchangeable lenses.

Before we go on to consider the models of the Contax which fall in our period, it would be as well to cover some general points in connection with the lenses, and the mounting thereof, particularly in respect of certain fundamental differences between them, and the Leica lenses.

All of the Leica lenses were made in their own focusing mounts. They all carry cylindrical cams which couple them to the rangefinder via a lever. The purpose of these cams is to impart

the same amount of movement to the rangefinder, irrespective of how much the lens must move to achieve correct focus over any given range of distances. As we have seen, the amount of movement needed increases greatly as the focal length of the lens increases.

On the Contax cameras, the system is different. The coupling to the rangefinder is rotary. About three-quarters of a turn moves the rangefinder over its full range of about three feet to infinity. The focusing mount for the standard (50 mm) lens is a part of the camera, and the standard lenses lock into this by what is called the inner bayonet. There is also an

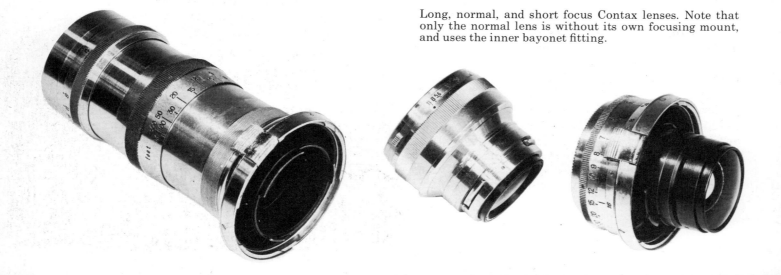

Long, normal, and short focus Contax lenses. Note that only the normal lens is without its own focusing mount, and uses the inner bayonet fitting.

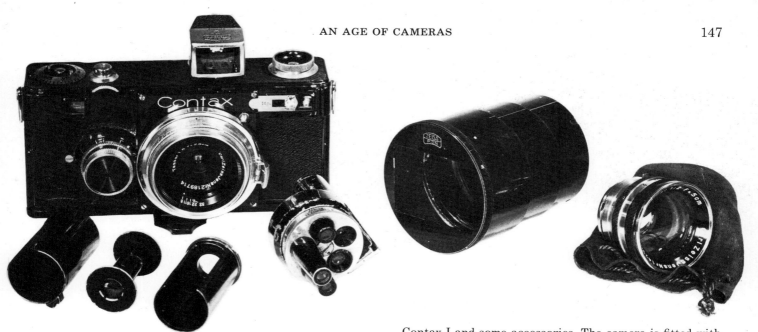

Contax I and some accessories. The camera is fitted with the 28 mm wide angle Tessar, and the appropriate finder. In front, the parts of a Contax cassette, next the multiple finder, the adjustable hood, and the standard lens of the one, with its doeskin bag.

outer bayonet, which carries coupled lenses of all other focal lengths—longer than the standard ones, or shorter.

These other lenses are in their own focusing mounts, which move them all over the same focus range for the same amount of rotation—although of course they must move the linear distances called for by their focal lengths to achieve this focusing range.

So they all mount onto the camera by the outer bayonet mount, and also couple rotationally to the inner bayonet mount.

This means that to change lenses you must match all settings at infinity, or the rangefinder coupling will be wrong. Lens changing is therefore more difficult than it is on the pre 1939 Leicas, which you could just screw on and off, and never mind the setting.

The First Contax

The Contax I, which appeared in the spring of 1932 was a very compact and solid little camera. Even so, it was slightly larger than its Leitz contemporary, the Leica II, and weighed a little more. It had a built in coupled rangefinder of more than twice the base length of the Leica rangefinder, which makes it very critical, and more useful for the longer focus coupled lenses. The winding knob of the Contax I is on the front of the body, just alongside the lens. By means of this knob, you select your shutter

speed, wind the shutter, and wind the film on as well. So double exposure is not possible.

Shutter speeds on the first batch of Contax I cameras ranged from 1/25 sec to 1/1000 sec. Within a year of the first model appearing, slow speeds were added, and the Contax I available in 1933 had a range of shutter speeds from 1/2 to 1/1000 of a second.

The actual blind mechanism in the Contax I is repeated in the Contax II and III, and in the Contaflex TLR, and is worthy of special mention. It is an all metal blind, made like a very

The typical Contax slatted shutter.

The Contameter is a close-up outfit depending upon a specialized rangefinder for focusing.

small version of the top of a roll top desk. There was a legend that this blind was so complex as to be unreliable, and that it seized up solid in cold weather. All I can say to that is that I have had my own Contax II for a good many years now, during which time I have used it in Russia and Denmark, and it has never given me a moment's trouble. I suspect it could be troublesome if it was tampered with, and I can imagine oiling doing it a lot of no good.

Like the Contessa Nettel shutters, the Contax shutter has three crossing speeds, two of which are controlled by escapements, and one is direct. Slit width is also varied, so that the final exposure depends on both crossing speed, and slit width.

The mechanism of these shutters is both robust and beautifully made. None the less, they belong to the older generation of focal plane shutters, in which the slit is moving continuously across the plate, and images of moving objects are therefore distorted. The Leica shutter was already moving towards the ideal for its lower speeds—the blind moved fast, even for long exposures, and the greater part

of the exposure was the period during which the shutter was wide open.

With all the pre-war Contax models, you had a choice of standard lenses. Tessars at $f/3.5$ or $f/2.8$, and Sonnars at $f/2$ or $f/1.5$. Prices ranged from £27.50 to £51.50. The Leica II, with $f/3.5$ Elmar, which you could equate with the $f/3.5$ Tessar, cost £26.50.

The Sonnar series of lenses were a development of the Tessar. They were much more highly corrected, and therefore capable of working well at big apertures. As you know, big aperture reduces depth of field, and makes critical focusing a must. The superb Contax rangefinder makes this astonishingly easy, and the quality of those Sonnars, even wide open is excellent.

There were also ten other lenses of varying focal length. On the Contax, because of the greater distance (compared to the Leica) between the two 'eyes' of the rangefinder, it was considered practical to couple lenses of as much as 180 mm focal length. However, there was one famous Contax lens of this focal length, the Olympia-Sonnar, at $f/2.8$, which was used in a reflex housing, called the Flektoskop. In these days, before the coming of the modern SLR with its great facility for telephoto work, this very fast and massive lens was responsible for some very fine long distance sports photography.

Also used with the Flektoskop were Sonnars of 300 and 500 mm focal length.

There was a second type of reflex housing for use with the Contax cameras, called the Panflex. This could be used with suitable long focus lenses, but its main purpose was for very precise macro work with short focus lenses.

Contax Two and Three

The other models of the Contax which appeared before war broke out in 1939 were the Contax II and III. These two fine cameras came out in 1936, and as far as I have been able to check, they both came out together.

It was logical that they should do so, for they may be regarded as two versions of the same camera, the difference between them being that the Contax III incorporated a photo-electric exposure meter. This was an excellent and very sensitive meter, which was built into the camera for convenience of use, but was not coupled in any way to the exposure mechanisms of the camera.

So all points of camera design apply to the III as well as the II.

Lens coupling was identical with the Contax I, and nearly all Contax lenses will fit any Contax from the first model to the last—which includes the two post war models, the IIa and IIIa.

The shutter mechanism was bascially the same as that of the Contax I, but the winding knob was transferred from the front of the camera to the top right. This was an improvement in 'usability', for the major drawback in use of the Contax I is that you find yourself changing your grip on the camera between taking and winding, whereas with the II and III you carry straight on with the camera at eye level.

The range of shutter speeds was as the later model Contax I, except for the highest speed, which was increased from 1/1000 to 1/1250 of a second. I believe that there were some late models of the Contax I which also had this higher top speed, but I have never seen one.

Rangefinder and viewfinder come together in the Contax II and III, and the mechanism is very smooth and precise. As on the Contax I, focusing is effected by the fingertip operation of a small knurled wheel, above the lens at about eleven o'clock. One small point to watch is that you do not cover the rangefinder window while you are focusing.

An extra feature compared to the earlier Contax is the delayed action mechanism. Having set your shutter in the normal way, you then move a small lever on the camera front through about ninety degree anti-clockwise. To release, you now slide a small button, just above the lever pivot, away from the lens. Now you have about ten seconds before the exposure will be made.

The fitted case was almost a status symbol in the thirties. This hide case was specially made and fitted out to take a Contax and its accessories.

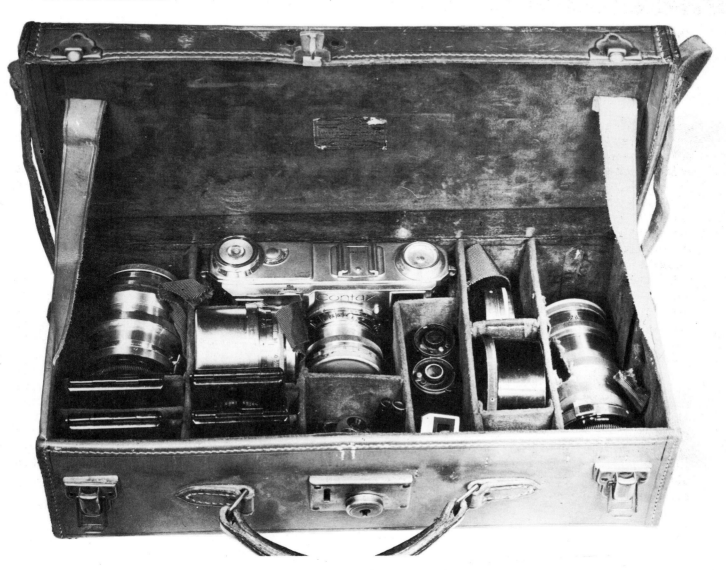

This delayed action lever has a second use, which is very seldom mentioned. If you set your shutter at 'B', wind it, and then use the delay mechanism, you will find that it will open the shutter, and then close it again after an exposure of about three seconds.

This can be very useful for time exposures when you don't happen to have a tripod. You can just stand the camera somewhere, and once you have set off the mechanism the exposure will be made without you touching the camera.

The meter on the Contax III must have been the most advanced made when it appeared. It is housed on top of the camera body, and the sensitive cell, which faces forward, is covered with a door when not in use. This springs open at the touch of a button, and you will see the needle move under its glass cover on the top of the housing.

To use the meter, you must use the knob which you will find at the top left of the camera body. This knob is in three layers, with three knurled rims, increasing in size downwards.

The top rim is the rewind knob for the film.

The middle rim is used to set film speed.

The bottom rim is used to adjust a delicate balancing circuit in the meter, and you turn it until the meter needle comes to rest on a clearly marked datum.

Now you can read off your possible combinations of shutter speed and aperture on a pair of engraved scales just above this bottom rim.

I am told that this balancing adjustment alters the pressure on a carbon impregnated felt washer, which changes its resistance slightly with this changing pressure. I am also told that once disturbed, the balance of the circuit can be ruined, and that no spares are available.

So I have never tried to examine this mechanism on my Contax III. It works perfectly still, after about thirty-five years, so I am quite content to take it on trust.

As with the Leicas, there is a vast range of accessories to be had for the Contax cameras, which adds to the fascination of collecting these two super cameras. Whole books have been written already on these as separate subjects, and it would be superfluous to detail them here.

My object in writing this book has been to provide a guide to camera development between 1879 and 1939, and I have been very much aware of the fact that any one chapter that I have written could have formed the subject for a complete book.

However, I have also been aware that what I might have been recording in many cases was minor variations on a central theme, which could have been a little tedious.

Before leaving the subject of the Leica and the Contax, mention must be made of the hybrids that occasionally crop up.

As you can well imagine, in the thirties up to the outbreak of war, both the Leica and the Contax had its staunch adherents. There were Leica men, and Contax men.

Hybrids

But there were some who liked the simplicity of the Leica body, but who held the view that the Contax Sonnar series of lenses was better than anything that was available in the Leica range as it then existed.

Consequently you will find Leicas, with Contax lenses, for which expensive adapters have been hand made to couple them to the Leica rangefinder. In the case of the standard 50 mm Sonnars, which had no focusing mounts of their own, this was quite a complex business. With the other lenses, the focusing mounts that belonged to them were sometimes adapted, but how the job was done was very much up to the individual craftsman who tackled it.

This Zeiss camera bears a Goerz name—the 'Tenax'—so it must be dated after the amalgamation took place.

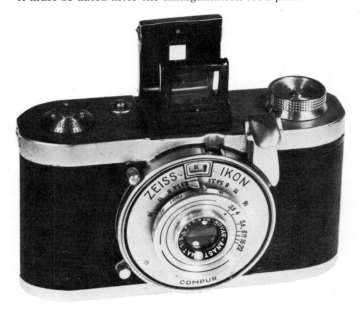

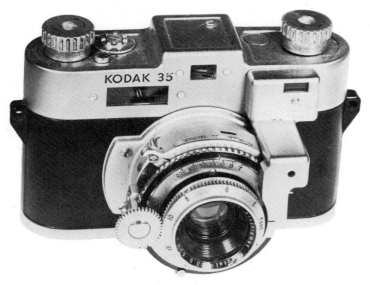

This inexpensive rangefinder camera from Kodak appeared right at the end of our period.

Where the bigger lenses, which used a reflex housing in any case, are concerned, the job was simpler, and merely demanded a suitable simple attachment fitting.

By the same token, one comes across other lenses, some of them quite old, fitted to these reflex housings.

Also, of course, various other lens makers of high repute made special lenses for both the Contax and the Leica, and one does find specimens fitted with these coupled, but non-standard lenses.

Other Miniatures

Following upon the success of Leica and Contax, a large number of other miniature cameras appeared. There were some that used VP roll film, and took 16 exposures on it, each slightly larger than the standard 35 mm frame, there were some which used perforated 35 mm film, and there were some which used the new Kodak 'Bantam' 828 size, which was, in effect, unperforated 35 mm stock.

Apart from the first miniature SLR cameras, like the Exacta, which has been mentioned already, there are two basic types to be found in these miniatures, irrespective of the type of film they used.

There were the 'solid' cameras, which resembled the Leica in its broad configuration.

And there were the miniature bellows cameras, which were very positively self erecting, and form a most intriguing area of small camera design.

Any of these miniature designs which catered for lens interchangeability must fall into the first of these two classes. I do not know of any in the second class which can be properly said to be interchangeable lens jobs, though I have seen some fitted with short telephoto lenses. However, these lenses had to be removed before the camera could be folded.

Taking the 'solids' first, one nice chunky little camera from Kodak was the Pupille, which used VP film, and dates from 1936. It had no rangefinder, and used lens collar focusing, and a Compur shutter. Houghtons produced the Multex, also using VP film.

Also of this period are the earlier Robot series, which took negatives about one inch square on 35 mm film, and had clockwork power film wind and shutter setting. This enabled you to take up to 24 frames in rapid succession.

The miniature bellows cameras are manifold. Zeiss Ikon, makers of the Contax, produced a very nice one about 1935, called the Super Nettel. This incorporated the same sort of rotating wedge rangefinder that you find on the Super Ikontas, a Contax type shutter, and is a very pleasant little camera indeed. It was made with either a 3.5 or a 2.8 Tessar, and in my view the smaller aperture camera is the nicer one of the two. At this period, an aperture of $f/2.8$ tended to push the Tessar computation of the time a bit too far. Let me hasten to say that modern Tessars of this aperture have not this limitation.

Probably one of the best known—and best—series of Cameras in the bellows-miniature field are the Kodak Retinas. These came from their

A Retina one. This famous range of Kodak cameras comes from the Stuttgart factory.

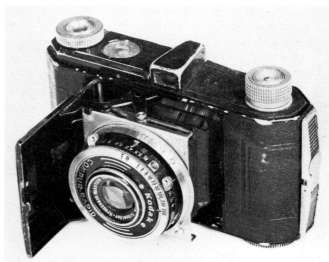

Stuttgart factory, and owe a lot to the redoubtable Dr Nagel.

Most of the Retina I cameras are pre 1939. They are all non-rangefinder cameras, using 35 mm film, and Compur shutters. As far as I know, all the pre-war Retina I cameras were black finished. The ones with satin chrome finish are post-war. They were fitted with Schneider Xenar lenses, of $f/3.5$ aperture. They had double exposure prevention, and the very precise helical focusing moved the complete shutter and lens assembly.

There are some thirty-odd variants of the Retina I, all dating from before 1939, and broadly speaking, the simpler ones are the earlier. They are chunky, solid, and a pleasure to use. The one I have was full of the sand of the North African desert, having been swapped with a captured German officer for some cigarettes, but after a thorough clean up, it still works very well.

The Retina II showed up about 1938, and this has a coupled rangefinder. Many Retina II cameras, however, are post-war. Broadly speaking, the ones with separate range and viewfinders are pre-war. The post-war models have a combined range and viewfinder. Some Retina II cameras were fitted with $f/2$ Schneider Xenon lenses. Evidently Schneider, whose Xenar was very like the Tessar felt that 3.5 was the biggest aperture the design could be pushed to

Retinas must be among the most compact and pocketable high performance cameras ever produced. They are well worth seeking out, and I do not know of any collector who has a complete set of all the variants.

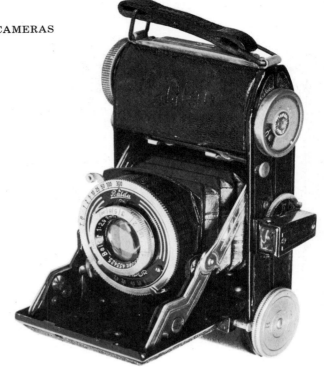

The Agfa Jubilette. The nineteen thirties saw the birth of many compact folding '35 designs.

Those last few years, before Hitler's war brought about the end of an era, and with it the end of an age of cameras, were very fruitful in the area of small folding cameras, and they are cameras that people who owned them still speak of with what can only be described as affection.

There were the little Kodak Bantams. The Foth Derby, the Agfa Karat, and the Plaubel Makinette—all of them well thought out, well made and pleasant-to-use little cameras. There was the Agfa Jubilette, the Wirgin Edinette, the Dollina, and many many others.

A comparison of small cameras. On the left, another Goerz design that bore the name Tenax, and used 127 film. The middle camera also used 127, but took 16 exposures. Right, a Contax. The modern 35 mm camera is often bigger and heavier than earlier roll film jobs.

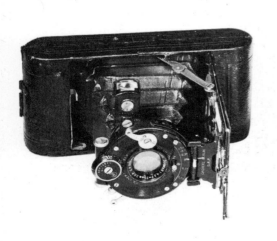
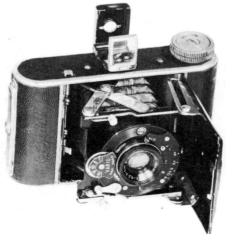

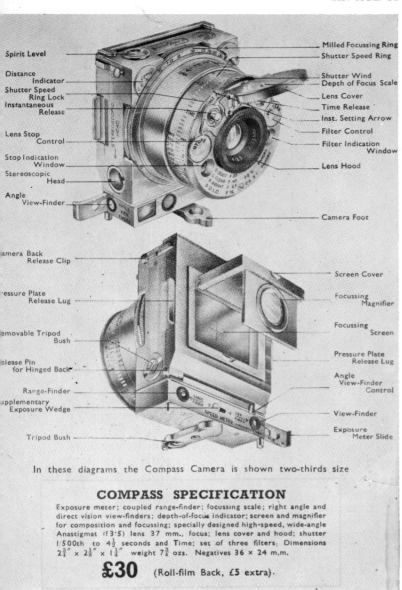

Spirit Level

Distance
 Indicator
Shutter Speed
 Ring Lock
Instantaneous
 Release

Lens Stop
 Control
Stop Indication
 Window
Stereoscopic
 Head

Angle
 View-Finder

Milled Focussing Ring
Shutter Speed Ring

Shutter Wind
Depth of Focus Scale
Lens Cover
Time Release
Inst. Setting Arrow
Filter Control
Filter Indication
 Window
Lens Hood

Camera Foot

Camera Back
 Release Clip

Pressure Plate
 Release Lug

Removable Tripod
 Bush

Release Pin
 for Hinged Back

Range-Finder
Supplementary
 Exposure Wedge

Tripod Bush

Screen Cover

Focussing
 Magnifier

Focussing
 Screen

Pressure Plate
 Release Lug

Angle
 View-Finder
 Control

View-Finder

Exposure
 Meter Slide

In these diagrams the Compass Camera is shown two-thirds size

COMPASS SPECIFICATION

Exposure meter; coupled range-finder; focussing scale; right angle and direct vision view-finders; depth-of-focus indicator; screen and magnifier for composition and focussing; specially designed high-speed, wide-angle Anastigmat (f 3·5) lens 37 mm., focus; lens cover and hood; shutter 1/500th to 4½ seconds and Time; set of three filters; Dimensions 2¾" × 2⅛" × 1¼" weight 7¾ ozs. Negatives 36 × 24 m.m.

£30 (Roll-film Back, £5 extra).

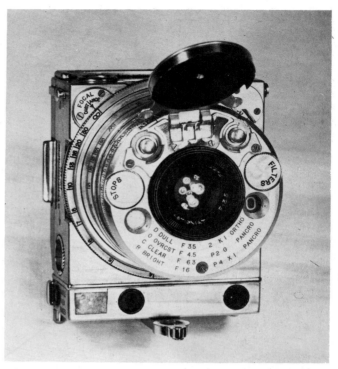

The Compass II, shown here actual size. Stops and filters both operated on simple revolving discs.

They all had the virtue of being pocketable. Which is more than you can say of any other modern 'miniatures' over the half-frame size.

If one word describes them, other than 'miniature', it is 'workmanlike'. Cameras such as the later Retinas, the lovely Zeiss Contessa, and the Contina, carried the breed over into the years after the war.

But before leaving this fascinating area of camera design, there is one more miniature which must be mentioned, for it was in a class quite by itself, and had not the war intervened, it is interesting to speculate on the extent to which it might have been developed.

This was the Compass camera, made in Switzerland by Lecoultre, an honoured name in the watch and clock industry.

It was basically a tiny, all metal plate camera, to which could be added a small roll holder for 35 mm film. Within its very small bulk, it included a rangefinder, and an exposure meter, and provision was made for practically everything that you could ask of a miniature camera. Lenses were not interchangeable, and the f/3.5 Kern lens—yet another variant of the Tessar design—was a good lens, but left room for the performance of the camera to be improved by the employment of better, more modern and highly corrected lenses, and without the war, this might well have happened.

The first model Compass appeared in 1936, and is very rare indeed. When the second model came out, just before the war, the makers, in their advertisements made an announcement the like of which I have never come across elsewhere.

The first model, they implied, was not quite perfect, and owners of the number one were therefore invited to return their cameras to the factory, when they would be supplied with a Compass II, free of charge.

So that's why the model I is very, very rare indeed.

Conclusion

At the end of our story of an Age of Cameras, there are some types of cameras I have not mentioned in this survey of the mainstream cameras that are likely to come the way of collectors.

There are also a few things I want to say as a collector, because they may be of help to other collectors. They may even help them to avoid a few stupid mistakes that I have made.

First, those other cameras. There are the all metal studio cameras that come within our age of cameras, and which are the immediate ancestors of the modern, highly sophisticated monorails. Most of these were very expensive cameras in the first place, and they are still either kept for use by professional photographers, or, when they do come on the market, are highly saleable as working cameras. As a result, these cameras just do not come the way of the ordinary collector.

To put them in relation to the earlier, wooden studio cameras, there is almost nothing they can do that cannot be done with a wooden camera. However, they do it better, and with much greater convenience.

It is undoubtedly true that many wooden cameras, some of them half a century old or more, are still earning their living. So it is hardly surprising that their later and much more durable metal counterparts have not yet been retired.

The same is true of what might be called the metal field cameras—the Linhoffs and the MPPs. My own half plate Linhoff dates from the last decade of our period, and I have no intention of regarding it solely as an item in my collection just yet. If I sold it, it would be quickly bought as a working camera.

However, there are some cameras which were designed to do a specific commercial job, and which must now be regarded as obsolete, but which, none the less, do not seem to crop up. Perhaps they are just gathering dust somewhere. There is also the point that they were never produced in anything like the quantities of the majority of camera types we have been considering.

One very interesting species of camera is the beamsplitter.

Beamsplitter cameras, such as the Bermpohl, were cameras designed to produce three colour-separation negatives simultaneously. After passing through the lens, the beam of light is diverted by means of semi silvered mirrors, so that it takes three paths, and produces three images. Thanks to filters, these three images represent the red, blue and yellow components of the subject, whether it is, say, a painting, or an object of some sort.

The three negatives are not coloured, but printing plates can be etched from them, which when inked with the appropriate coloured printing inks, will combine together to produce a coloured reproduction in print.

Cameras of this type—there were four or five different makes—were used by printers for colour repro work in the twenties and thirties. But today they have been supplanted by more modern techniques of colour separation.

Possibly, because they were of little use

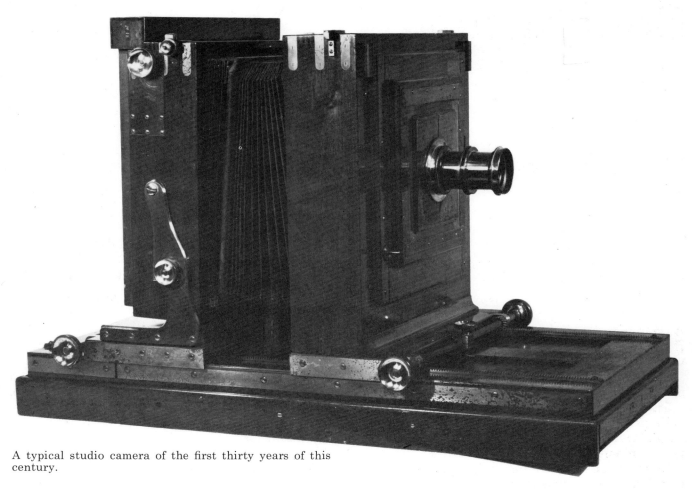

A typical studio camera of the first thirty years of this century.

apart from their intended function, they were scrapped when they became obsolete. I don't know. I just haven't ever come across one. Small ones—$2\frac{1}{4}$ in × $3\frac{1}{4}$ in negative size were made, but the majority were much larger than this.

The while-you-wait ferrotype cameras beloved of the beach photographers of my boyhood are another hard-to-find class of cameras. They were robustly and rather inelegantly built by such makers as Fallowfields and Sharp and Hitchmoughs, and never looked to be anything very special or impressive. Perhaps, because of this, they were just thrown away when they were worn out. Before the war, one still saw them in use on the beaches of sea-side resorts. Then the war ended the working life of the old generation of beach photographer—and when

the new generation came along after the war, they were all using miniature cameras. But there must be some of those old beach cameras still about, somewhere.

Another form of beach camera, which had rather more 'eye appeal', was the button camera. These produced small round pictures which were then pressed into souvenir buttons. These cameras were often in the form of a small cannon, and the novelty of their appearance must have been a factor in attracting custom. The cannon form seems to have been something of an accident, for the early examples of these, dating from the eighties, 'shoot' your picture from the wrong end. The later ones, made between the wars, have the lens at the 'muzzle' end of the cannon. The workmanship of these cameras was rather cheap and cheerful, but the few that I have seen all commanded prices which were beyond my pocket.

Speaking of the cheap and cheerful, there were many cameras made which cannot be regarded seriously from a photographic standpoint, because they were made for the novelty

A ferrotype 'button' camera. Cameras like this did a good novelty trade at seaside resorts during the holiday season.

satisfy Mr Eastman, and were withdrawn and replaced by a model with a redesigned back. As a result, the few 'box-lid-back' Brownies that got out to the public must be among the rarest of all Kodak cameras.

Cameras may also be rarities because of their country of origin. Of course, many cameras that were made in the countries of continental Europe were imported and sold in England and America in large numbers, right through our age of cameras. But many—particularly the cheaper ones—were not, and they are very worth while for the collector. This is not only true of the cheaper cameras. There were some very nice cameras, originating in such countries as Switzerland and Czechoslovakia which seem to have been sold in their home markets alone. In that this must have limited the number made, these are rare in any terms.

Bits and Pieces

Bits and pieces are always worth having—especially lenses. A surprising number of good old cameras show up minus their lenses, and in my own experience I have often been able to fit them up with correct lenses that I have acquired quite separately.

Old double dark slides sometimes crop up. Don't scorn them, even if they are broken. If they are wooden slides, they are a wonderful source of matching wood for repairing wooden cameras, or for making lens panels. Believe me, new wood is quite useless for these purposes.

On the subject of repairs, the bellows of old cameras have often suffered badly, especially if the camera has been wrongly collapsed, and then left in that state for years. Sometimes they are so bad, that nothing can be done, and they virtually fall apart when you touch them.

But if they are all there, and crumpled, they can be restored. Take them off the camera, carefully. They are generally glued in place, and the use of an ordinary table knife will break the brittle old glue.

When you have got them on their own, separated from any wooden parts, thread them

trade, back in the twenties. They took various forms, were usually of glued cardboard construction, and were anything but durable. Consequently they deteriorated rapidly, and were just thrown away. Now, of course, they are rarities. Some quite small ones were made like a twelve division egg box, and had twelve tiny simple lenses, which took twelve minute pictures on a single plate. They were known as 'postage stamp' cameras, and date mostly from the nineties. The shutter was just a sheet of card, with twelve holes to correspond with the twelve lenses, which you moved up and down by hand to make the exposure.

They sold for a few shillings when they were current, and most of them seem to have been thrown away years ago. They are very worth preserving, if you should be lucky enough to find one.

Another class of rarities are cameras which were in some way unsatisfactory, and were withdrawn by the makers, and replaced by an improved model. The earliest type of box Brownie is a case in point. This simple camera was fitted at the back with a detachable cover which is quite literally like the lid of a cardboard box, and while they seem to work quite well, and to be quite light-tight, they did not

over a narrow board, and go over each side in turn with one of the cream type leather dressings, that come in pots. I generally use the white sort. This will clean the leather surface, and also render it rather less brittle, by 'feeding' it.

At this point, deal with any splits, by sticking patches of thin black fabric on the inside of the bellows with one of the adhesives recommended for sticking cloth. Don't use an adhesive which dries out stiff and rigid.

Now comes the bit which needs care, and can be disastrous, as I well know. With your bellows threaded over the board, and a bit of old blanket inside to act as a pad, you must iron them.

Put a damp cloth over them first, and use an iron that is no hotter than your hand can stand comfortably. Iron each side in turn, moving the bellows about so that you don't miss any part of them. If the creases don't come out, let the iron get a little hotter—but beware. If it gets too hot, it will shrivel up the old leather. The iron should just make your damp cloth steam slightly. There should be no hissing when it makes contact.

Do this ironing with great caution. It works very well indeed, and when you have eliminated the deformation caused by unwanted creasing and crumpling, you will find it quite easy to coax the bellows back into the proper folding pattern.

The proper folds are structural. Between the leather on the outside of the bellows, and the black fabric lining, are strips of paper, and it is the small gaps between these strips that determine where the folds occur.

Now you can glue the bellows back onto their woodwork. I have described this process in some detail, because it is one which can dramatically improve the appearance of an old camera. It is restoration pure and simple, and cannot possibly be regarded as faking.

There is another measure that can be taken with bellows. As I pointed out earlier in this book, the older type of bellows, which have square folded corners, were very vulnerable to wear, and the leather at the points along the two top edges is frequently rubbed through. If you have had your bellows off for cleaning and ironing, it is a simple matter to turn them top to bottom when replacing them. The bottom corners are generally in far better condition than the top. You may, of course, find that this step has already been taken by the man who owned the camera and used it, or by a repairer, many years ago.

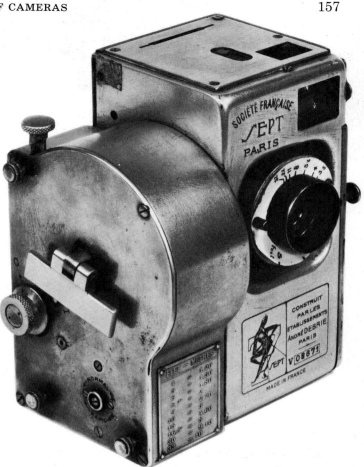

A short run cine camera, equipped for taking single shots on standard 35 mm film.

Some bellows, you will find, are very dry and brittle, often on one side only. I fancy that this side corresponds to the position in which the photographer who used the camera in its working days habitually placed his camera light. If this is the case, then all you can do is to keep applying a good leather dressing at frequent intervals over a period of weeks. If the leather is too far gone, it won't do any good, but if there is any 'life' left in the leather, it is quite surprising how it will revive.

If you need to replace leather on bellows, you are really up against it. The 'skivers' of very thin leather which were once used for this purpose are now almost unobtainable—and as for matching a particular colour or grain of leather, you can forget it.

That is why the wreckage of any old camera, however hopeless, is valuable. There will be

something there which you can use in restoring another camera which is not beyond hope.

But I suppose that the greatest joy of owning a number of ancient cameras is in using them. Perhaps you can't get plates, or roll films of the right size, but you can load up with cut film.

The old book form double dark slides are very easy to load with cut film. It only needs to be backed up with stout card, and it will be in perfect register. The other forms of double and single dark slide require that your film should be held in a 'sheath'—a thin holder of metal. Most of these sheaths have edges which are folded over the top edges of the film, and when the film is in the carrier, it is lying too far back by a distance equal to the thickness of these edges. This need not bother you, as long as you pack the mounting of your ground glass focusing screen so that it sits within its frame at precisely the same depth as the emulsion surface of the film, held in its sheath, in the double dark slide.

A decent depth gauge is necessary equipment, if you want to get the most out of old cameras.

It is quite useless taking a great deal of trouble over focusing on ground glass if, when you replace the ground glass by a plate or film, it does not lie in precisely the same plane.

Old cameras are not, in the main, nearly so easy to use as modern ones, though they can give you some very beautiful results.

Using an old camera is a bit like getting back on a horse after you have been driving a car. There is a quality of skill and personal involvement that you had almost forgotten. . . .

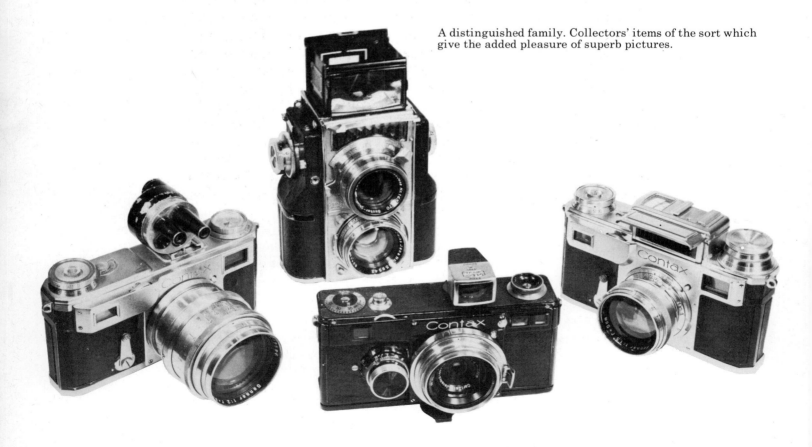

A distinguished family. Collectors' items of the sort which give the added pleasure of superb pictures.

Acknowledgement . . .

One cannot write a book like this one without help. In the first place, my thanks must go to my old friend, the late Cyril Leppard, who kindled my interest in the older cameras by selling me a pigskin covered Newman and Guardia "Special B" at Brunnings, in High Holborn, where he was one of the experts in their photographic section. Stanley Brunning himself, who also has since died, had a great interest in the history of cameras, and I must express my gratitude to him for a great deal of information, and not a few interesting cameras. The "Kodak" chapter at one point threatened to take over this whole book, and had to be pruned back to present the essential "mainstream" story. That so much information was available was entirely due to the generous help extended to me by the Kodak museum at Harrow. Thank you. The Leitz company, too, helped me with pictures of their pre-war models. Mr H. A. Garrett, surely the senior member of the English repair trade, had many memories to contribute, going back to his own youth as an apprentice with the Ross company, and senior members of the retail trade, such as Mr Albert Bell, and Mr Wooster of Bawtree's told me much that was fascinating, apart from finding me several nice cameras. Finally, my thanks are due to that notable editorial dynasty, the editors of the B.J. Almanac, who packed so much information into the pages of their fat little annuals.

Edward Holmes

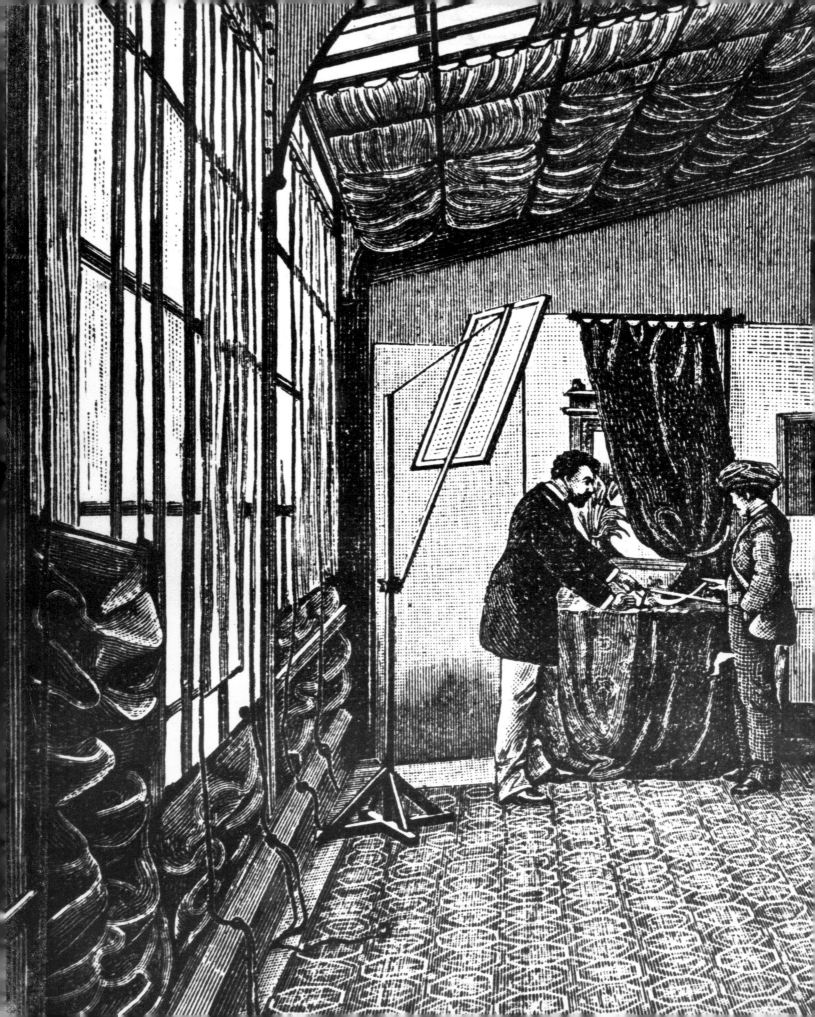